SOUTH DEVON COLLEGE LIBRARY

* 7 9 4 8 0 *

Chartered Institute of Environmental Health

KU-540-166

Body art, cosmetic therapies and other special treatments

Reference

Barbour Index

Editor
David Denton

While Ref

79480 | 646.72015

Published by
Chadwick House Group Ltd
Chadwick Court
15 Hatfields
London
SE1 8DJ

Telephone: 020 7928 6006
Fax: 020 7827 9930

© Barbour Index plc 2001

Chadwick House Group Ltd
(exclusive licensee for UK)

All rights reserved: no part of this publication may be reproduced, stored in a retrieval system, or transmitted in any form or by any means, electronic, mechanical, photocopying, recording, or otherwise without prior written permission.

Applications for reproduction should be made in writing to:

Copyright Manager
Barbour Index plc
New Lodge
Drift Road
Windsor
Berkshire
SL4 4RQ
United Kingdom

First published in Great Britain in 2001

ISBN 1-902423-80-1

DISCLAIMER

The information in this publication is intended for use by adequately qualified, trained and experienced people acting under appropriate supervision and using their own skill and judgement. It is intended to be a useful source of relevant information, but it is not intended to be comprehensive and it should not be relied on as a sole source of information.

Absence of omissions or errors cannot be guaranteed, and neither the publisher nor its sources accept any liability for these. Users should verify for themselves whether the information is appropriate and up-to-date at the time of use.

CONTENTS

FOREWORD

Most germs are only visible under an ordinary microscope, and many are not visible even then. Their ability to cause disease and to kill, is still a source of wonder. Even more amazing is how small a dose is sometimes sufficient for them to do their worst. Hepatitis B virus is a classic example of such an organism: it is too small to see except under an electron microscope, it can survive in the environment for many months, and a tiny dose is enough. In an outbreak caused by a tattooist some years ago, by tattooing one young man who happened to be incubating the disease at the time, he managed to get enough virus on his needles and other equipment to infect at least 30 others over a period of two months. As viruses do not grow outside body cells, this means that the virus persisted in his studio for all that time, and there was more than enough of it around from one young man to make at least 30 healthy people ill.

This outbreak (see note 1) was in many ways a landmark, because it stimulated the production of guidelines for hygienic skin piercing (note 2) which were rapidly adopted through most of the country, both by environmental health departments and by the professional skin piercers. At that time they consisted of acupuncturists, ear piercers, tattooists and hair electrolysists. Fortunately, hepatitis B virus was more resistant and more infectious than HIV and hepatitis C virus, so that when these other infections came along somewhat later, the precautions taken to prevent transmission of HBV were more than enough to prevent HIV and HCV. The subsequent rarity of outbreaks can testify to the success, and practicality, of the guidelines.

Since then other types of service for the general public which involve piercing the skin have come to light or have become more popular. Moreover the problems of localised bacterial infections after skin piercing remain. The laws governing these practices are complex. Hence the need for this book which covers many of these complicated issues, and includes many of the new forms of body piercing which have now become so popular.

I need to include in this foreword some observations on the avoidance of local bacterial infections. Bacteria may be introduced by un-sterile instruments (hopefully now very rare), from the surface of the skin, or by invading the wound later if the hygiene is inadequate. It is important to avoid infection caused by organisms on the skin.

There seems to be no consensus amongst skin piercers on the disinfection of skin, and even in this book there are variations in the recommendations. There is as yet no 'magic fluid' that will sterilise skin without damaging it. Thorough cleansing followed by disinfection is the best one can achieve. The fact that there is no ideal skin disinfectant is reflected in the large, and often costly, number of preparations marketed for this purpose. Of all these, 70% alcohol (ethanol or isopropanol) remains the most effective and useful skin disinfectant and the one least likely to cause harm.

It evaporates without leaving irritant residues, and is non-polluting. Also, unlike some other water-based disinfectants, organisms will not grow in it. 70% alcohol provides adequate disinfection of clean skin even though it evaporates quickly. It is, after all, used in hospitals and health-care establishments for skin disinfection prior to surgery and for other invasive procedures. Admittedly, it is flammable and should be stored and used away from potential sources of ignition. Also, repeated reuse can de-fat, dry and crack the skin, but this is unlikely to be a problem during short term use for skin piercing. Other water-based skin disinfectants (antiseptics) have drawbacks, for example they are considerably less effective and may be irritant or stain the skin.

After the piercing, it is best to leave the wound completely alone, and dry, for 48-72 hours. By this time, if the customer wishes to disinfect the site, alcohol may be re-applied without discomfort, and this will help to keep the wound dry. Alcohol must only be used to disinfect the skin *and not for treating an infection*. I suggest that the industry move to using only disinfectants with an alcohol base within about a year of this book's publication (from January 2002), to ensure uniformity and effectiveness.

I strongly endorse this book also in not recommending the use of ethyl chloride as a local anaesthetic spray. This is a barbaric practice.

In a book of this type there are bound to be differences in opinion, and by writing this foreword I do not necessarily agree with everything in it. Nevertheless, it is an excellent attempt to put together the guidelines for the varied types of piercing - some therapeutic, some cosmetic, and some for reasons unknown, and I hope it will be used to make this country, already probably the safest in the world for skin piercing, safer still.

Norman Noah

Professor of Epidemiology and Public Health
London School of Hygiene and Tropical Medicine

Consultant Epidemiologist
PHLS Communicable Disease Surveillance Centre

December 2000

Notes

1 An outbreak of hepatitis B from tattooing. Limentani A, L Elliott, N D Noah and J K Lamborn. The Lancet; 1979, 2, pages 86-88.

2 A guide to hygienic skin piercing. Noah, Norman. PHLS Communicable Disease Surveillance Centre, 1983.

PREFACE

It is often said that Nature abhors a vacuum, but as Barbour Index has found, not so much as people dislike a void of reliable information. Aristotle's familiar principle drove the creation of this collection of works, and to mix my metaphors, what a bag of ferrets it has been!

The first draft of the book was developed from a trawl of existing practice and my thanks to the many local authorities, individuals, associations and institutes who so generously gave their material, and to Margaret Goodwin for giving the collection form and coherence.

Our aim is to provide technical information for both regulators and regulated in the very uncertain world that is skin piercing and 'special treatments'. The book offers background reading and more formal guidance, for example, to be used in drafting conditions for licensing or registration. It is for this reason the book should not be seen as a cover-to-cover read. Rather, it is a best practice toolbox in a setting of supporting information. Readers are intended to use the topics relevant to their project and ignore the rest; I believe this is sufficient reason to excuse the repetitive content, should you choose to ignore my advice and read the book at one sitting.

The final draft is the outcome of very extensive consultation. This gives rise to my allusion to ferrets. Firstly, there was the ferreting out of the plethora of organisations concerned with the subject matter of this book. Much of this was via word of mouth, but now (thankfully) the Web is a good source of contacts. Second, the antagonistic nature of many organisations. This gave rise to much contradictory advice, and where I have not found evidence to support one view (or my own view) you will see the editor sitting firmly on the fence.

During the drafting of the book the subject itself has developed rapidly:

- the Scottish Parliament and the States of Jersey started consultation on new regulations dealing with skin piercing in their respective territories

- the NHS changed its policy on infection control, leading to more stringent requirements on community practitioners

- a new London Local Authorities Act gained Royal Assent, introducing a new class of special treatment exemptions

- the Health Professions Council appointed a president to shadow the Council For Professions Supplementary to Medicine during a transitional period. The new Council will have a profound impact on, for example, the practice of acupuncture and (in the longer term) on training and accreditation in the other complementary therapies

- the House of Lords published an extensive report on complementary therapies

- the European Commission opened a scientific investigation into dyes and inks used by tattooists in the EU.

All this virtually guarantees the need for a second edition, not least if long-promised legislation on skin piercing is produced south as well as north of the border!

David Denton
Managing editor

April 2001

ACKNOWLEDGEMENTS

I have had help from many friendly and considerate people during the drafting of this book. I would like to especially thank:

Alan Longford, Barry Walsh, Danny Green, David Morgan, Gordon Burrow, Graham Jukes, Grant Dempsey, Heather Beach, Ian Watson, Jan Jones, Jas Mankoo, John Manolakis, Julie Snelling, Karen Carr, Kim Gunn, Lionel Titchener, Lizzie Georgiou, Louise Clark, Michele Wehden, Mike Garton, Nigel Topham, Norman Noah, Pat Ware, Paul Lehane, Paul Sampson, Peter Hoffman, Roger Havard, Susan Bazin, and Sybil Perkins.

PIERCING AND OTHER BODY ART

Over the last decade, body piercing has increased dramatically in popularity as a fashion trend among young people. In recent times piercing has its origins in the gay and sado-masochist scene in San Francisco, but its anthropological roots go back far in time. This chapter covers body art – piercing, branding and scarification - but excludes tattooing, which is discussed in its own dedicated chapter.

Skin piercing is an ancient cultural phenomenon which has only emerged into mainstream Western society over the last three decades. Body decoration was one of the earliest expressions of art and was practised by men and women of the palaeolithic and neolithic times. It may have also been used for therapeutic reasons, for example in combatting ailments such as arthritis.

In traditional societies, skin piercing is a long-established custom denoting social position, whereas in the industrialised West, it is employed more as a means of expressing individuality and youthful rebellion. Nonetheless, a survey of 'Body Art' magazine readers with piercings revealed that 79% were aged 29 years or over, 58% were in a long-term relationship, and little more than half considered themselves adventurous.

EAR PIERCING

Ear piercing is the most popular form of skin piercing, and in Western society around 80% of females have their ears pieced. The earring business is worth around £50 million annually in the UK alone.

Many indigenous peoples practice ear piercing. Piercings are used to denote membership of a family or group, to mark an important life stage or event, or to reflect beliefs and mythology. They are normally carried out using sharp bones or thorns. The Suya tribe of Brazil pierces children's ears as a way of showing that they must listen to their elders. The ear disc is believed to aid learning and denote wisdom.

African Sambuni women wear one double strand of beads looped from their ears for each son that passes into warrior-hood. Lips, noses and ears are also pierced during childhood. Piercings denote tribal identity and are thought to protect against the supernatural.

Also in Africa, the Surma people pierce the ear several times around the rim and extend the lobe with an ear disc. Pierced ears relate to tribal myths about the origins of skills, such as weaving.

Ear-cartilage piercing is especially popular among the Masai and Fulani peoples. These piercings are thought to emphasise beauty and wealth.

FACIAL PIERCING

In many societies of Africa, India, South America, Indonesia and Australia, nostril, lip and septum piercing occur as part of rituals marking the passage from childhood to adulthood. Lower labret piercing (adornment of the lip with a piece of shell or stone) is found among tribes in the Amazon, West Africa, India and North America, while piercing of the upper labret is unique to tribes in Chad.

LIP PIERCING

In South America, Txucarramae boys wear lip discs made of a lightweight wood called 'sara'. As the boys grow, the discs are replaced with larger ones of up to 120mm in diameter.

The Suya of Brazil also pierce children's lips to show that a child is gaining in speech and understanding. In adult males lip piercing represents skills in speaking as well as in warfare.

NOSE PIERCING

Nose piercing was first recorded in the Middle East approximately 4,000 years ago. The practice is still followed among the nomadic Berber and Beja tribes of Africa, and the Bedouin of the Middle East. A nose ring is given by the husband to the wife at their marriage, and is her security if she is divorced. The size of the ring denotes the wealth of the family.

Nose piercing was introduced in India in the 16th Century by the Moghul emperors. It signified marriage and wealth.

Nose piercing in the West is first thought to have appeared among the hippies who travelled to India in the late 1960s. It was later adopted by the Punk movement of the late 1970s as a symbol of rebellion against conservative values and ideals.

TONGUE PIERCING

The only evidence of tongue piercing found in anthropological literature concerns the ancient Maya of Mexico and Central America. Maya royalty practised temporary tongue piercing as a means of communing with the spirits of their ancestors during special rituals. Today, it is a form of piercing increasingly popular in the Western world.

BODY PIERCING
Nipple piercing

Nipple piercing was popularised in the 14th century by Queen Isabella of Bavaria. She introduced a form of dressing which opened the neckline to the waist. This exposed the breasts and led to the piercing of nipples from which gold chains were hung. Later, in the 1890s, the so-called 'bosom ring' came briefly into fashion.

Nipple piercing has been practised by the Karankawa Indians of Texas and is still practised in the mountains of Algeria by women of the nomadic Kaybyle tribe.

Navel piercing

Navel piercing appears to be a Western invention, although there exist myths telling of ancient Egyptian princesses who had their navels pierced to signify their royal status.

Genital piercing

Male genital piercing is believed to have evolved from a practice originating in Ancient Greece, during the Olympic Games. Greek athletes competed in the nude, so to prevent unbecoming movement of their genitals and reduce the risk of chafing and tearing, they fastened a ribbon around the foreskin and tied the ends securely at the base of the penis.

Southeast Asian, Indian and Arabian cultures also perform genital piercings, but these are traditionally executed at puberty to mark the passage of adolescents into manhood.

The piercing of the female genitalia is mainly a modern-day invention, although there is a reference in anthropological literature to Trukese women (who originated from Polynesia), who pierced their labia and hung little bells from them to attract suitors.

It is likely that the so-called 'Prince Albert' form of piercing is a modern myth, in that it is very unlikely the Royal personage was adorned in this way. Nonetheless, the Prince Albert is one of the more common forms of modern day genital piercing.

TYPES OF BODY ART
Scarification

This is an extreme form of permanent body art and includes both branding and cutting in order to produce scar tissue on the skin surface.

Scarification is used as:

• a rite of passage

• a badge of honour

• a beauty mark for attracting members of the opposite sex

• historically, a means of identifying criminals and slaves

Camphausen (1997) describes the process as 'incising or slashing the skin. Sometimes the process is repeated over time in order to achieve deep and clearly visible marks; in other cases the wound is kept open temporarily in order to create pronounced and visible scars. The main reasons for being 'cut' today seem to be body adornment and decoration'.

Cutting is carried out using a surgical scalpel, taking care not to slice too deep due to the risk of serious injury to skin, nerve or capillary tissues.

The depth of the cut is dependent on the skin of the individual being cut, and is usually carried out on the chest or the back. Cuts may be enhanced using ash or tattoo ink.

Any parts of the body subject to stretching, pressure or movement are unlikely to be satisfactory sites for scarification.

Branding

A form of scarification, usually achieved by burning the skin with heated metal to form a simple but permanent design.

The practice has its roots in animal husbandry where branding was used to mark livestock. Among humans, it was employed as a means of identifying slaves in Ancient Egyptian and Roman civilisations.

In recent years, branding has been adopted as a means of adornment, used alongside, or instead of, tattooing. It is carried out using small strips of surgical stainless steel heated by holding with pliers over a flame, often a blowtorch.

The practitioner's art involves:

• making a design which will remain well-defined after the process

• holding the hot metal on the skin long enough to create scar tissue (first or second degree burns), but not so long as to inflict third degree burns

• maintaining a steady hand to ensure all the strikes with the branding steel are of the same character - uneven pressure will produce uneven scar tissue

Although there are conflicting reports on the subject of pain due to branding, NEHA (1999) notes that 'branding does hurt. Usually the pain is described as coming after the brand is done, during the healing period'.

It takes a long time for a brand to heal (up to a year), and its size will tend to expand during the healing process, possibly spoiling the ultimate design.

Braiding

This is the most extreme form of scarification and involves cutting adjacent strips of skin - keeping one end attached - and braiding them together. The loose ends are then re-attached to the skin.

NEHA (1999) states that this 'is not practiced by reputable body art professionals; not only is it extremely painful, the risk of infection and permanent injury is high'.

Amputation, clitoridectomy and labia removal

In some cultures, a bereaved person might have an amputation after the death of a loved-one, serving to denote a pain never forgotten and a wound forever visible.

Other cultures and subcultures have resorted to the complete amputation of a finger in response to a personal failing, the result of which can never be rectified. Among members of Japan's centuries-old criminal underworld, the Yakuza, the sacrifice of a finger is a form of ritual suicide and is seen as the only means of proving that one understands the true gravity of one's failing.

Elsewhere, appalling practices such as infibulation see the labia cut away and the edges of the wound sewn together, in order to ensure that the girl/young woman may not engage in sexual intercourse. Clitoridectomy is where the visible part of the clitoris and parts of the labia are cut away, resulting in the loss of erotic/sexual sensation. Such forms of mutilation are outlawed in the UK.

Beading

This is described by Camphausen (1997) as 'the insertion of small beads under the incised skin of the phallus, possibly as an attempt to make a small one bigger (or rather thicker) or to provide additional sensory stimulation to one's partner'.

TYPES OF BODY PIERCING
Ear

The lobe or the upper cartilaginous parts (the helix) of the ear are the most usual sites for piercings. It should be noted that these two areas of the ear are made up of different types of tissue, and have different healing times. The lobe takes six to eight weeks, the helix, three to six months.

Other sites that may be pierced are the tragus, the conch and the rook.

The lobe is a common site for piercing with proprietary piercing guns. Many piercers frown upon their use anywhere other than the earlobe.

Nose

Piercings can be made in the nostril or the septum - the part dividing the nostrils. The healing time can be as long as six months. Such piercings may be problematic because of the difficulty in disinfecting (and keeping clean) the wet mucosal surfaces on the interior of the nose.

Mouth

Lips, cheeks, and the tongue are usual sites, and jewellery should be carefully selected to avoid chafing or irritation of the teeth or gums. Piercing through the coloured part of the lip is not advised.

Tongue piercings must be carried out with particular care, owing to the risk of severing large blood vessels, or causing trauma to nerve tissue. The tongue will commonly be swollen for one or two weeks after the piercing procedure.

All mouth jewellery is subject to plaque build-up, meaning thorough aftercare using denture cleaner is necessary. The British Dental Association suggests that people seek advice from their dentist for detailed after-care instructions concerning all mouth piercings.

Likewise, maintenance of the jewellery itself is crucial for avoiding accidental swallowing or inhalation should it break up or become detached.

Eyebrow

Care must be taken not to interfere with nerves immediately beneath the eyebrow. The permissible depth of piercing will depend on the individual, but is unlikely to be more than about 10mm. The healing period is around two to four months.

Eyebrow piercings are commonly rejected by the body.

Surface

These usually involve the neck, the chin, the forearms and wrist. However, they are likely to reject, as the skin tension puts pressure on the jewellery.

A good knowledge of human anatomy is very important before undertaking surface piercings, owing to risk of damage to nerves, blood vessels and the musculature.

Navel

A common site for piercing, the navel has considerable variations of shape between individuals. Not all are suitable for piercing, and placement and choice of jewellery is critical for success.

Healing time varies considerably, and may take up to one year.

Navel piercings are potentially hazardous because of the navel's direct link to internal organs and the abdomen generally. Infection of the navel can result in severe infections of, for example, the liver - with potentially serious medical consequences. In particular, umbilicus piercing is not recommended, owing to the risk of visceral infection.

Nipple

Another common site for piercing, again with position and choice of jewellery critical for success. Female piercings must not be made through the areola, although it is permissible for male nipples. The healing period is likely to be in the region of four to eight months.

Genital

Naturally, genital piercing must be discussed according to sex.

Clearly, for both sexes intimate contact is involved. There are also age of consent implications. For example, it is not possible for a girl aged less than 16 years to give consent for these procedures. For females below this age, genital piercing constitutes indecent assault, while the 'Prohibition of female circumcision act 1985' prohibits 'mutilation' of the labia or clitoris. It is good practice for piercers not to complete genital piercings on girls less than 18 years of age, even with their parents' consent.

Both sexes are affected by the 'Sexual offences act 1956' to the extent that neither girls nor boys under the age of 16 years may give consent to intimate sexual contact if it is for sexual gratification.

Female

The sites involved are the clitoris, the clitoral hood, the labia, the forchette and the triangle. All are dependent on the individual's anatomy and generally speaking, the more pronounced the part, the higher the chance of success.

Healing times vary between a few weeks (clitoris and clitoral hood) to several months (outer labia).

Male

The sites involved are the glans (ampallang, apadravya, dydoe, Prince Albert). Piercings can go through the urethra, the foreskin, the frenum, and the scrotum, or may simply consist of surface piercings of the pubic area.

Healing periods vary considerably from a few months (Prince Albert) to over a year (ampallang and apadravya).

JEWELLERY
Recommended metals for body art

Piercers are advised to use the following metals:

- stainless steel complying with Directive 94/27/EC and the 'Dangerous substances and preparations (nickel) (safety) regulations 2000'. This is an austenitic, low carbon, iron-chromium-nickel-molybdenum alloy. At the time of writing there was no agreed classified name for this material, other than brand names. It is formulated to minimise the risk of nickel-prompted allergic reaction and has superior resistance to pitting and crevice corrosion

- titanium (6AL4V)

- solid gold of at least 14 carat. Many gold alloys may not be suitable owing to the risk of allergic reaction, while 18 carat gold (or higher) may be considered too soft - leading to being easily scratched and able to harbour infection.

Silver is *not* suitable for use with new or unhealed piercings due to its property of tarnishing easily. It causes discolouration of the piercing, and the metal's softness enables microorganisms to become entrapped.

Allergic response to jewellery

It is recognised that jewellery containing nickel may cause allergic reactions in some people. This can prevent proper healing and cause sensitivity to other items. New Scientist (1999) reports that: 'Scientists in Finland…have shown that body piercing is probably causing a steep rise in allergies to nickel across the Western world'. Sensitised individuals find may belt buckles, wristwatches, spectacle frames and jewellery impossible to wear.

The issue of nickel allergy has been addressed in Directive 94/27/EC, which (inter alia) states that nickel may not be used:

- in post assemblies inserted into pierced ears and other pierced parts of the human body, unless such post assemblies are homogeneous and have a nickel concentration of less than 0.05% by mass

- in products intended to come into extended, direct contact with the skin. This includes earrings, finger rings, etc

- if the rate of nickel release exceeds $0.5mg/cm^2/week$.

These requirements were originally delayed due to the difficulty of agreeing test methods, but are now included in the 'Dangerous substances and preparations (nickel) (safety) regulations 2000'.

The requirements came into force on 20 July 2000, in relation to the supply of products to which they apply by the manufacturer in, or importer to, the United Kingdom, or, in the case of products manufactured in or imported into the United Kingdom on behalf of another person, by that other person. The only exception is where products are supplied by retail, in which case the requirements become active on 20 July 2001.

PROBLEMS ASSOCIATED WITH BODY PIERCING

Infections and transmission of communicable diseases

Local and systemic infections due to skin piercing and the risk of blood-borne infections such as hepatitis B, hepatitis C and HIV are well documented in the medical literature.

Khanna and Kumar noted, in a letter to the British Medical Journal (BMJ 2000; 320: page 1211), that the microflora of piercings have not been scientifically described, unlike those of sutures and staples, where *Staphylococcus epidermis* is the commonest organism. They guess that *E.coli* is the most likely culprit in genital piercings.

Because of the presence of protective biofilms, Khanna and Kumar advocate removal of body jewellery in cases of infection, with investigation focused on the possibility of local or systemic infection to be controlled by an appropriate antibiotic. It should be noted that care must be taken to correctly identify that an infection is the problem, rather than (for example) friction or migration of the jewellery.

Bury and Rochdale survey

Between March 1998 and February 1999, a survey was conducted among GPs in Bury and Rochdale, where there are 11 known body piercers operating among the local population of 389,000. The survey aimed to document the problems associated with body piercing (see Benons et al, Environmental Health Journal, October 1999).

A total of 472 complications were reported by GPs, representing 56% of practices in the district. The report stated that 'the commonest complications are bleeding, local infection, and oedema of surrounding tissues leading to embedding of the jewellery'.

The report further detailed that 'local trauma to the pierced site may require (jewellery) removal for immediate management of tissue damage. While removing any form of intra-oral jewellery, the risk of accidental aspiration must be considered'.

Other potential problems include:

- chipped teeth
- excessive bleeding
- interference with urination
- loss of function due to nerve damage
- piercing in the wrong place
- swelling
- tearing

The report also noted that 'the frequency of these complications does not appear to have been determined, although we understand from our discussions with body piercers that this may be up to 30%'. However, there was no statistical evidence to support this figure.

ANAESTHETICS

The use of anaesthetic sprays and creams is common practice in body piercing. Treatment with ethyl chloride and xylocaine are the best known among piercers and local authorities who monitor them.

An environmental health officer from Hinkley and Bosworth Borough Council served a prohibition notice (under section 3(2) of the 'Health and safety at work etc act 1974') on a local piercer, forbidding use of local anaesthetics.

The notice specifically prohibited use of xylocaine spray on clients receiving body piercing. The piercer appealed against the notice to the Employment Appeals Tribunal, who subsequently modified the notice to require questioning of clients regarding contra-indicating health issues, prior to using the anaesthetics. It should be noted that Astra Zeneca has market authorisation for xylocaine anaesthesia of oral mucous membrane using a 4% topical suspension.

Xylocaine spray is described in the data sheet provided with the product as a metered-dose pump-spray anaesthetic product containing lignocaine in an alcohol solution. Like all anaesthetics it can depress excitable tissues, and so it may have adverse effects on the central nervous system, on respiration, and on the cardiovascular system. However, the data sheet also points out that 'such events would only occur when significant quantities of the product has been ingested and under normal conditions of use and handling it does not present a hazard'.

Because of the potential side effects of this product, the manufacturer advises that before use of xylocaine, a contra-indication questionnaire (provided in the notes with the product) should be completed, and a record made of the responses. If clients answer 'yes' to any of the questions then a doctor or dentist should be consulted before proceeding.

Another anaesthetic which causes some concern, and which is commonly used by body piercers is ethyl chloride.

Ethyl chloride is described in its data sheet as a highly-volatile liquid with an ether-like odour; contact with the liquid can cause local anaesthesia and eventually, frostbite. It is sold in 100ml glass tubes, which have a rounded base similar to a test tube. The instructions for use and handling advise 'avoid use near naked flames, high temperature surfaces and electrical equipment. In the event of breakage the area should be evacuated at once and well ventilated until the gas has dispersed'.

This compound was mentioned in guidelines issued by Professor Norman Noah of the London School of Hygiene and Tropical Medicine who stated unequivocally that 'ethyl chloride should not be used as an anaesthetic'.

A further topical anaesthetic used by piercers is EMLA cream - it should be noted that this is a prescription only medicine in the UK. It contains 2.5% lidocaine and 2.5% prilocaine, and is applied 1 hour before the procedure. Numbing of the skin occurs 1 hour after application, reaches a maximum at 2 to 3 hours, and lasts for 1 to 2 hours after removal.

Anaesthetics administered by injection are not permitted for use in the UK, except by dentists and medical doctors.

AFTERCARE FOR NEW BODY ART

New piercings are likely to become swollen and are susceptible to infection during the healing process. Many factors can affect wound healing, including:

- nutritional status

- piercing-related issues, including poor practice, rough handling, tight skin or jewellery, or poor blood supply to the chosen piercing site

- presence of foreign material, for example implants

- scar formation

- a moist environment around the piercing

- initial biological response - severity of inflammation, local infection, etc

- localised infection.

After-care treatment is entirely dependent on the location and type of body art. For instance, aftercare for the inside of the mouth will be different in detail to that suggested for an external, dry area like an earlobe or tattoo.

Here are a number of recommended practices common to aftercare of all forms of body-piercing:

- piercings should be kept dry, so far as practicable

- the aim is to prevent introduction of infection and help natural healing processes

- do not touch the piercing for at least 48 hours

- wash hands thoroughly before handling the piercing or jewellery

- do not use fingernails to move jewellery or manipulate the piercing

- to maintain mobility of the jewellery it should be turned no more frequently than once or twice a day with clean hands, handling the jewellery as little as possible – for example by using a tissue

- try not to remove encrustation (scab) as this protects the piercing from infection

- after a shower etc, dry the piercing using cotton swabs or tissue - do not use a towel or face cloth

- avoid restrictive clothing around navel and genital piercings.

It should be noted that usefulness of antiseptics and advice on frequency of cleansing versus risk of infection are still matters of custom and practice. There is disagreement on the usefulness of antiseptics in piercing aftercare.

Current medical advice strongly recommends that the piercing be handled as little as practicable; 70% alcohol (or other antiseptic in 70% alcohol carrier) should only be used for antisepsis if required. This is because 70% alcohol is unlikely to introduce infection into the wound, and some doctors believe it has an important beneficial drying effect on the piercing.

There are a wide variety of healing times for piercings, which may not be completely healed for several months. Appropriate jewellery should always be worn in the piercing even when fully healed. Further advice should be obtained from the piercer, or form a doctor or dentist if removal of the jewellery is desired.

The following are indications of infection:

- prolonged redness and swelling (this may be normal in fresh piercings)

- sensation of heat at the site of the piercing

- pain, usually throbbing or spreading pain

- unusual discharge (yellow, green or grey pus).

In case of infection, a doctor should be consulted as soon as possible.

Piercing and other body art

TATTOOING

Tattooing is an ancient art form of permanent colour marking below the skin surface. It requires a very strict hygiene regime to prevent the spread of infection.

The principle of tattooing is to penetrate the outer skin layers and to introduce colour so that when the skin heals, the colouration remains visible. Some Japanese methods do not involve use of colour, so tattoos are only seen when the body is in a warmer environment and the patterned skin surface becomes apparent.

The ancient practitioners - mainly Maori and Japanese - used sharpened bamboo sticks as needles, and even today, people occasionally tattoo themselves with ordinary needles leaving a series of dots coloured with Indian ink. In the past, tattoos were traditional in the armed forces, especially in the Royal Navy where up to 60% of sailors were adorned with them. With many young celebrities sporting tattoos, over 12% of the general adult population now have them, rising to over 50% of the population of prisons and other institutions.

The modern tattoo machine consists of a motor - a set of electric coils similar to a door bell chime, which is connected to a tube containing the tattoo needles. The tube consists of three parts, making up the grip and tip where the needles emerge to pierce the client's skin. The needle bar goes through the tube, and the top end connects to the motor by a small cam with an armature that connects to the top of the needle bar which has a loop in its design; the needle has the ability to operate at up to 3,000 strokes per minute. To reduce vibration, and produce the correct tension on the needle bar, strong rubber bands are used on the motors and needle bar. A number of needles are soldered onto the needle bar and these pierce the skin when the tattoo gun is switched on. A small number of needles are used to give a clearly defined outline, whilst a larger number of needles are soldered onto the bar to 'fill' the tattoo with colour.

The tattoo machine is foot-activated, by way of a pedal, and uses a transformer to reduce the operating voltage to 12V. It can be taken apart, and while the motor (also known as the 'tattoo frame') cannot be sterilised, it should be wiped clean with 70% alcohol.

The tips, grips and needle bars are made of stainless steel and can be sterilised. To ensure the needles are clean before sterilisation, ultrasonic cleaners, which use a vibrating liquid to clean into equipment crevices, are universally used.

The type of equipment found in a tattoo studio includes:

- autoclave
- cleaning materials (alcohol swabs, disinfectant, etc)
- individual pots for colours
- racks and stands capable of being autoclaved
- razors (single-use, or capable of sterilisation with disposable blades)
- single-use equipment such as latex gloves and spatulas for Vaseline
- ultrasonic cleaner
- waste storage equipment (sharps boxes, pedal bins with liners, etc)

There are a number of standard precautions that must be observed to reduce risk of transmission of blood-borne micro-organisms including human immune deficiency virus (HIV), hepatitis B and hepatitis C viruses.

PROCEDURE MANUALS

It is recommended that all tattooists produce a procedure manual to assist in training and ensure that best practice is used consistently.

The contents of the manual should include:

- a regular review of storage facilities for sterile packs, chemicals, protective clothing and waste
- a validation of the sterilisation process, testing of packages and seals, sterility tests, copies of autoclave maintenance details, etc
- handling and cleaning of protective clothing etc procedure
- hand-washing procedure
- management of exposure to blood and body fluids
- sterilisation procedures
- studio cleaning procedures, including all furniture and fittings
- waste disposal procedure.

BEST PRACTICE TATTOOING
Preparation

1 Sterilise and set up all equipment in advance to ensure skin-penetration procedures can be undertaken without interruption. Interruptions increase the risk of transferring micro-organisms

2 All equipment must be disposed of, or cleaned and sterilised (if appropriate) before re-use

3 Any liquids or gels (eg, lotions, creams, oils and pigments) should be measured and decanted into single-use containers for each client; excess or unused liquids and gels must be discarded immediately

4 If re-usable containers are used they must be cleaned and sterilised after each use

5 Collapsible squeeze tubes/bottles or pump packs should be used to dispense liquids and gels

6 Vaseline or other gels should be removed with a clean, unused spatula or spoon

7 Stock should never be returned to original containers

8 Vaseline or other gels should be applied to the client's skin using a spatula, cotton bud, cotton wool ball, or gauze pad, which must be disposed immediately after use. These implements should not be re-dipped into the fluid.

Records should be kept of all clients, including the date, time and details of the procedure performed. For example: 'female, 25yrs, swallow on left shoulder, 1:30pm, 15 June 2000'. Names and addresses of clients will allow for easy follow up if required. Mobile operators must record the location where all procedures were performed.

Persons under the age of 18 should not tattooed ('Tattooing of minors act 1969'); action can be taken by the police under this legislation. Similarly, nor should any persons be tattooed who appear to be under the influence of drugs or alcohol.

Preliminaries

The client will normally choose a design selected from a standard patterns, and a price will be agreed.

The tattoo artist should check that the person is over the age of 18 years of age, wants the tattoo, knows that a tattoo is permanent, and is not under the influence of drink or drugs.

Clients should ensure that the tattooist is registered with the local authority, needles are changed and sterilised between customers, the colour is freshly made-up, and that the studio is visually clean and well organised.

A record must be made of the client's name, age, type of tattoo, date, etc, and a signed copy of their consent obtained.

Skin preparation

The client's skin must be clean and free from infection including sores, wounds, rashes and cuts around the area to be worked upon. Before starting the procedure, the skin must be wiped with a suitable antiseptic, which is allowed to evaporate completely. This takes approximately 1-2 minutes.

Suitable antiseptic solutions include:

- 70% w/w ethyl alcohol
- 80% v/v ethyl alcohol
- 70% v/v isopropyl alcohol

Operators should ensure that the use-by-date on antiseptics has not expired. Antiseptic *must not* be used after its expiry date, because it is probably ineffective.

Shaving

Regarding shaving, the following points shall be noted:

- a disposable plastic safety razor should be used (on one client only); traditional cut-throat razors are not recommended
- the area to receive the tattoo should be shaved to remove unwanted hair
- if petroleum jelly or a lubricating gel is to be placed on the client's skin, enough for one client only should be removed from the stock container with a clean spatula, and placed into a small container
- a new spatula must be used if more petroleum jelly or lubricating gel is required from the stock container
- roll-on or stick-type applicators are *not* appropriate for multiple use situations and must not be used.

Design

Unless the tattoo artist carries out freehand designs, a stencil is used on the skin to provide an outline of the design. Because of the high risk of cross-contamination, it is important that stencils are not re-used on other clients. If used for transferring the stencil, freshly made-up Dettol should be used very sparingly. Alternatively, some artists use a single-use methylene blue transfer stencil.

The tattoo procedure can then begin.

Tattooing

Initially the artist will complete the outline. The needle is dipped in the appropriate liquid colour and the tattoo machine guided through the skin; the needle will frequently be re-dipped in the colour, and from time to time, is placed in a single-use cup full of clean water in the ultrasonic cleaner to remove excess ink and skin debris.

The excess colour that splashes onto the skin can be removed by regular wiping with gauze or paper tissue. The use of Vaseline makes the skin more supple and will keep any excess ink on the surface of the skin, making it easier to wipe away.

This operation creates minor surface damage to the skin and will only rarely give rise to bleeding at the time of the tattoo operation.

When the outline has been completed, the design is filled in using a needle bar containing more needles than the outline equipment. Very large pieces of work may be worked on over a period of weeks, while smaller tattoos can be completed at one sitting.

Aftercare

Once the tattoo is completed, it is usual for the area of damaged skin to begin to weep. The tattooed area should be covered using a sterile dressing (eg, Melolin in an individual paper-peel pouch, or suitable equivalent) and the tattoo artist should also give aftercare advice to the client.

It is best practice to supply the client with written aftercare information covering the following:

- post-tattoo procedure
- infections and what to look for
- general care instructions, in particular the hazards of skin contamination by chemicals, oil, grease, and biohazards such as raw meat
- healing times
- reminder to consult a doctor in case of infection, allergic reaction or other cause for a delay in healing.

After a customer has been tattooed, the needle bars must be disengaged from the tubes, the needles ultrasonically cleaned before the ink dries, and the needle bars and tubes placed in a puncture-resistant container that can be put into the autoclave - for example, a surgical stainless-steel kidney dish. This container should be kept away from sterile needles and equipment.

The elastic bands or plastic bags used on tattoo machines should also be disposed of after each client. At the end of each work session the needles are 'burned off' the needle bar using a naked flame at the soldered junction. The needles, unless re-sterilised, should be discarded to a 'sharps' box, while needle bars are cleaned, sterilised and made ready for re-use.

Pigment/colour capsules must be disposed of after each client. Because they may still contain colour, they should be wrapped in a plastic bag to prevent spillage of colour onto other disposable equipment. All disposable equipment and materials should be properly stored in the correct waste bin.

PREMISES

Tattoo studios should be physically divided into two areas: a front reception and waiting room with seating and displays of the designs that can be purchased; and a treatment area screened from the public area, as many tattoo procedures should be carried out in privacy.

The studio should include the following:

- adequate artificial and natural lighting
- wall and floor finishes must be durable and washable; they must be clean and capable of being maintained in a clean condition
- work surfaces must have smooth impervious finishes such as laminate or metal, capable of not being damaged by regular cleaning with hypochlorite or phenolic type materials
- the treatment area must have sufficient space to store equipment
- washing facilities with hot- and cold-water supply, ideally with foot-, elbow- or infra-red operated taps to prevent cross contamination
- liquid soap or detergent from a dispenser; bars of soap can harbour bacteria and be a cause of cross contamination
- hot air dryers or disposable towels for hand drying; textile towels should not be used.

NEEDLES

The following points must be noted:

• needles and other equipment used for tattooing should be sterile, disposable, and single-use wherever possible

• needles soldered onto needle bars should be cleaned before sterilisation. Excess solder must be removed and the needle and needle bar placed in an ultrasonic cleaner to further remove excess solder, flux and other residues

• re-usable needles (ie, not those manufactured from carbon-steel) or other skin-penetration equipment must be cleaned and sterilised before every use

• packaging should be opened, or equipment sterilised at the start of the procedure, and either placed on a sterile surface/tray, or removed directly from packaging for use as required

• sterile needles should be handled with sterile forceps

• tips and grips should be re-assembled, and needlebars inserted in the tattoo machine while wearing single-use gloves

• needles *must not* be tested for sharpness on the operator's skin before use. Should the operator accidentally touch the sharp end of a needle at any stage during the process, it must be replaced immediately by a sterile needle

• any needles that exhibit burrs, hooks, damage or blunt points should be disposed of to prevent injury to clients

• hollow needles should not be used for tattooing, as skin damage will occur.

DYES/COLOURS/PIGMENTS

Tattoo pigments can be purchased from wholesalers ready made-up in applicator bottles. Wholesalers produce blended bulk, milled, coloured pigments in dry powder format. Some more-finely graded pigments (made-up of particles of less than six microns), have various additional components introduced to make the powder dispersible in water. The colour is suspended in the liquid mix until a thick, cream-like consistency is achieved.

Inert organic compounds are used to produce tattooing inks. They must be of a medium particle size (chemical dyes are unsatisfactory) and are mixed into a suspension with glycerine, de-ionised water and alcohol.

Pigments should not be subject to autoclave heat and pressure, either before or after being dissolved, as this is likely to change their chemical and physical properties. Some suppliers have the pigment treated with a gamma radiation source to assure sterility at the time of irradiation; this is of limited usefulness unless the tattoo pigment is carefully handled throughout the supply chain.

Modern tattoo inks are much brighter than previously, and are able to be 'worked' into the skin more effectively, hence the tattoo definition is more reliable and persistent. For black and shading effects, Indian ink ('Pelican') is normally used as this makes a perfect black colouring. It can be diluted with sterile, distilled water for delicate shading effects.

In the past, red, purple, yellow and green pigments containing excessive levels of heavy metals were associated with skin reactions. This problem appeared again in the UK during 2000 with delayed, severe and chronic skin reactions possibly due to a contaminated batch of Red Pigment 170 (red 3RSX). The symptoms were inflammation in a swollen, raised, itchy, scaly area, with late scarring, after some months which may require plastic surgery. At the time of writing, this reaction has not been linked with an identified offending contaminant, pigment ingredient, or environmental factor. The pigment supplier considers exposure to sunlight (UV radiation) may be a factor, while the Public Analyst who examined the implicated batch considered the pigment particle size range may be implicated. A survey was being conducted via the British Association of Dermatologists to ascertain recent experience of adverse reaction to red tattoo dyes. In addition, the European Commission has begun an investigation into tattoo dyes and pigments, as they are not currently regulated alongside other cosmetics (tattoo pigments are explicitly excluded from the cosmetic products Directives).

It should be noted that all tattoo pigments are manufactured for a purpose other than tattooing. Safety data for a skin-contact purpose is generally not available from the original producer as the pigments are intended only for industrial applications. This unsatisfactory position is lessened by the long experience tattooists have in using these industrial pigments without harm.

UK tattoo pigment suppliers have set up the Tattoo Pigments Registry. Its aim is self-regulation of tattoo pigment safety and quality pending publication of European or other national standards. Where possible, safety data sheets are to be issued by these suppliers supported by data obtained through examination by a public analyst.

In general, the following points should be noted:

• pigments should be obtained from a reliable supplier. Tattooists should ask their supplier for evidence that heavy metals and other hazardous substances are absent in the dyes and pigments.

• pigment should be purchased ready diluted, or the concentrate should be diluted with sterile and chemically-inert diluent

• pigment or solution(s) that have been used for one client must not be used for another client

• enough solution for one client should be dispensed into sterile, disposable containers

• any solution left over must be discarded along with the container

• if non-disposable containers are used they must be cleaned and sterilised prior to each use.

CLOTHING

Operators should wear clean, washable overclothing intended exclusively for use when attending clients, there should be no pockets on the overclothing. A clean garment should be worn at least daily, and clothing should be changed once it has been soiled - many tattoo artists use plastic disposable aprons.

Protective overclothes should be removed and stored in the work area before breaks, including lunch, smoking, drinks and toilet breaks.

GLOVES

To protect both the tattoo artist and the client, single-use gloves should be used. Care must be taken when donning them, and in their removal. Bear in mind some people have an allergy to latex gloves, in which case an alternative should be used.

LINEN

The following points should be followed regarding the use of linen:

- linen be replaced with single-use paper towels or liners

- where single-use paper materials are not in use, clean linen garments or towels should be used on each client

- used linen should be removed from the treatment area once the client leaves or when it becomes soiled. It should be stored before laundering in a suitable closed container

- used and clean linen must be stored separately

- all linen including towels, capes, garments and other washable fabrics must be washed with hot water and detergent, rinsed, dried and stored in a clean, dry, dust-free location.

OPERATOR HYGIENE

Broken skin or infections on the exposed parts of an operator's body must be covered with a waterproof dressing, to protect the operator and clients.

If a cut or abrasion is on the hand, disposable gloves must be worn throughout the tattooing procedure. It is recommended that wearing latex gloves become standard procedure during tattooing.

SMOKING, EATING AND DRINKING

Operators must not smoke, eat or drink while attending clients. These activities allow close contact with the mouth, transferring micro-organisms to the hand, which can then be spread to the client, and vice versa.

ANIMALS

Animals must not enter rooms where skin penetration procedures are performed. This will prevent the soiling of the premises and the introduction of vermin.

An exemption may be granted for animals used by the sight and/or hearing-impaired.

CLEANING WORK SURFACES

After use by each client, the surface of chairs, couches and the like, as well as benches, tables and other working surfaces where there has been contact with the client's skin, are to be washed with warm water and detergent, and then dried with a clean disposable wipe; covered with a clean towel; or covered with disposable paper.

All protective coverings on surfaces and equipment should be removed, taking care not to contaminate the underlying surfaces of chairs, worktops etc. These single-use coverings should be disposed of in the clinical waste bin.

At the end of each working day (and when they become visibly soiled) the surfaces should be washed with warm water and detergent, and dried with a clean, disposable wipe. If any surfaces have become contaminated with blood or any other body fluid, they should be carefully cleaned in accordance with the 'Guide on infection control'.

OTHER FORMS OF TATTOO

Micro-pigmentation

This is sometimes described as cosmetic enhancement or semi-permanent make-up, and the process involves tattooing, but is used to produce natural pigmentation on body areas eg. replace eyebrows and eye lines, etc. All hygiene standards for basic tattooing are required.

Nail tattoos

This is an out-dated fashion, and involves using tattoo guns to put designs on fingernails. The same hygiene standards as tattooing are required which is perhaps why manicurists now place transfers under plastic lacquers with no risk of cross-contamination.

Temporary tattoos

The only genuinely temporary tattoos are transfer, airbrush and henna tattoos.

Transfer tattoos

Transfer tattoos are highly coloured and adhere to the skin. They can be washed off or will fall away after one or two days.

Airbrush tattoos

Airbrush tattoos do not involve any penetration of the skin. A stencil is applied to the area and pigments suspended in an alcohol product are sprayed onto the skin through the stencil using an airbrush (ie: liquid transfer to the skin by air pressure through a small aperture). The effect will be a coloured tattoo and the colouring dries as the alcohol evaporates. The 'tattoo' effect lasts for three to five days.

Henna tattoos

Henna tattooing is a process that involves staining the surface of the skin, an effect lasting approximately one to two weeks; it does not involve penetration of the skin using needles. The skin must be cleaned with an alcoholic wipe prior to carrying out the procedure in order to remove micro-organisms.

Operators performing henna tattooing must have hand-washing facilities at the point of operation. Henna stencils arc to be disposed of after use on one client. Enough henna must be dispensed for each client into a single-use container, and any excess should be disposed after each client. Only genuine natural henna should be used: henna substitutes must not be used, as they may contain para-phenylene diamine (PPD), a potent contact allergen. It should be noted that henna is a cosmetic, and is only cleared by the EU authorities for use as a hair-colouring agent (shampoo), but is nonetheless often used as a skin-contact cosmetic.

The EU Scientific Committee for Cosmetic Products, and Non-food Products intended for Consumers has reached the following conclusions on para-phenylene diamine (PPD). When PPD and similar chemicals are used for skin staining (temporary tattoos), active sensitisation may occur within a few weeks and the reactions can be very severe. Skin pigmentary variation may persist for a long period following such reactions. The sensitisation will be life long. Following active sensitisation there may be extensive cross reactivity to other commonly encountered chemical substances to which the consumer may be exposed. These include other hair colouring agents, textile dyes, drugs and rubber chemicals. The Committee is of the opinion that PPD and similar chemicals should not be used in skin stains (temporary tattoos).

INFECTION CONTROL

Effective infection control, including the establishment of safe working practices, cleaning, disinfection and sterilisation, is the key to assuring safe operations and satisfied customers. The aim is to reduce the risk of causing infection (as far as is reasonably practicable) among customers and those employed to provide skin piercing and other services.

The guidelines in this chapter apply to tattooists, body piercers, acupuncturists and other skin-piercing practitioners, such as electrolysists. They do not cover ear piercing by trained practitioners using piercing guns according to manufacturers' instructions.

In addition to the obvious health objectives of infection control, legislation contains specific requirements regarding cleaning, disinfection and sterilisation.

In most of England and Wales, the 'Local government (miscellaneous provisions) act 1982' grants local authorities the power to make by-laws regulating acupuncture, tattooing, ear-piercing and electrolysis. These by-laws make registration conditional on a number of issues, one of which is hygiene and control of cross-infection. Key phrases found in these by-laws include:

• cleanliness of premises and fittings

• cleanliness of persons

• cleansing and, so far as is appropriate, the sterilisation of instruments, materials and equipment used

In London, legislation covering a more comprehensive set of treatments makes similar requirements relating to 'cleanliness and hygiene of the premises and equipment'.

UK health-and-safety legislation requires those offering services to the public to take all reasonably practicable steps to safeguard the health and safety of their customers, their employees, and themselves. Failure to successfully take such steps can result in criminal proceedings, as well as civil proceedings for breach of duty of care.

In order to offer a healthy, safe and lawful service to the public, it is important to understand and observe the practices outlined below. If more detailed advice is required, contact the Community Infection Control Nurse via your local hospital, or the local authority Environmental Health Officer.

Appendix 2 contains a checklist covering the essentials of infection control and safe working practice. This can be used to assess the adequacy of control.

INFECTION HAZARDS

During any skin-piercing procedure there is a risk of infection to both the operator and the client, as well as anybody else who may be exposed to body fluids and contaminated materials.

Local infections

Infections may be localised in the area of the piercing, perhaps due to *Staphylococcus* or *Pseudomonas* bacteria. They may give rise to localised inflammation and pain, or can result in more chronic problems with pus, exudate, odours, and scar tissue.

Viruses are of more concern, however, especially those which cause hepatitis B and C, and HIV.

Hepatitis B

Hepatitis B occurs by contamination with infected blood, serum or tissue fluids. Poor practice in tattooing and acupuncture have been known to be the cause of outbreaks.

The virus is very robust and able to survive for a number of years on (for example) laboratory work surfaces. In addition, the virus is highly infective - Professor N Noah in his 'Guide to hygienic skin piercing' notes that one millilitre of infected blood may contain enough virus to infect up to 12,500 people.

For practical purposes, the most common source of the hepatitis B virus is the human being. A person in apparent good health can pass on the virus before becoming ill. Such people are known as 'carriers'.

Hepatitis B is a notifiable disease under both public-health and health-and-safety legislation. However, because of its long incubation period (generally three months, although it can vary between two and six months) it is not easy to track down the original cause of the infection. Body-piercers and acupuncturists should have a hepatitis B vaccination to protect themselves, their families and their clients.

The sterilisation of equipment at 134°C for three minutes destroys the hepatitis B virus.

Hepatitis C

Hepatitis C is acquired through intravenous drug use and the sharing of needles. It was also spread through blood transfusion prior to the introduction of screening in 1991, and via blood products before the viral inactivation programme in the mid 1980s. There is a small risk of infection associated with skin piercing, and infection through sexual intercourse can also occur.

After exposure to the virus, patients are often asymptomatic, however about 20% will develop acute hepatitis. Estimates of prevalence for hepatitis C in England and Wales vary considerably, from 200,000 to 400,000. There is also great variation in prevalence between certain subgroups of the population: 0.04% in blood donors, 0.4% in antenatal attenders (in London), 1% in genito-urinary clinic attenders and up to 50% of intravenous drug users.

No vaccination is available for hepatitis C, although a combination therapy is obtainable for the treatment of moderate to severe hepatitis C.

HIV and AIDS

The UK Government has allocated a great deal of resources to HIV, on schemes such as needle exchange for intravenous drug abusers. Such people may wish to indulge in skin piercing, such as spider web tattoos on arms to hide track marks.

AIDS and HIV are transmitted in the same way as Hepatitis B. Steps taken to eradicate the Hepatitis B virus by sterilisation will also eradicate the risk posed by HIV.

No vaccination is available for HIV, although in case of emergency (such as a needle-stick injury) medical advice should be sought as various specialist treatments are available to minimise risk of infection.

Table 1. Choice of decontamination procedures

Risk	Application	Recommendation
High	Items in close contact with a break in the skin or mucous membrane or skin piercing involved	Sterilisation
Intermediate	Items in contact with intact skin, or mucous membrane	Sterilisation or disinfection required. Cleaning may be acceptable in agreed situations
Low	Items in contact with healthy skin or mucous membranes or not in contact with patient	Cleaning

PREMISES

Essential requirements are as follows:

- sufficient space in which to conduct the business. This should facilitate easy movement, handling of equipment, and performance of procedures

- physical separation of clean operating areas from general circulation, storage and administration areas

- impervious, readily cleansable surfaces in the operating areas, including furniture, equipment, walls, floors and ceilings; this implies the absence of fabrics such as carpets, curtains, etc

- good lighting and ventilation

- sufficient work surfaces to accommodate essential equipment

- handwash basin with dispenser soap and disposable paper towels. This must be conveniently accessible to operating areas, and should be properly connected to a drainage system and kept clear at all times for immediate use

- hot and cold mixer taps to assure running water at the appropriate temperature

- sink with hot and cold running water in which equipment can be safely and effectively cleaned. This should not be immediately adjacent to the operating area.

PERSONAL HYGIENE

Good working practice

Hand washing is the single most important means of preventing spread of infection, and hands should be thoroughly washed using soap and hot water:

- immediately before and after tattooing or skin piercing procedures

- after removing gloves and after visiting the toilet.

- when the hands (or any unprotected part of the body) are accidentally contaminated by blood, bodily fluids or secretions (including your own)

- before handling food and drinks.

Also note that:

- hands should be thoroughly dried using a disposable paper towel

- finger nails should be kept short and clean

- cuts and abrasions to the hands and arms should be covered with a waterproof dressing at all times.

- there should be no smoking, eating or drinking facilities in the studio.

Protective clothing

Another important element of personal hygiene is protective clothing, for both operators and their clients.

Latex or synthetic rubber must be worn by everybody coming into contact with bodies and secretions or fluids of other persons, or objects and equipment which may be contaminated by them.

The aim is to protect customers from micro-organisms that may be present on the operator's hands and which could be transmitted via skin contact, and to shield the operator from the customer's blood or skin micro-organisms.

A new pair of disposable gloves should be worn for each client. These should be replaced if a puncture is seen or suspected. Hands should always be washed after removing gloves, as the process of removal will almost certainly result in them becoming contaminated. Domestic houseware gloves may be used for general cleaning around the studio.

Apart from gloves, the operator should wear clean, washable clothing. A disposable plastic apron is useful for keeping work clothes clean during procedures such as resting a part of the customer's body on the operator's knee. Please note, cotton towels are *not suitable* for this purpose.

BLEEDING

Should bleeding occur, the following procedures should be observed:

- put on latex disposable gloves

- stop the bleeding by applying pressure with a dry sterile dressing

- dispose of the used dressing in a clinical waste (yellow plastic) sack

- dispose of gloves in a clinical waste (yellow plastic) sack.

Deal with any spillage, be it blood or any other bodily fluid. Blood, vomit, and faecal matter, etc, pose a health risk and must be cleaned up immediately using the following procedure:

- put on disposable gloves

- cover spillage with paper towels

- pour bleach on the spillage

- wipe up with towels and dispose of in a clinical-waste (yellow plastic) sack

- discard gloves in a clinical-waste (yellow plastic) sack

- wash hands thoroughly.

Clothes that are visibly contaminated with blood should be handled as little as possible, and only then using household cleaning gloves. They should either be washed with detergent and hot water (70°C minimum for 25 minutes), or be discarded as clinical waste.

Table 2. Temperature, pressure and holding times for autoclave sterilisation (wet heat)

Minimum temperature (ºC)	Holding time (mins)	Pressure (Bar)	(lbf/in²)
121	15	1	15
126	10	1.5	20
134	3	2.25	30

CLEANING, DISINFECTION AND STERILISATION

Clean is defined as 'free from ... dirt or contaminating matter' (Concise Oxford English Dictionary).

Disinfection means the reduction in numbers of bacteria to levels where infection is unlikely to occur.

Sterilisation is the process of rendering objects free from all forms of life, including viruses, protozoa, fungi, and bacteria and their spores.

The Microbiology Advisory Committee to the Department of Health has provided guidance on the choice of decontamination procedure related to the infection risk. This is detailed in Table 1.

It can be seen that while not every piece of equipment needs to be sterilised, equipment in the low-risk group must be clean and capable of being cleaned.

EFFECTIVE INFECTION CONTROL

Equipment that comes into contact with intact skin must be cleaned before re-use, this includes chairs and workbenches. Equipment must be cleaned with detergent before it is sterilised. Equipment with complex shapes, such as forceps, tattooists' needle bars, etc, should be cleaned ultrasonically.

All floors, work surfaces and equipment (benches, sinks, basins, couches) must be cleaned at least once a day using detergent. Surfaces must be dried using natural ventilation. Wet or damp surfaces invite microbial survival.

Surfaces should be cleaned immediately soiling or spills occur, or when visibly soiled. Walls and ceilings need only be cleaned periodically.

Effective cleaning ensures that equipment is clean to the naked eye and free from any residues. Soiled equipment must never be stored or processed in clean areas.

During skin piercing, the skin, serum, blood and traces of tissue will contaminate the piercing equipment. It is therefore important that scrupulously sterile systems and equipment are maintained to prevent infection of piercing practitioners and their customers.

Sterilisation

All equipment used to penetrate the skin must be sterile. Where re-useable equipment has been in contact with broken skin, it should be considered contaminated and therefore should be cleaned and sterilised prior to re-use, in accordance with manufacturers' instructions. This means any equipment coming into contact with broken skin must be fit for sterilisation (ie, no wires, plastic, leather or other heat-sensitive material) or must be disposed of as clinical waste in a yellow plastic clinical-waste sack after single use.

Much of the equipment used in skin piercing is specially manufactured to have very smooth surfaces, thus ensuring poor adhesion of dirt and debris to those surfaces. Nonetheless, hollow needles and equipment with complex surfaces require special precautions.

In tattooing, the needles are soldered onto a needle bar, which allows debris to accumulate between the various metal parts. For this reason, ultrasonic cleaners are used to ensure the area is free of debris prior to sterilisation.

For most body piercing a hollow needle (generally a canula or hypodermic needle) is used and the hollow needle should preferably be disposed of as a contaminated single-use item.

Moist heat is more efficient than dry heat (see the Appendix 1 for practical details).

Sterilisation depends on the following factors:

Cleanliness

- equipment must be clean to enable effective sterilisation
- the correct temperature must be maintained for a specific time
- the time required is dependent upon the temperature (see Table 2).

Circulation

There must be sufficient air/steam circulation round all of the equipment, including the inside of hollow parts (such as the canulas of needles).

Moisture

Steam is very effective in ensuring heat transfer to micro-organisms and infective agents, ensuring their death or inactivation.

The recommended method of sterilisation is autoclaving. This employs heat, the most efficient and reliable form of sterilisation. For practical purposes, bench-top autoclaves ('steam sterilisers') are either of 'traditional' design, in which the steam passively displaces air from the autoclave chamber and load, or of 'vacuum' design, which actively removes air from the chamber and load before steam is introduced.

The very best sterilisation practice requires use of a vacuum steam steriliser, to ensure that all parts of the load (especially hollow needles, etc) are exposed to steam at the required temperature.

Traditional bench-top steam sterilisers are acceptable for solid or unwrapped instruments. They may also be used in circumstances where a vacuum steam steriliser is temporarily unavailable. In this case the instruments must be positioned within the chamber to enable drainage of all lumens or hollows. Pouches or other wrapping must *not* be used in a traditional bench-top autoclave.

For both types of equipment, it is essential that the instruments are scrupulously, ultrasonically cleaned to remove visible contamination by debris before they are sterilised.

The process of sterilisation involves exposing the equipment to heat for a specified period of time. This means that autoclaving at a higher temperature and pressure can be carried out for a shorter period of time. Table 2, shows the recommended temperature and time combinations using saturated steam under pressure. Most users opt for 134°C for three minutes, but any of these three combinations are acceptable.

Autoclaves and other sterilising equipment must be used and maintained strictly in accordance with manufacturers' instructions to ensure reliable operation.

Other techniques

Other 'sterilisation' methods include:

- dry heat
- boiling
- use of pressure cookers
- soaking in sterilant/detergent
- ultraviolet light exposure
- use of dishwashers
- use of microwave ovens.

These methods may produce temperatures high enough to sterilise but they cannot be relied on to satisfy all the requirements; *none* of these methods are recommended.

Skin disinfectants

Alcohol may also be used to disinfect skin. Ethyl or isopropyl alcohol (70%) impregnated wipes are a convenient way of using alcohol on the skin. It is unsuitable for use on the genitalia for reasons of discomfort.

Chlorhexidine is an effective disinfectant for skin and mucous membranes, such as the inside of the nose or mouth. Stored solutions of chlorhexidine in water easily become contaminated and should be freshly made up for each use. Alternatively, they should be maintained as sterile solutions and dispensed from a container via a plunger. Chlorhexidine has a limited shelf life and is neutralised by organic matter (eg, dirt), soap and anionic detergents.

Benzalkonium chloride is a quaternary ammonium salt with antiseptic properties. Usage concentrations range from 0.01% to 0.1% for cleansing of wounds and skin surfaces. It is incompatible with soaps and detergents, and with other substances, including aluminum, cotton, and hydrogen peroxide.

Iodine is now rarely used by nurses and physicians, but may found in use in piercing studios as 'povidone iodine' or 'betadine'. This is an iodophor used to prepare skin for a piercing procedure, but is irritant for some clients and should not be used where there is a history of allergy to (for instance) seafood or where questioning indicates the client has experienced a rash after iodine use. It is unsuitable for use on the genitalia owing to discomfort.

Proprietary disinfectants/antiseptics such as 'Hycolin', 'Dettol' and 'Savlon' can be used when diluted as per the manufacturers' instructions, but they are *not recommended* as skin disinfectants. They are neutralised by organic matter, soap and anionic detergents. These disinfectants may be used sparingly for such tasks as removing surplus tattoo ink, or applying tattoo stencils.

A further proprietary antiseptic is 'Techni-Care', which is an amphoteric-phenolic mixture with active ingredients chloroxylenol and cocamidopropyl PG-dimonium chloride phosphate.

It should be noted that many tattooists use petroleum jelly, such as 'Vaseline', on clients' skin. This has no cleaning or disinfecting properties, but does make the skin more supple, thus increasing client comfort. However, care must be taken in the manner in which it is dispensed, as it could be a source of cross-contamination. Single-use gauze or a disposable spatula should be used to apply the jelly, making sure the container does not become contaminated. Alternatively, it may be applied via a large diameter syringe, providing the end of the syringe does not come into contact with the skin.

Environmental cleaning and disinfection

Successful cleaning depends on the selection of a disinfectant capable of performing the required task, and its careful use under appropriate conditions of concentration, duration of exposure, temperature, pH and absence of neutralising substances.

The cleaning of equipment and the working environment is essential and must be carried out prior to sterilisation or disinfection to ensure removal of the majority of micro-organisms. Disinfectants are often inactivated by organic material, such as soiling and dirt. They may also be inactivated by other cleaning products, such as anionic detergents and soap.

Hypochlorite solutions (bleach) are recommended for disinfecting work surfaces and general equipment, and for cleaning up after a blood or other body-fluid spillage.

An effective working strength of a hypochlorite solution for general disinfection is 1,000 parts per million – in general this equates to a 1:100 dilution of fresh household bleach in water. Cleaning up after a spillage of body fluids requires a stronger bleach solution, and the World Health Organization recommends a dilution of 1:10 bleach in water.

It should be noted that proprietary brands of hypochlorite ('Domestos', 'Milton', etc) may vary in strength, and they deteriorate after lengthy storage. They can also be corrosive to metals, and discolour fabrics.

Soap or detergent (washing-up liquid) and water is sufficient for cleaning floors, walls and other general surfaces in the studio.

Alcohol (70% Isopropyl) is effective in disinfecting the motor parts of tattoo machines in particular.

Glutaraldehyde (eg, 'Cidex') has been suggested as an effective disinfectant in previous guidance. It is an irritant and an allergy sensitiser and is *not recommended* on health-and-safety grounds.

The effectiveness of chemical disinfectants is highly specific, for while some may be used on surfaces but not equipment, others are only effective on skin. Disinfectants are generally classified according to their principal active ingredients:

- halogens, mainly chlorine and iodine
- oxygen releasing compounds, such as hydrogen peroxide
- surface-active compounds, such as amphoteric disinfectants and quaternary ammonium compounds.

It is important to ensure that manufacturers' instructions are closely followed, and that care is taken to ensure that chemicals are not stored in direct sunlight or in hot environments. Such vigilance can dramatically alter the product's efficiency.

To maintain safe working methods it is advisable to restrict the number of chemical disinfectants as they may be hazardous if mixed together.

Bleach, 70% alcohol, and general household detergent used for their different and separate purposes should meet most cleaning and disinfecting requirements.

RECORD KEEPING

Record keeping is often viewed by operators as an onerous task, of little value to the business. But consider the position of the operator who is accused of malpractice against a customer, or of causing serious infection or scarring. Without records of who has been treated, and when, and of what type of procedure was carried out, there is little (if any) effective defence. Accurate customer records signify a professional approach, and show acceptance of responsibility for the work and its consequences.

Should there be an outbreak of communicable disease (eg, hepatitis), the public health authorities will certainly visit all implicated businesses to investigate the potential source of infection and follow up anyone at risk of infection. Customer records are invaluable to such investigators, as they can be used to eliminate those not at risk or at fault, as well as isolate the cause of the outbreak. It is no exaggeration to say that lives may be saved by accurate record keeping should things go wrong.

Furthermore, records help operators track the progress of their business, providing valuable data on who the frequent customers are, along with their needs, tastes and inclinations. Needless to say, such information can be put to good use for commercial development.

Operators should record the following information for each customer:

- date of procedure
- client's name, address and telephone number
- age given
- procedure carried out, including position on the body, type of jewellery used (if applicable)
- relevant medical history, including any documentation from a medical practitioner
- any previous tattoos or piercings noted
- additional comments.

It is helpful to obtain the client's signature on a release form confirming that the above information was obtained (or requested) and that it is accurate.

Note that the 'Data protection act 1998' applies to these records, meaning they must be kept confidential. Records should be stored for at least three years.

CROSS-CONTAMINATION

Infection can be spread from client-to-client, client-to-operator, operator-to-client and even operator-to-operator, by the transference of bacteria or viruses through cross-contamination.

Cross contamination often arises from unforeseen causes, such as handling telephones, verniers and rulers, etc during a procedure, or basic problems like infective cleaning, dirty door handles, or confusing sterile and used instruments.

Infection can occur where skin is pierced using the following faulty techniques:

- equipment used on more than one client without cleaning and sterilisation
- needles, jewellery or equipment dropped on the floor and used on a customer without further sterilisation
- used and clean instruments come into contact with each other
- unclean surfaces have clean instruments placed upon them
- used, disposable gloves are not taken off correctly, meaning hands can become contaminated
- using punctured gloves, leading to infection of the practitioner or the client
- contaminated materials (eg, stencils, swabs, spatulas, etc) not stored properly before being sent for disposal
- surfaces not adequately protected; eg, disposable paper sheets not changed after each client
- during tattooing, colours, petroleum jelly, etc, are not being changed between each client
- accidental needle penetration of operator's own skin ('needle-stick injury').

It should be noted that in most skin-piercing activities, little blood is in evidence. However, blood and body serum need not be visible on a needle or instrument to pose an infection hazard, with risk of transmission to others.

Unbroken human skin - skin without cuts or lesions - is the body's foremost natural defence against infection from the environment.

Needle-stick injuries: first aid

Where a needle-stick injury occurs take the following steps:

- encourage the puncture to bleed
- wash under cold running water, without soap
- cover with a dry dressing
- seek medical advice as soon as possible (preferably within one hour) at the accident and emergency department of the local hospital - a protective injection can be given against Hepatitis B (but not Hepatitis C). This must be done within 48 hours of the injury taking place. Treatment is also available to minimise risk of infection by HIV
- record any puncture wound or contamination of broken skin, mouth or eyes and report the incident to the employer (if applicable)
- the employer must record the details and investigate the incident to find out how it could have been prevented.

If an infection occurs as a result of the incident, it should be reported by telephone to the environmental health officer or local office of the Health and Safety Executive (see the 'Reporting of injuries, diseases and dangerous occurrences regulations 1995').

APPENDICES

APPENDIX 1: BENCH-TOP STEAM STERILISATION USING AN AUTOCLAVE

An autoclave is an instrument designed to reliably produce steam in a pressure vessel to enable accurate, moist heat temperatures of between 121°C and 134°C. The pressure build-up ensures steam temperatures of above 100°C.

To ensure the correct time/temperature range is achieved, the autoclave should have an automatic timer and temperature indicator. A pressure gauge offers reassurance that saturated steam is available in the autoclave, but for the practical purposes of this guidance only measurement of time and temperature is essential.

The easiest and safest type of autoclave is a fully-automatic version where the full sterilisation cycle is completed before the access door can be opened. Automatic recording of time and temperature at a specified point within the autoclave is also a good idea, although manual recording is acceptable but time-consuming (and liable to errors through shortcuts or distraction).

It should be noted that autoclaves are complicated pieces of equipment and, compared to the costs of other items needed for skin piercing, are relatively expensive. Their use is, however, the only reliable way of ensuring heat/steam sterilisation.

Vacuum autoclave systems are also available on the market. They work on the same principle of steam and elevated temperature, but additionally enable hollow instruments with very fine cavities ('lumens' or 'canulas') to be effectively sterilised by withdrawing the air from all parts of the autoclave and its contents. In addition, they work more effectively on porous loads, or those with hollows or complex shapes. Vacuum autoclaves are more expensive than regular autoclaves and involve greater commitment to ensuring they are used in accordance with manufacturers' instructions.

Autoclaves should be checked and serviced regularly. Local authority licensing officers will require evidence of written reports to verify effective performance.

Purchase of bench-top autoclaves

When purchasing autoclaves consideration should be given to its intended use, the range of sterilisers available, and installation and commissioning procedures.

Autoclaves should comply with BS 3970:Part 4:1990: 'Specification for transportable steam sterilisers for unwrapped instruments and utensils'.

Use of autoclaves

The general method of use is as follows:

- disassemble instruments and jewellery, so far as practicable
- thoroughly clean instruments - use an ultrasonic cleaner
- rinse all instruments in running water. If possible, dry them before putting them in the autoclave
- steam must be generated from fresh sterile irrigation water. Distilled water is not recommended, as it contains contaminants that may cause an allergic reaction if injected
- use the autoclave trays to hold equipment, not bowls or dishes
- allow space between equipment, instruments, etc
- open hinged instruments
- do not overload
- bowls, dishes and containers being sterilised should be placed on their sides to allow free flow of steam. Do not position them so that condensed steam (water) will become trapped
- all forms of instrument wrapping materials (including pouches) are inappropriate for use with traditional bench-top autoclaves
- discard any water remaining at the end of each working day.

Storage of instruments and utensils after sterilisation

Autoclaves are designed for processing of equipment for immediate use within a clean environment.

Place the sterile instruments on a sterile tray and cover them with a sterile piece of paper ('sterile field'). Re-sterilise the equipment if not used within two to three hours.

Unless the steriliser has a vacuum drying cycle, steam is condensed within the sterilising chamber, possibly resulting in a wet load. It is inappropriate to store wet equipment.

Testing effectiveness

Autoclaves require regular testing, as their effectiveness is critical to customers' safety. In addition, there are specific legal requirements dealing with their safety as pressure vessels.

Daily

Measurements of time and temperature are required at the start of each cycle, the end of the maximum holding time, and at the end of the cycle.

Check the 'cycle completed' indication, that the door cannot be opened immediately the start button has been pressed, and that there is no observable malfunction.

Weekly

In addition to the daily test, check the door seal for wear or distortion, the door safety devices, and the pressure devices.

Keep a complete checklist record. An example record sheet is shown at Appendix 3.

Autoclaves and safety

The 'Pressure systems safety regulations 2000' require owners of autoclaves to ensure they inspected periodically by a competent person. This can be arranged via the autoclave supplier or manufacturer.

APPENDIX 2: INFECTION CONTROL ASSESSMENT
Tattooist/body-piercing/electrolysis/acupuncture

Practice name:

Address:

Person interviewed:

Male/female

Date:

Treatment offered:
- Tattooing
- Body piercing
- Electrolysis
- Acupuncture

Please mark the box for all questions

General sanitation

		✓ ✗ or n/a
1	Soap is available at all wash hand basins in the practice areas	
2	Paper towels are available at all wash hand basins and sinks in practice areas	
3	Wash hand basins are free from reusable towels	
4	All wash hand basins are free from nail brushes	
5	Mixer taps or thermostatically controlled hot water is available at wash hand basins and sinks in practice areas	
6	Sinks and wash hand basins in practice areas are free from cups and drinking facilities	
7	Access to hand wash basin is clear eg: no equipment soaking in the wash hand basin	
8	An appropriate disinfectant (eg, 70% alcohol) is used to clean the clients' skin prior to the procedure	
9	Disposable Single-use razors are used to shave clients' skin prior to the procedure	
10	Local authority by-laws available on premises	
11	Safe working practices are available and known to operators	
12	Verbal and printed aftercare information for tattoo/piercing is available for clients to take away	
13	Creams/ointments are in single-use sachets, or are dispensed in a manner which will prevent contamination	
14	Single-use sterile dressings are applied following tattooing, branding or scarification	

Protective clothing

		✓ ✗ or n/a
15	Non sterile latex/vinyl gloves	
16	Disposable plastic aprons	
17	Goggles or face shields and/or masks available where risk assessment indicates their use	

Body-fluid spillage

		✓ ✗ or n/a
18	Paper towels and appropriate disinfectant (eg: bleach) is available for cleaning up body fluid spillage	
19	Operators are aware of the procedure for dealing with body fluid spillage	

The practice environment

		✓ ✗ or n/a
20	All general areas are visually clean	
21	Practice areas are clean and free from carpets and extraneous items	
22	All sterile products are stored appropriately above floor level	
23	Client couches/chairs in the practice areas have wipeable surfaces	
24	Client couches/chairs in the practice areas are in a good state of repair	
25	Disposable paper sheets are used to protect the couches/chairs in the practice area	
26	Modesty cover blankets are laundered and changed daily or when contaminated	

Use of detergents/disinfectants and antiseptics

		✓ ✗ or n/a
27	Disinfectants are used at the correct dilution and appropriately	
28	Chemical disinfectants are used for non-autoclavable equipment (eg, tattoo gun motors)	
29	Deep sink is available for washing items separate to hand-washing facilities	
30	Data sheets are available on hazardous products for risk assessment and safe working methods	
31	Environmental surfaces are cleaned appropriately between clients	
32	Environmental surfaces are protected with disposable paper sheets between clients	

Waste disposed of safely

		✓ x or n/a
33	Practitioners have written instructions on the safe disposal of waste	
34	Foot-operated waste bins are in working order in practice areas	
35	Appropriate yellow bags are used for storage of clinical waste before disposal	
36	Clinical waste and domestic waste is correctly segregated	
37	Waste bags are less than ¾ full, and securely tied while awaiting collection	
38	Clinical waste is stored in yellow bags, in designated area prior to collection	
39	Storage area is locked and inaccessible to unauthorised persons and pests	
40	Storage area is cleaned at least weekly and immediately following a spill	
41	Yellow bags are labelled with business name and address - in accordance with the Duty of Care	
42	Protective clothing (eg, gloves and aprons) are available to staff handling clinical waste	
43	Check documentation: Clinical waste is collected by a registered waste carrier and disposed of by incineration	

Sharps and needle-stick injury

		✓ x or n/a
44	'Sharps' boxes are available for use	
45	'Sharps' boxes conform with BS 7320 and UN 3291	
46	'Sharps' box is less than ¾ full, with no protruding sharps	
47	'Sharps box' is assembled correctly - check lid is secure	
48	'Sharps box' is labelled with source business name and address	
49	Staff are aware of hepatitis vaccination policy	
50	Staff are aware of procedure in case of needle-stick injury	
51	'Sharps' boxes are stored above floor level and safely out of reach of children and visitors	
52	'Sharps' boxes are disposed of via a registered waste carrier	

Equipment decontaminated and stored appropriately

		✓ ✗ or n/a
53	No evidence of single-use equipment being re-used	
54	Sterilising equipment is maintained on an effective maintenance programme (see HTM 2010, the 'Pressure systems regulations 2000' and/or the 'Guide to infection control')	
55	Steam sterilising equipment cycle checked and recorded daily	
56	Steam sterilising equipment is checked weekly in accordance with HTM 2010 and/or the 'Guide to infection control'	
57	Sterilising equipment is clean and in a good state of repair	
58	Instruments are autoclaved unwrapped (or in pouches where the autoclave incorporates a pre-sterilising vacuum cycle)	
59	Water boilers and glass bead equipment are not used for instruments requiring sterilization	
60	Used, contaminated equipment is stored out of client areas immediately after use	
61	Procedure is in place to accommodate breakdown and repair of sterilising etc equipment (autoclaves, ultrasonic cleaning machines, etc)	
62	Ultrasonic cleaners are equipped with a lid, emptied daily and kept dry overnight	
63	Dye/pigment/ink containers are single-use only and are appropriately disposed of following use	
64	Sterile disposable needles are single-use only	
65	If needles are re-used they are appropriately decontaminated and then sterilised before subsequent use	

Indicate method used:

• Front-loading bench-top autoclave, eg Little Sister

• Top-loading bench-top autoclave, eg Prestige

• Water boiler

• Hot-air oven

• Other

		✓ ✗ or n/a
66	Have you ever had clients return to inform you of infection as a result of piercing or tattooing by you?	
67	Have you ever had clients return to inform you of infection as a result of piercing or tattooing at another studio?	
68	Are you immunised against Hepatitis B?	
69	Do you require clients to sign a consent form?	
70	Do you ask clients health-related questions prior to undertaking the procedures	
71	Do you keep records of client information?	
72	Do you belong to any professional organisations? Say which:	
73	Where do you purchase products from?	
74	How long have you been in practice?	0-4 years 5-9 years 10-15 years >15 years

APPENDIX 3: AUTOCLAVE DAILY RECORD SHEET

Copy form for use
Please keep these records in date order for inspection

Autoclave reference number:
Week commencing:

Daily test:	Monday	Tuesday	Wednesday	Thursday	Friday	Saturday
Cycle counter number (if available)	.					
Time to reach holding temperature						
Temperature during holding period						
Pressure during holding period						
Total time at holding temperature/pressure						
Initials of authorised user						

Weekly test:	Yes/No	Comments
Door seals secure		
Door safety devices functioning correctly		
Safety valves operating correctly		

Comments

Name	Date	Signature

THE LAW ON SKIN PIERCING AND SPECIAL TREATMENTS

Businesses offering skin-piercing and special treatments are affected by a wide range of laws and duties relating to public health, occupational health and safety, environmental protection, and in some parts of the UK, to public control licensing. Most of this law is administered by local authorities, often through their environmental health department, and there are currently 320 English, 33 London, 32 Scottish and 22 Welsh local authorities responsible for enforcing health and safety in skin piercing and special treatment premises. In other cases, the police force is the enforcement agency.

This complexity and uneven regional coverage leads to confusion among regulated and regulators alike. The aim of this chapter is (at least) to describe this range of law, and perhaps give insight into the purpose of regulation affecting businesses.

Specific regulatory powers to control skin piercing and other special treatments vary throughout the UK. At the time of writing, there are two areas of legislation available to local authorities. These are the general provisions of the 'Health and safety at work etc act 1974' and adoptive licensing/registration powers in the 'Local government (miscellaneous provisions) act 1982' and the 'London local authorities act 1991' which only applies in the London boroughs. In addition, many local authorities have local licensing legislation applying to their particular area.

Health and safety at work etc act 1974

The 'Health and safety at work etc act 1974' is the enforcement tool used by local-authority officers to ensure health-and-safety standards are maintained, so far as reasonably practicable, in commercial premises such as body-piercing studios and special-treatment businesses.

Section 3 of the Act states that 'it shall be the duty of every (employer or) self-employed person to conduct his undertaking in such a way as to ensure, so far as is reasonably practicable, that he and other persons who may be affected thereby are not thereby exposed to risks to their health or safety'.

The 'Health and safety (enforcing authority) regulations 1998' allocate the enforcement of health and safety in skin piercing and special-treatment businesses to local authorities. If the activity is carried out within domestic premises then enforcement falls to the Health and Safety Executive.

Enforcement officers may prosecute offences, or issue improvement or prohibition notices under Sections 21 and 22, respectively, for breaches of the Act.

Under Section 21 of the Act, if an inspector is of the opinion that a person 'is contravening one or more of the relevant statutory provisions; or has contravened one or more of the provisions in circumstances that make it likely that the contravention will continue or be repeated', he may serve an enforcement notice. For example, improvement notices can be served for structural issues and improving working practices.

Under Section 22 of the Act, if as regards any activities to which the section applies an inspector is of the opinion that 'as carried on or about to be carried on by or under the control of the person in question, the activities involve or, as the case may be, will involve a risk of serious personal injury', the inspector may serve a prohibition notice. Prohibition notices, for example, can be served if unsafe practices are identified.

For example, an environmental health officer employed by Hinkley and Bosworth Borough Council issued a prohibition notice on a body piercer. The notice prohibited the use of xylocaine spray on clients receiving body piercing. The body piercer appealed against the notice and the employment tribunal modified the notice to require clients to be questioned regarding contra-indications for use of the anaesthetic and other health issues, and the replies to be recorded. A further amendment required that xylocaine should not be used on the tongue as there is a danger that it could relax and may cause aspiration.

Local government (miscellaneous provisions) act 1982

If the local authority formally resolves that the provisions of the Act apply within its district, then the authority can register acupuncture, tattooing, ear-piercing, and electrolysis procedures - all of which involve actual, or risk of, skin piercing. Bye-laws are made by the council to bring the Act into effect locally.

Both the person undertaking the activity, as well as the premises, must be registered with the local authority. The Act provides for a reasonable fee to be charged for registration and for local authorities to make bye-laws and set standards in relation to the activities.

For ear piercing, the 'Local government (miscellaneous provisions) act 1982' states that the bye-laws can set standards for cleanliness of premises and fittings, cleanliness of registered persons and their assistants, and for cleansing and, where appropriate, sterilisation of instruments, materials and equipment used in connection with ear piercing.

There is no power for local authorities to refuse registration, and the registration remains in force until the operator withdraws or a Magistrates court cancels it. Magistrates can only cancel the registration if the local authority prosecutes the proprietor of the registered premises for offences under the legislation or bye-laws, *and* requests a revocation of the registration.

The Act does not apply to other forms of skin piercing, such as cosmetic piercing of parts of the body other than the ear. However, the majority of legitimate skin-piercing businesses offer ear piercing and this means that during the initial registration inspection, local-authority officers have an opportunity to offer advice on good practice for safe body piercing.

London local authorities act 1991

This Act enables the London borough councils (including the City of London) to licence premises intended to be used for special treatment, provided they adopt the provisions. It has been amended by the 'London local authorities act 2000'.

'Special treatment' includes body piercing (termed 'cosmetic piercing' in the Act), as well as a miscellany of other therapies and treatments These treatments include massage, manicure, acupuncture tattooing, and chiropody, as well as light, electric or other special treatment 'of a like kind', and vapour, sauna or other baths.

The powers cover any premises used, intended to be used, or represented as being used, for the reception or treatment of persons.

Exclusions

There are many exclusions; for example, dentists offering acupuncture, hospitals, nursing homes, and premises which are not used for gain or reward, or premises where the special treatment is carried out by, or under the supervision of a medical practitioner registered by the General Medical Council. Any bona fide member of a body of health practitioners is also excluded providing it has given notice in writing to the borough council that it:

• has a register of members

• requires qualifications by way of training for, and experience of, the therapy concerned as a qualification for membership

• requires its members to hold professional indemnity insurance

• subjects its members to a code of conduct and ethics, including a prohibition of immoral conduct in the course of their practice

• provides procedures for disciplinary proceedings in respect of its members, and has supported that notice with satisfactory documentary evidence, if required by the council.

A 'health practitioner' is defined in the 'London local authorities act 2000' as 'a person who uses his skills with a view to curing or alleviating of bodily diseases or ailments, but does not include a person whose skills are employed mainly for cosmetic alteration or decorative purposes'.

Other exclusions include premises which are used by a person who is registered by a board under the 'Professions supplementary to medicine act 1960' *solely* for the practice of the profession in respect of which he is registered, and for the practice of the profession in respect of which he is so registered, and for the conduct by him of any business ancillary to such practice and no other purpose. This covers practitioners such as state-registered physiotherapists, chiropodists, osteopaths and chiropractors.

The amending Act enables London borough councils who have adopted the Act to resolve to exclude such special treatments as they choose (Section 27(2)(c)).

Administration of the act

The Act is adoptive, meaning that the London borough council must resolve to adopt its powers before it can come into effect in that London borough. To date, 27 of the 32 boroughs have adopted the special treatment powers.

A London borough may grant or renew a licence on any such terms and conditions as it specifies. The conditions for the granting of a licence may relate to the:

• maintenance of public order and safety

• number of persons who may be allowed to be on the premises at any time

• qualifications of the person giving the special treatment

• taking of proper precautions against fire, and the maintenance and proper order of means of escape in case of fire

• means for fighting fire and means of lighting, sanitation and ventilation of the premises

• maintenance of safe conditions and means of heating the premises

• hours of opening and closing the establishments for special treatment

• safety of any equipment used in connection with the special treatment and the way in which the treatment is given

• cleanliness and hygiene of the premises and equipment

• manner in which the establishment is operated and way it is advertised

The licence period is for a maximum of 18 months and a reasonable fee for a licence and renewal may be charged. The authority may refuse or cancel a licence on a number of statutory grounds including the condition and conduct of the premises, the fitness and qualifications of the staff, and the safety of the equipment.

There are various grounds for refusing a license:

• premises not structurally suitable

• likelihood of nuisance

• unsuitable means of lighting, heating and ventilation

• unsafe equipment or method of treatment

• unsuitable means of escape in case of fire or 'first aid' fire fighting

• applicant not a 'fit and proper person'

• practitioner not suitably qualified

• practitioner has been convicted under the Act

• premises have been, or are improperly conducted

Birmingham City Council has similar powers under the 'Birmingham City Council act 1990', as does Nottingham City Council under a local Act.

Greater London (general powers) act 1981

To further confuse this issue, a different Act applies in the five London boroughs who have not adopted the provisions of the 'London local authorities act 1991'.

The 'Greater London (general powers) act 1981' allows the local authority to register the person and the premises from which the activities of acupuncture, tattooing or cosmetic piercing are carried out. The authority is able to make bye-laws to secure the:

• cleanliness of premises required to be registered under this section and the sterilising, so far as is appropriate, of the instruments, towels, materials and equipment used in connection with the practice or business

• cleanliness of persons engaged in such practice or business in regard to both themselves and their clothing

• keeping of records of activities in connection with the practice or business

The local authority is also able to charge an appropriate fee to cover all or part of the inspection and administrative costs.

Local authorities act 1972

As well as the specific legislation outlined above, local authorities also have general powers to make bye-laws under the 'Local authorities act 1972'. Section 235 of this Act allows for bye-laws to be made for the good rule and government of the local authority and for the prevention and suppression of nuisance.

However, the potential of this Act is limited in that it impedes local authorities making bye-laws where there is provision to do so under other Acts. Consequently, the general powers provided by this Act have been superseded by the other statutory provisions discussed above.

Nursing homes and mental nursing homes regulations 1984

The ' Nursing homes and mental nursing homes regulations 1984' have a number of objectives, among them to ensure that Class 3b and Class 4 lasers intended for medical and cosmetic treatments are used only by 'properly qualified staff'. This is usually interpreted as meaning specifically-trained people acting under medical or dental supervision - a circumstance that may not be found in beauty salons offering epilation using a variety of laser equipment.

Local health authorities are charged with registering premises where such laser treatments are offered. DHSS Circular (84)15 offers a degree of practical guidance, but plainly with NHS standards of operation in mind.

Prohibition of female circumcision act 1985

Female circumcision is the partial or total excision of the labia or clitoris for non-therapeutic reasons. Most of these procedures are irreversible and have lifelong adverse effects for the woman concerned.

Section 1 of the 'Prohibition of female circumcision act 1985' states that it is an offence for any person to 'excise, infibulate or otherwise mutilate, the whole or any part of the labia majora or labia minora or clitoris of another person, or to aid, abet, counsel or procure the performance by another person of any of these acts on that person's own body'.

The definition of 'otherwise mutilate' has not been tested in UK courts. This Act raises the question of whether it is an offence for piercers to pierce the genitalia of women in any way at all.

OTHER LEGAL ISSUES

A number of other points should be considered, again, all of them tending to confuse the legal position of someone offering body piercing.

Civil law

Civil law imposes duties of care on business operators to safeguard the health, safety and well-being of their clients and employees. An important point to note is that the term 'so far as reasonably practicable' does not apply where civil claims are concerned - employers have an absolute duty of care to their employees and customers.

The penalties for breach of civil law are financial - with no risk of imprisonment - but there is no limit to the level of damages that can be imposed. There is a statutory duty to insure against claims by employees under the 'Employers' liability (compulsory insurance) act 1969', and to display the certificate of insurance in a prominent place. Professional indemnity insurance, while not compulsory, provides financial security in the event of a claim.

It should be noted that damages due to death resulting from a negligent act are generally not insurable, emphasising the need for effective management controls.

Age of consent and maturity

Owing to the permanence of a tattoo, the 'Tattooing of minors act 1969' imposes an age limit of 18 years on persons to be tattooed. However, throughout the UK there is no general statutory limit on the age of persons to be body pierced, and there have been several reports of children aged less than 16 being pierced, much to the annoyance of their parents. Stokes (1996) reported such a case where a 12-year-old girl had her navel pierced. In the report, the chairman of Rochdale Primary Care Group, Dr Nick Dawes, stated 'we see these problems regularly... there should be parental consent for under-sixteens and proof of age and identity for those over'.

A High Court case involving giving of contraceptive advice to minors (Gillick) set out broad age-related rules that can be applied to minors seeking body piercing (including ear-piercing). Under-sixteens can probably give consent if the practitioner judges them to have reached sufficient maturity to fully understand the implications of their request, and if they are given sufficient information for them to make a sound decision. Note that *both* of these criteria must apply.

Advice on the 'Family law reform act 1969' indicates that those aged 16 and above *can* give consent to any surgical, medical or dental treatment, showing a degree of consistency between statute law and the common law.

Many of the councils have introduced age limits for body piercing, but these vary from authority to authority. For example, Bexley LBC has no age restriction and both Brent LBC and Edinburgh City Council have a lower age limit of 16 for body piercing. In Croydon, more complex criteria apply, and piercing may be carried out on under-sixteens if the parent is present and gives consent, and on 16-18 year olds if personal identification (including a photo) is tendered; for clients aged 18 or older, there are no restrictions on age grounds.

Suitable forms of identification include:

* passport
* other 'proof of age' schemes, for example, that run by London Underground
* consent forms with declaration of age
* parent or guardian present as witnesses.

The Law Commission is working on proposals to make it lawful to cause intentional consensual injury to another - up to a level described as 'seriously disabling injury'. The consent should be codified (ie, rules or procedures collected together in law or official guidance), and effective statutory controls should be put in place to ensure the practices are properly and hygienically carried out in licensed premises by fully-licensed practitioners.

The Law Commission report also recommends the 18-year age limit for tattooing be introduced for any body piercing below the neck. It is presumed this is made to allow ear and nasal piercing of minors.

Offences against the person

Body piercers are vulnerable to accusations of assault, including:

* common assault: this is unlikely as legally it is possible to give consent
* actual bodily harm: if physical evidence is available, for example, a bruise or graze
* grievous bodily harm (gbh): this must involve a break in the 'whole continuity of the skin', such as a cut. It is not possible to give consent to grievous bodily harm. In 1994, a group of sado-masochists were convicted under this heading for carrying out procedures akin to body piercing (Regina v Brown and others). The judge excluded surgery, tattooing and ear-piercing from the scope of his judgement, stating 'piercing parts of the anatomy other than the ears is lawful, provided that the piercing is carried out for decorative or cosmetic purposes and not for sexual gratification'
* indecent assault: touching female breasts, or male/female genitals without consent. In the UK, a female younger than 16 years cannot give consent to nipple or genital piercing.

Level of competence

In a case involving the death of a client (Shakoor) after administration of a herbal remedy, the defendant (a practitioner of traditional Chinese medicine) was discharged after the court determined he met these three criteria of proficiency:

* competent to practise according to the system of law and practice under which would be judged
* knowing, rather than believing, that a remedy is not harmful
* taking steps to maintain awareness of remedies which have been reported adversely, for example, by subscribing to relevant professional journals.

GOVERNMENT POLICY

England

A survey of local authorities was carried out by the Department of Health in 1994 as part of a review on skin piercing enforcement. The review arose out of a lack of information about the effectiveness and enforcement of the legislation, the costs to businesses and local authorities, and technological advances in some types of skin-piercing equipment.

A total of 33 questionnaires were sent to local authorities in London and 306 to local authorities in the rest of England.

The survey revealed a number of inconsistencies in the legislation, particularly in relation to fees charged for registration/licensing, and a number of enforcement issues. It was agreed that there was scope for rationalisation and partial deregulation.

England and Wales

On the 3 October 1996, the Department of Health (DoH) and Welsh Office issued a joint consultation document concerning the regulation of skin piercing as part of the government's deregulation initiative.

The consultation was open to local authorities, local-authority associations, NHS, public health and environmental health interests, advisory committees, trade associations, acupuncture organisations, skin-piercing businesses, manufacturers of skin-piercing equipment, consumer groups, HSE and the Law Commission.

It proposed changes in legislation designed to reduce the burden to business without increasing the risk of blood borne virus transmission, and to offer necessary public health protection for certain types of skin piercing outside London.

The Department of Health concluded from this research that 'on public health grounds there is a continuing need for regulation because of the risk of blood-borne virus transmission through skin piercing'. Following this consultation there was support from enforcement authorities and business for primary legislation to give all local authorities the power to regulate businesses offering cosmetic body piercing. The following activities would be exempt:

• businesses that undertake hair electrolysis using sterile disposable probes for each customer, or ear piercing with ear-piercing guns using pre-sterilised single-use studs and clasps in an intact package

• skin-piercing practitioners who belong to bodies of health practitioners recognised by the local authority or registered by a board under the 'Professions supplementary to medicine act 1960'. This exemption currently operates in London.

In a letter to local authorities (DoH, 30 June 1998) it was stated that 'Ministers have concluded that primary legislation should be introduced, if parliamentary time allows, to give local authorities outside London powers to regulate businesses providing cosmetic body piercing.' To date, this legislation has not been introduced.

During 1999 a question addressed to the Secretary of State for Health was asked in the House of Commons, as to what plans there were to empower local authorities to licence and regulate body-piercing activities (Burden 1999). Once again, the response received was that there was support from enforcement authorities and business for primary legislation to give local authorities outside London powers to regulate businesses providing cosmetic body piercing (Jowell 1999).

Further Parliamentary questions on skin piercing have been asked by Dr David Clark (20 April and 12 May 1999) and Mr Bob Russell (27 April 1999). In particular, Ms Jowell was informed that Bury and Rochdale Environmental Health Departments had surveyed 209 GPs of whom 113 replied. The GPs reported 191 cases involving infection of the navel, 167 cases involving ear piercing, 57 cases involving nose piercing, 23 involving nipple piercing and 17 involving tongue piercing. The figures for the two authorities were almost identical (Clark 1999).

Tessa Jowell MP, then Minister for Public Health, stated the government's primary concern was for cosmetic body piercing to be done in a safe and hygienic manner, so that the public are protected from possible risks to health. The government's strong preference is for good practice to be spread by means of self-regulation, and it intends to work with the industry to secure that objective.

The Bury and Rochdale body piercing study appears to indicate that self-regulation may not effectively control the public health risks. This view is supported by Professor Norman Noah, consultant epidemiologist at the Public Health Laboratories' Communicable Disease Surveillance Centre who in response to the survey stated, 'I was surprised that the results were that high. It suggests there could well be a problem out there that needs to be investigated' (Noah, 1999).

Scotland

Calls for tighter controls on skin-piercing businesses in Scotland have grown in recent years as the popularity of piercing has risen greatly. The Scottish Executive issued a consultation paper in February 2001 with the objective of devising tighter controls to reduce the risk of transmitting blood-borne viruses and other minor infection from dirty equipment or contaminated tattoo colours.

For the purposes of the consultation paper, the term 'skin piercing' includes:

• cosmetic body piercing

• tattooing (both permanent and semi-permanent)

• semi-permanent make-up (micropigmentation)

• ear piercing

• acupuncture

• electrolysis.

The consultation period was not complete at the time of writing.

Other developments

In August 2000, the NHS Executive issued a consultation document 'Modernising regulation: the new health professions council'. While aimed principally at the mainstream health professionals with the objective of updating self-regulation to improve protection of patients and the general public, the proposals will have implications for practitioners offering some of the special treatments covered in this publication.

Specifically, the scope of the regulatory framework - now administered (*inter alia*) by the Council for Professions Supplementary to Medicine, under the 'Professions supplementary to medicine act 1960' - will be extended to include professions and occupations which may give rise to harm to client health or welfare through invasive procedures or application of unsupervised judgement.

An umbrella body is proposed (provisionally, the 'Health Professions Council'), whose objective will be protection of the public (rather than the professionals) through agreed and enforceable standards of education, training and conduct. It will have sufficiently-flexible procedures to admit a wider range of occupations than is currently recognised by the NHS. The body will be established by Order made under the 'Health act 1999'.

WASTE DISPOSAL

It is important to ensure that waste produced by any business is handled properly to guarantee safe and lawful operations. For the type of special-treatments businesses covered by this book, an effective waste system comprises two key elements: the segregation of hazardous and non-hazardous waste storage prior to collection; and the employment of a registered waste carrier to remove and dispose of the wastes appropriately.

Some wastes, having been in contact with skin, blood or serum, are contaminated by hazardous materials, and their safe disposal is important to prevent the risk of infecting employees, the public, waste-disposal contractors, and the environment generally. The employment of single-use disposable equipment, which is, by definition, discarded after each client, is good practice for preventing cross-contamination. However, it may create a waste-storage and disposal problem.

The 'Environmental protection act 1990' introduced a legal framework to protect the environment, by (among many other things) placing duties on those who create or collect waste, and those who receive waste for ultimate disposal.

Section 34 introduced a statutory duty of care for the entire chain, from the actual waste producer, to those responsible for the ultimate disposal of the waste at landfill sites and incinerators. The duty of care applies to anyone who produces, imports, carries, keeps, treats, or disposes of waste. Naturally, businesses which offer special treatments must observe the duty of care. For practical reasons, the duty does not apply to householders with regard to their own domestic waste.

DUTIES OF THE WASTE PRODUCER

The waste producer or holder, which means the business creating the waste material, has a legal duty to ensure that waste is handed over to an 'authorised person'.

For practical purposes this includes:

• a waste collection authority; for example, the local council

• a registered carrier of controlled waste, or someone who is exempt from registration; for example, a specialist contractor.

Registration of waste carriers is covered by the 'Controlled waste (registration of carriers and seizure of vehicles) regulations 1991', and is regulated by the Environment Agency (or in Scotland, the SEPA).

Before employing a waste carrier, the waste producer should check the carrier's registration by asking to see the certificate of registration or an official copy of the certificate provided by the Environment Agency. Photocopies should *not* be accepted as proof of registration.

HOW WASTE IS CLASSIFIED
Definition of waste

Waste includes any substance which constitutes a scrap material or effluent, or any other unwanted surplus substance arising from the application of any process; or any article to be disposed of which is broken, worn out, contaminated or otherwise spoiled.

The law goes on to identify different classes of waste, all of which fall under the heading of 'controlled waste'. These classes are known as:

• household waste. This means waste from a domestic property, for example, a building or self-contained part of a building which is used wholly for the purposes of living accommodation. This includes caravans, residential homes for the elderly, educational establishments, and premises forming part of a hospital or nursing home.

• commercial waste. This means waste from premises used wholly, or mainly, for the purposes of a trade, or a business or for the purposes of sport, recreation or entertainment. It excludes household waste and industrial waste.

• industrial waste includes clinical waste, special waste, and waste from ships, laboratories, workshops, vehicle-maintenance premises (including for aircraft and boats/ships), and animal premises. It also includes specific materials such as scrap metal (except from dwellings), oils, solvents and imported waste.

For the purposes of the special-treatments businesses, we need only further consider commercial waste and, specifically, clinical waste.

COMMERCIAL WASTE

This includes non-hazardous materials such as waste paper, litter, waste food, etc. Local authorities have a duty to collect commercial waste if requested, but are entitled to charge for the service.

Shop premises, including special-treatments studios, will only receive a commercial waste collection, not domestic waste collection. The service may be provided by the local authority, or a specialist waste contractor.

Special treatments will give rise to some innocuous waste products but will also create more hazardous clinical waste (see below).

CLINICAL WASTE

Clinical waste is defined in the 'Controlled waste regulations 1992' as any waste:

• 'which consists wholly or partly of human or animal tissue, blood or other body fluids, excretions, drugs or other pharmaceutical products, swabs or dressings, or syringes, needles or other sharp instruments, being waste which unless rendered safe may prove hazardous to any other person coming into contact with it'

• 'arising from medical, nursing, dental, veterinary, pharmaceutical or similar practice, investigation, treatment, care teaching or research, or the collection of blood for transfusion, being waste which may cause infection to any person coming into contact with it'.

Waste likely to be produced in by a special-treatments business may include syringes, tattoo needles, soiled tissues and swabs, and other similar materials.

Guidance has been prepared jointly by the Health and Safety Executive (HSE) and the Environment Agency categorising clinical waste into risk-group categories A to E. While these categories are related to the risk presented, other factors are relevant, such as the method of storage.

In this guidance, human tissues and soiled swabs fall into 'Category A', and syringes and needles into 'Category B'. The HSE's guidance goes on to state that details of precautionary measures to be considered for clinical waste include:

- accidents, incidents and spillages
- handling
- immunisation
- labelling
- packaging
- personal hygiene
- personal protective equipment
- segregation
- storage
- training and information
- transport, on-site and off-site
- treatment and disposal

Risk assessment is likely to determine a number of issues surrounding the handling and control of clinical waste. For the type of waste produced by special-treatments businesses not all aspects of the list will apply.

In order to remove clinical waste, special-treatments businesses will generally have a waste-collection contract with either the local authority or a specialist contractor. The council and contractors are likely to refer to clinical waste as 'special waste' to distinguish it from the non-hazardous commercial or domestic waste they normally deal with.

For the special-treatments waste producer, the choice of a competent disposal contractor is an essential element of compliance with the duty of care. The waste producer must be satisfied that whoever has possession or control of his waste will handle, and eventually dispose of it, legally. Because transport of clinical waste is covered by the 'Carriage of dangerous goods by road regulations', the contractor is also responsible for complying with the requirements of these Regulations to ensure safe transit to the final disposal point.

The discovery of fly-tipped clinical waste will almost certainly result in the prosecution of the waste producer, even if the waste was handed over to a contractor in good faith. Given the nature of the waste, it is therefore vital for waste producers to prove that they took all reasonable steps to verify the credentials of the waste-collection contractor.

REASONABLE STEPS

The 'reasonable steps' to be taken by waste producers to comply with the duty of care will depend on the nature of the individual company or business and the types of waste produced.

Smaller companies

For a small company producing minimal quantities of clinical waste, the steps are likely to be fairly simple. The company must ensure that the carrier is registered, that he delivers the waste to a licensed waste management site, and that the statutory documentation requirements are fulfilled. The specialist contractor will be able to advise on this last point in detail.

Larger companies

Larger companies, or organisations producing substantial quantities of clinical waste, may need to go to greater lengths to assess and employ a suitable contractor, not least because it is an expensive process.

A policy for the overall management of clinical waste should be developed and implemented. When developing the policy, relevant persons should be consulted, including employee representatives, local EHOs or infection-control nurses, health-and-safety officers, etc.

It is essential that the policy should be:

- written in a clearly understandable manner
- available to all staff
- kept up-to-date
- available in all areas
- relevant for different levels of training, knowledge and experience.

HANDLING CLINICAL WASTE BEFORE DISPOSAL
Waste storage

The waste producer must store waste in such a way as to prevent its escape or leakage while on site, in transit, or in storage.

Containers should always be used and these should be adequate to protect the waste, and to prevent leakage and spillage. The container should preferably be labelled with a description of the waste.

Risk assessments will indicate the procedure for 'Category A' waste (eg, contaminated swabs and tissues), and should include the following measures:

- placing waste in yellow waste sacks, in sack holders, or other appropriate enclosed containers at the point of generation
- replacing sacks daily or when three-quarters full
- not transferring loose contents from container to container
- sealing sacks with a plastic tie, or heat sealers, purpose-made for clinical-waste sacks
- prohibiting the use of staples or string to close the sack, as these do not provide secure closure and may puncture the sack or foil thereby exposing the contents
- providing lids for bins, which can be sealed for collection
- collecting with appropriate frequency.

'Category B' waste, which will include skin-piercing needles ('sharps') must never be placed in containers used for the storage of other waste, and particularly not in plastic sacks, but should be put into properly-constructed 'sharps' containers. The containers, which are usually yellow in colour and made of a hard material such as plastic, should meet the requirements of BS 7320:1990 and/or be UN type-approved.

While in use, 'sharps' containers should be kept out of the reach of members the public, in particular small children and people who may not appreciate the risks associated with this type of waste.

To avoid the risk associated with over-filling, 'sharps' containers should be removed when three-quarters full, sealed and labelled. They should not be placed in regular waste sacks.

Keeping them separate during storage and transport ensures compliance with the duty of care, and ensures that any faulty or broken containers which may leak fluid or allow penetration of sharps, are more obvious.

Care must be taken when placing blades or needles in the 'sharps' container to prevent personal needle-stick injuries.

Storage of waste from special treatments, especially tattooing and body piercing, is minimal, as only a small amount of waste will be generated. Waste should be emptied regularly and should not pose a health risk to anyone likely to come into contact with it.

Once the collection contractor has been selected it is important to ensure that the waste is presented for collection safely.

TRAINING AND INFORMATION

Many special-treatments businesses are effectively one-man operations, but where others are employed, all staff involved in handling clinical waste need training information and instruction in:

• risks associated with clinical waste, its segregation, handling, storage and collection

• personal hygiene

• any procedures which apply to their particular type of work

• procedures for dealing with spillages and accidents

• emergency procedures

• appropriate use of protective clothing.

Personal hygiene is very important in reducing the risk of infection.

The Regulations require that the self-employed are similarly aware of the hazards they face and how to deal with them.

WASTE SEGREGATION

Waste segregation is important. Colour coding is widely used for waste containers, with yellow reserved for clinical waste (eg, 'sharps' containers), which will be sent for incineration.

Accidents, incidents and spillages

In the event of accidents, incidents and spillages in body-piercing studios, and for the purposes of applying the Health and Safety Commission Guidance, consideration should be given to the appropriate administration of first aid, reporting of the incident to a responsible designated person, and recording the incident.

Note that any spillage of 'sharps' should not be picked up by hand, and a spillage of soiled materials, such as swabs and tissues, should be handled carefully, and consideration given to personal-protective equipment and personal hygiene.

Sharps

'Sharps' which are handled incorrectly, and not disposed of adequately, are dangerous. Injury from a contaminated blade or needle is the main route for occupationally-acquired infection by blood-borne viruses such as HIV, hepatitis B or hepatitis C.

ULTIMATE DISPOSAL

Ultimately, clinical waste requires disposal by incineration. Many years ago, some hospital incinerators were able to receive the sharps bins. However, these days, thanks to the duty of care aspects, as well as stricter environmental controls, a special-waste contractor should be employed.

Organisations catering for smaller skin-piercing establishments do exist and their details can be obtained from the appropriate trade organisations.

RISK ASSESSMENT

As well as specific legislation covering skin piercing and special treatments, there are overarching safety requirements of workplace health-and-safety legislation to consider.

In this chapter we turn to the particular duty of making assessments of the risks posed by body piercing and special treatments business activities.

GENERAL WORKPLACE RISK ASSESSMENTS

Risk assessment is a practical and methodical procedure for identifying work-related hazards, and for evaluating the risks associated with them. The aim is to take remedial action to deal with these risks, and to review them at regular intervals.

The risk assessment enables a business to deal with hazards according to their health or safety priority, and is an opportunity to gain commitment to health-and-safety objectives of all concerned.

Contrast the risk-based approach to traditional methods where change is introduced only after a serious incident, new controls are often over-zealous and often conflict with other business goals, review is a low priority, and controls fail to keep pace with change.

Legal requirements

The 'Management of health and safety at work regulations 1999' impose a duty on all employers and the self-employed to:

- use competent personnel to identify the workplace hazards

- make suitable and sufficient assessment of the health-and-safety risks posed by their work activities and anyone else affected by them (such as customers), so far as is reasonably practicable

- determine and implement remedial actions which will eradicate or reduce those risks. This includes management programmes to ensure the controls are maintained.

In addition, a number of Regulations deal with specific, individual hazards and require risk assessment of these hazards. These include hazardous chemicals, pathogens, fire, asbestos, lead, noise, etc, as well as workplace hazards to young people, pregnant women and new mothers.

ACTION LIST

Preparing for risk assessment

Classify the various work activities into similar types (for example, handling clinical waste) and include infrequent activities involving few personnel, as well as mainstream activities. Do not forget lone workers (such as cleaners), young people, and the special hazards faced by pregnant women and new mothers.

Organise for risk assessment by gathering information on the controls currently in place; machinery, substances and processes currently in use; any special legislation that applies to the business; and instructions and data available from manufacturers and suppliers.

The steps involved in risk assessment include:

- identifying the hazards using a checklist

- evaluating the hazards and determining the risks using an assessment method common to all the hazards to enable comparison

- reviewing control measures in the light of the assessment

- recording and communicating results

- implementing remedial actions

- reviewing your assessment

- identifying the hazards via practical assessment.

 It is essential to actually visit the area being assessed, and while the assessment is in progress:

- discuss any problems encountered with those concerned

- do not apportion blame for any inefficiency found

- involve anyone who becomes part of the assessment

- write down any significant findings

- ensure that any immediately hazardous situations are dealt with or brought to the attention of those responsible.

Implement remedial actions

There is an order of priority in which remedial measures should be considered:

- can the hazard be eliminated altogether? (the long-term solution)

- can it be reduced at source?

- remove the person from the hazardous situation

- contain hazard by enclosure

- reduce employee's exposure to hazard

- use protective equipment (a short-term option)

The aim should always be to eliminate the hazard. If new or revised controls are required, always discuss the intended controls with those involved. Whatever remedial actions are put in place, it is essential that safe systems of work, or safe-working procedures, and training are included.

Record and communicate results

Employers are only required to record their assessments if they have five or more employees. Nonetheless, it is good practice to do so, otherwise reviewing hazards and their management will subsequently be difficult.

The record should include:

- type of assessment undertaken

- specific location/activity or reference number, etc

- date

- assessor

- hazards found, including any numerical data

- who was at risk, and how the harm could occur

- existing controls

- remedial actions

- priorities/action dates

- review date.

Throughout the risk-assessment process, there should be a clear means to communicate at each significant stage. Bear in mind the following points:

- conceptual stage: advise employees at all levels of the nature of risk assessment

- competent advisers: ask for volunteers (subject to approval) during training of staff involved

- include staff on your assessment team

- actively seek assistance from those being assessed

- ask for feedback: do the control measures work?

- larger businesses may want to use their magazine, notice boards, etc.

RISKS DUE TO SUBSTANCES

Fatalities and illnesses caused by exposure to hazardous substances are among the most serious concerns of businesses, employees and the public who are affected - often without knowing it.

Many health effects of substances are instant (for example, the freezing effect of ethyl chloride), whereas others are delayed over a much longer period of time (think of the respiratory effects of glutaraldehyde).

Because of this, it is essential to have a strategy to eliminate or control exposure within, or better than, the requirements of current legislation and scientific knowledge.

COSHH

The 'Control of substances hazardous to health regulations 1999' (often abbreviated to simply COSHH) provide a legal framework to protect people against the risk of their health from hazardous substances used at work.

All employers have to consider how COSHH applies to their work by identifying hazards, weighing-up the risks and deciding what action to take. Many special-treatments businesses will be able to comply with the regulations with little effort.

COSHH covers substances that can cause ill health by being used directly in work, or arising from the work. Substances hazardous to health include:

- substances or mixtures of substances, classified as dangerous to health and identified by their warning symbol (eg: 'irritant', 'corrosive', 'toxic', etc). The supplier must provide a safety data sheet setting-out basic information about the substance, for example, how to clear it up should there be a spillage

- any micro-organism, cell culture, or human endoparasite, which may cause infection, allergy, toxicity or otherwise create a hazard to human health. This includes such issues as the risk of needle-stick injuries

- substances listed in the HSE booklet EH40 'Occupational exposure limits'; a revised list is published every year

- any kind of dust in a substantial concentration.

This is not exhaustive, but covers circumstances likely to be encountered in a special-treatments business. Specifically, use of any chemicals with a hazard symbol indicates the need for a COSHH assessment.

As an example in special treatments, there is no warning label on household washing-up liquid and so, if used 'at work' in a studio, there is no need to consider COSHH. There is, however, a warning label on household bleach, so COSHH does apply when it is used and stored in the workplace.

WHAT TO DO

Complying with COSHH involves a number of steps, as follows:

- assess the risk

- decide upon any precautions needed

- prevent or control exposure to the substance

- ensure that control measures are used

- monitor exposure

- ensure all are informed, trained and supervised.

EVALUATING THE RISKS

Risk evaluation involves a combination of the following:

- potential for causing harm

- likelihood of the harm occurring

- frequency of exposure to harm

- exposure levels and duration.

Potential for causing harm

The substances with harmful potential were found during the information collection phase.

Likelihood of the harm occurring

Consider the following in relation to the information collected earlier, and consider the ways in which harmful exposures can occur. People can come into contact with a substance if they:

- work with it directly

- come into contact with contaminated clothing or surfaces

- are in the vicinity of areas where it is handled, transported, used, worked upon, collected, packed, stored, disposed of, discharged, or given off, etc; or where it is simply present in the environment

- are in the vicinity of an accidental release or spillage

- enter an enclosed space where it might be present

- disturb deposits of the substance on surfaces and make them airborne

- have the substance passed on to them from intimate personal contact or from others' clothing, for example, by laundering them at home.

Frequency of exposure to harm

Most risk is attached to people and activities where exposure is very frequent, for example, daily exposure to a respiratory sensitiser such as glutaraldehyde. Do not forget the consequences of non-routine work, such as accidental spillage, maintenance and repairs, etc.

Exposure levels and duration

Exposure levels can usually be determined by observing and asking the people concerned. An estimate of the degree of exposure can often be made by simple tests using indicator tubes, etc.

It is not always necessary to make measurements using instruments, and in many cases it is obvious that conditions are satisfactory without making any measurements at all. For instance, a process sealed inside a well-maintained enclosure is unlikely to cause significant exposure to those outside it. Nevertheless, measurement would confirm the effectiveness of control.

Always err on the side of caution if doubt exists. Measurement identifies the scale of a problem and can avoid both under- and over-reaction. Sometimes exposure cannot be established with confidence without taking detailed measurements. If there is still doubt, be on the safe side in deciding on precautions later. Always take into account the conditions that could be expected to give rise to the greatest exposures.

Certain anaesthetic sprays are often used in body piercing, ethyl chloride and xylocaine being the most well known. The supplier's data sheet describes ethyl chloride as a highly-volatile liquid with an ether-like odour. It is said to be a flammable liquefied gas under pressure and contact with the liquid can cause frostbite.

Xylocaine spray is described in its data sheet as being a metered-dose, pump-spray anaesthetic containing lignocaine in an alcohol solution. It can depress excitable tissue and can thus cause adverse effects on the central nervous system, etc, but such events would only occur if a quantity is ingested.

MEASURES TO COMPLY WITH LEGAL REQUIREMENTS

Not all problems can be solved immediately and priorities are required. Deciding these involves asking what are the most serious risks to health, what are the risks that are likely to occur soonest, and what are the risks that can be dealt with soonest?

The most important is the seriousness of the risk and this should be dealt with immediately. Less-important matters should not assume priority merely because they can be dealt with easily or quickly.

COSHH contains an explicit duty to prevent exposures to hazardous substances, but where that is not reasonably practicable employers must adequately control the exposure.

Prevention of exposure

This is the first priority and can be achieved by:

• changing the method of working

• modifying processes to exclude production of hazardous wastes or by-products

• substitution by a less-hazardous substance, which could be the same substance in a different form.

Changing established practices, even with good intentions, requires careful consideration of all the implications of the new risks that are created.

Control measures to prevent exposure

This guidance does not describe the range of exposure prevention and control strategies available. These are referred to in detail in a range of HSE and other publications. The aims of control measures are to reduce the exposure as far as reasonably practicable, and in all cases to below the maximum exposure limit as set out in EH40 and the COSHH Regulations.

Trade association publications, HSE guidance notes, etc, may provide useful ideas.

Reasonable practicability

A number of health-and-safety requirements are subject to 'reasonable practicability'. Reasonably practicable has a specific meaning in law. However, deciding what is, or is not, reasonably practicable depends on individual circumstances and cannot be subjected to standard formulae.

'Reasonable practicability' is essentially a matter of balancing the degree of risk against the time, trouble, cost and physical difficulty of the measures necessary to control it.

Clearly the greater the risk, the more reasonable it is to do something about it; and vice versa. It is important to remember that the judgment is driven by the risk and not the size or financial position of the employer concerned.

In other words, the standard of 'reasonable practicability' is the same regardless of the employer's circumstances. It should also be noted that what is accepted as 'reasonable practicable' changes with time, as technology and toxicology develop.

There are various sources of information and indicators to aid decisions on 'reasonable practicability':

• HSE codes and guidance

• industry guidance

• accepted good practice, but this may not necessarily be the same as usual practice

• recommendations of manufacturers and suppliers

• the hazardous nature of the substance involved and the risk it presents, both of which will be clear if the earlier stages of assessment are suitable and sufficient.

Best practice guidance
BODY ART

This 'Best practice guidance' permits tattooing, nose, tongue, navel, nipple, genital piercing, and other body piercing, branding and scarification - subject to important qualifications.

The guidance prohibits amputations, beading, castration, clitoridectomy, finger amputation, labia removal or 3D-body art, for any other than a medical reason.

Physicians registered with the General Medical Council, who perform any of these procedures as part of recognised patient treatment are exempt from this 'Best practice guidance', although adherence to it is recognised good working practice.

Individuals who pierce only the outer perimeter and lobe of the ear with a pre-sterilised single-use stud and clasp ear piercing system are covered by a separate, specific ear-piercing 'Best practice guidance'. Local authorities will investigate consumer complaints concerning alleged misuse or improper use of ear-piercing systems, on for example, noses.

SCOPE
Body piercing

The perforation of the skin and underlying tissue, usually with the aim of inserting jewellery. Popular sites are the nose, tongue, labaret, nipple, eyebrow, and navel. The genitalia may also be pierced in a variety of ways.

Branding

A form of scarification, achieved by burning the skin with heated metal to form a simple but permanent design. Branding may be performed using stainless-steel strips, cauterising irons, or lasers.

Micropigmentation

This is a form of tattooing in which small amounts of natural pigment are applied into the skin. The effect is said to last for approximately three years, and is applied as a beauty treatment to the eyebrows, to enhance the lip line, and to produce beauty spots.

Scarification

The incision or slashing of the skin, leaving a scar for adornment and decoration.

Tattooing

Marking the skin with permanent pigments by puncturing the skin's outer layer (epidermis) using a needle or needles.

Temptoo/temptu

A tattoo in which the needles pierce the skin, but do not breach the epidermis. Temptoo dyes are said to rise to the surface of the skin and vanish over three to five years. It is difficult to control or guarantee the depth to which the tattoo needles penetrate.

There is little evidence to show that tattoos are temporary if produced by dye or pigment injection into the skin The infection hazards of skin piercing are present regardless of the stated lifespan of the finished tattoo.

Temptoos should be distinguished from temporary transfer skin decorations, which are regulated as cosmetics.

RESPONSIBILITIES
The responsibilities of the business operator include:

- taking all reasonable precautions for the safety of all persons using the premises. He or she will ensure compliance at all times with the relevant provisions of the 'Health and safety at work etc act 1974', and associated legislation

- carrying out and implementing the findings of a risk assessment of the business as required by the 'Management of health and safety at work regulations 1999'

- ensuring that a 'responsible person' is in charge of the premises at all times, and that they are familiar with, and implement, the requirements of the relevant best practice guidance

- ensuring that all persons carrying out special treatments are suitably qualified or trained, and are competent

- notifying the local authority in writing of any proposed change in his or her name or private address, of changes in the business address, of major changes in the treatments provided, or in the nature of the business carried on at the premises.

RESPONSIBLE PERSON

- the business operator must ensure that a responsible person is in charge of the premises at all times, and that he or she is familiar with, and implements, the requirements of the relevant codes of practice

- the responsible person must be aged 18 years or over

- he/she should be nominated, in writing, by the business operator, and this notification should be continuously available for inspection at the premises

- a responsible person must be in charge of the premises, and must be on site at all times when the public have access to the premises

- the responsible person must not be engaged in any other duties which will prevent him or her from exercising general supervision

- he or she should be assisted as necessary by suitable persons over the age of 18 years, to ensure adequate supervision.

CONDUCT OF THE BUSINESS
The business operator must ensure the following:

- good order and moral conduct in the premises

- no posters, advertisements, etc, should be displayed which are unsuitable for general exhibition

- no part of the premises should be used by persons for soliciting or other immoral purposes

- additional custom will not be sought through solicitation outside, or in the vicinity of, the premises

- all clients in any part of the premises must be decently and properly attired, unless receiving treatment in accordance with this best practice guidance

- neither the practitioner nor the client should be under the adverse influence of drugs, alcohol or other substances

- all piercing must be undertaken in conditions of appropriate privacy

- genital piercing by appointment only. Clients must be advised to be accompanied by a friend to ensure there is no misunderstanding or allegation of impropriety. Operators should be assisted by an apprentice or colleague of the appropriate gender.

Table 3. Choice of decontamination procedures

Agent	Preparation	Use
Hypochlorite (bleach)	Make up daily; dilute to 30% bleach/70% water	Cleaning up accidental blood spills Corrodes metal; excellent for other materials.
Chlorhexidine in alcohol*	Do not dilute	Skin preparation and disinfection of mucous membranes (eg, mouthwash)
70% alcohol	Pre-packed swabs; do not further dilute	Intact skin preparation, topical treatment of infected piercings (but not genitalia). Table tops, metals, including tattoo machines

* 70% alcoholic solutions only

AGE OF CONSENT

- clients must be aged over 18 years for tattooing, temptooing and all forms of body piercing other than piercing of the ear, nose, labaret, eyebrow or navel. This is a statutory requirement for tattooing, with criminal penalties on conviction by magistrates

- persons aged between 16 years and 18 years must show identification, which includes a photograph and date of birth; eg, a passport

- anyone aged under 16 years must be accompanied by a parent/guardian. Both the client and parent/guardian must sign a consent form.

CONTRA-INDICATIONS

The practitioner must discuss clients' medical history and ask whether they have experienced or suffered from the following:

- acne
- allergic responses to latex, anaesthetics, adhesive plasters, foodstuffs (eg, wheatgerm or seafood) and jewellery
- cellulitis
- conditions that compromise the immune system
- diabetes
- eczema
- genital warts (if appropriate)
- haemorrhaging/haemophilia
- heart disease/pacemaker
- high blood pressure
- impetigo
- psoriasis
- seizures; eg, epilepsy
- taking blood thinning medication; eg, aspirin

Where any of the above conditions exist, or there is a past history, written authorisation from the client's doctor is required.

The responses to questioning on contra-indications should be recorded with the client's record and consent form.

DISINFECTANTS

Disinfectants do not sterilise, they only reduce the number of some microbes. Disinfection is needed for skin surfaces about to be tattooed or pierced. It is important to use freshly-prepared disinfectants, as they have a limited shelf life and risk introducing infection into piercings.

Cleaning is required for table tops and general surfaces in the treatment area.

Sterilisation - the destruction of all microbes - is achieved by heating in an autoclave.

In addition to the above, body piercers may consider use of proprietary products for skin preparation of sensitive areas, such as mucous membranes and genitalia. It is important to ensure the product has an adequate shelf life, and will not support microbial growth in any circumstances.

EQUIPMENT RECOMMENDED FOR HYGIENIC TATTOOING

- alcohol impregnated swabs (pre-packed) for skin preparation
- autoclave
- disinfectants
- disposable caps or trays for pigment
- disposable latex, vinyl or nitrile gloves may be worn, but must be discarded after each client; they must be disposed of as clinical waste
- disposable razor or metal safety razor with disposable blades
- kidney-dish (autoclavable container for needles)
- melolin dressings, or suitable alternative.
- metal forceps (autoclavable)
- paper tissues (for handling lamps, telephones, etc), paper towels and cups
- plastic sleeves for clipcord, tattoo machine and spray bottles
- 'sharps' container
- single-use body art stencils, or transfer stencils
- spray bottle (in clean single-use plastic bag) containing fresh skin preparation antiseptic
- ultrasonic cleaner (with lid).

EQUIPMENT RECOMMENDED FOR HYGIENIC BODY-ART

- alcohol-impregnated swabs or other suitable pre-packed swabs for skin preparation
- autoclavable metal ruler for measuring jewellery, etc
- autoclave
- disinfectants
- disposable latex, etc, gloves may be worn, but must be discarded after each client. they must be disposed of as clinical waste
- disposable razor or metal safety razor with disposable blades
- jewellery (for display and demonstration only, and sterile, for use in body piercing)
- kidney-dish (autoclavable container for needles)
- lubricant jelly in sachets (*not* tubes or tubs)
- metal forceps and clamps (autoclavable)
- metal tray (autoclavable)
- single use pliers for holding the stainless-steel plate during the branding process
- pre-packed, hollow pre-sterilised disposable needles (recommended) of not less than 1mm diameter and not more than 2.5mm diameter (an alternative is re-usable and autoclavable hollow needles of the same range of dimensions)
- ring openers and closers (autoclavable)
- 'sharps' container
- single-use skin marker (recommend toothpick and gentian violet or food colour)
- single-use surgical scalpels for scarification
- sterile gauze, paper tissues (for handling lamps, telephones, etc), paper towels and cups
- surgical-steel plate, suitable for cutting into designs for branding
- ultrasonic cleaner (with lid).

INFECTION CONTROL PROCEDURES

Hand washing is the single most important means of preventing spread of infection. In general, you must thoroughly wash hands using soap from a dispensing unit and hot water:

- immediately before and after tattooing or skin piercing procedures after removing gloves
- after visiting the toilet
- when the hands (or any unprotected part of the body) are accidentally contaminated by blood, body fluids or secretions (including your own)
- before handling food and drinks.

Hands should be thoroughly dried using a disposable paper towel from a dispenser.

Finger nails must be kept short and clean.

Cuts and abrasions to the hands and arms should be covered with a waterproof dressing at all times.

There should be no smoking, eating or drinking facilities in the studio, including rooms reserved for cleaning and sterilising equipment.

Re-usable equipment shall be effectively sterilised in accordance with the 'Guide to infection control'.

It is recommended that any person carrying out body piercing procedures does not do so while suffering from an infection involving coughing or sneezing.

Before tattooing, branding or piercing
Check:

- as many needles as are needed for one day should be estimated, and soldered on with a lead-free solder to the stainless-steel rods in advance of a day's work. The assembled needles and bars should be rinsed in bicarbonate of soda, ultrasonically cleaned, and sterilised as described in the 'Guide to infection control'. Alternatively, single-use needles and needle bars should be autoclaved
- the tattoo machines ('motors' or 'frames') cannot be sterilised and they should be carefully damp wiped between clients with 70% alcohol. A freshly made-up 1.5% solution of phenolic disinfectant (eg, Hycolin) is acceptable for this purpose, although alcohol is preferred
- after being sterilised, the needles and needle bars may be left in the autoclave ready for use in the following 2-3 hours. Note that once the autoclave is opened, the contents are at risk of re-contamination
- sterile forceps should be used for handling sterile needles and bars. They should be re-sterilised with each batch of new needles
- assemble the equipment required for the client - inks, dyes, pigments, needles, scalpels, branding tools, etc
- go through the questioning of the client as to their requirements, contra-indications and formal consent
- record details as shown in 'Appendix 6'
- give the client after-care advice, but note you should also provide this in writing for the client's future reference.

Personal hygiene procedure

The practitioner must:

- scrub hands, nails, and wrists with soap and running hot water, dry them with clean disposable paper, and then wear new disposable gloves for each client
- wear clean overalls or a single-use, disposable apron, changed between clients
- cleanse the skin in the area of the tattoo or piercing site using a skin-safe antiseptic solution prior to carrying out the procedure
- needles *must not* be tested on the tattooist's skin before use on a client.

More details of this procedure are given in the 'Guide to infection control'.

Shaving, cleaning and marking of skin

The skin area to be treated should be wiped over with an alcohol-impregnated swab, or other suitable antiseptic preparation in sensitive areas such as the genitalia.

The mouth should be cleaned with a mouthwash prior to tongue or labret, etc piercing.

If the skin area is to be shaved, use a single-use disposable razor. A 'cut throat' type razor may nick the skin, is difficult to disinfect and therefore is not recommended.

Placement of the piercing should be marked with a single-use water-based marker pen. A single-use toothpick dipped in food colour or gentian violet is a suitable alternative. The bottle of food colour should be discarded after each client.

Vaseline (petroleum jelly BP)

Many tattooists smear the area to be tattooed with Vaseline. Do not take jelly from the jar with fingers, because contamination is likely. An autoclaved metal syringe (for example, an ear syringe as used by doctors), should be filled with Vaseline using a disposable or autoclave metal spatula.

The jelly is smeared over the area with a dry, single-use wooden spatula (eg, tongue-depressor), or autoclaved metal spatula.

Use of pigment

When using pigments the following points need to be observed:

• because needles are repeatedly dipped into pigments during tattooing, it is most important that fresh pigments are used for each customer. These may be held in single-use trays or caps: re-usable containers are *not* recommended

• pigment capsules should be firmly placed in holders while in use, to avoid the possibility of spillage. These should be made of autoclavable material, such as aluminium or stainless steel, and should be cleaned and disinfected between clients and sterilised between sessions.

Care of skin after tattooing and branding

The treated area must be covered with a lint-free sterile gauze which is taped to the skin with micropore tape. The aim is to keep the new tattoo dry and the gauze permits ventilation of the damaged skin surface, helping the healing process.

CLEANING AND DISPOSAL OF TATTOO EQUIPMENT
Needles

After each customer is tattooed, the needle bars must be ultrasonically cleaned and sterilised *before* the needles are de-soldered, in order to avoid infection risk from needle-stick injury.

Single-use needles and needle bars are recommended, however, re-usable needles and needle bars must be used once only and then cleaned and sterilised immediately before use on the next client.

Capsule holders, forceps, syringes, dishes, tips, grips and tubes

Must be sterilised immediately before each tattooing session.

Pigment capsules

Pigment capsules must be disposed of after each client, along with any other single-use equipment (eg, needles and spatulas).

JEWELLERY

All cosmetic jewellery which may come into contact with broken skin or mucous membrane must be sterilised.

Jewellery must be of a suitable size and grade. For body piercing this means solid 14ct or 18ct gold, niobium, titanium and platinum. This is to minimise risk of allergic reaction, harbouring of bacteria, or adhesion of newly-formed skin.

Other materials include PTFE, acrylic, bone and horn, hard woods, and stainless steel. Use of stainless steel is affected by the 'Dangerous substances and preparations (nickel) (safety) regulations 2000', and all stainless-steel jewellery must comply with these Regulations; note that Grade 316L stainless-steel does *not* comply.

Surgical-grade (316L) stainless steel is acceptable for use in needles, clamps and forceps, as the metal is not in prolonged contact with body tissues.

PRACTITIONERS

Practitioners must adhere to the following points:

• treatment should only be given by practitioners who have met the criteria for training and competency; see 'Training' below

• all practitioners should display a name badge in a manner approved by the local authority. The name should correspond with that shown on his/her record of training/competency

• piercers and staff involved in handling piercing equipment must be vaccinated against Hepatitis B, and must produce a medical certificate to that effect. Vaccination and confirmatory blood tests can be arranged through GPs.

TRAINING/COMPETENCY

Practitioners should be aware of the following:

• all persons carrying out body-art procedures ('practitioners') must attend a relevant course on infection control (eg, one run by a local authority/health authority and/or recognised trade association), and attend a refresher course at least every five years

• they must also be carefully and constantly supervised during their first year of practice by a practitioner who has been successfully performing body-art procedures routinely over the previous five years. It may take up to two years of full-time practice to achieve the minimum level of competence

• all persons must be able to demonstrate competency by answering a series of questions by the authorised officer, or anyone they deem necessary for the purposes of the inspection, eg: medical practitioner. They should be able to demonstrate knowledge/proficiency in subjects such as relevant anatomy, diseases and their transmission, infection-control procedures, precautionary approach to new procedures, etc

• full records must be kept on the premises of all qualifications, courses attended (with dates, and the titles of the courses, and the venue) and periods of supervision of all piercers/tattooists. These details must be available for inspection at all times

• body-art procedures should not be undertaken by persons under 18 years

• training shall include procedures on dealing with body fluid spillage (vomit, blood, urine, etc), needle-stick injury and all safe working methods established by the employer.

PROCEDURE MANUALS

It is recommended that all piercers and tattooists produce a procedure manual to assist in training and ensure that best practice is used consistently by all practitioners. The contents of the manual should include:

• hand-washing procedure

• handling and cleaning of protective clothing, etc, procedure

• studio-cleaning procedures, including all furniture and fittings

• sterilisation procedures

• a validation of the sterilisation process, testing of packages and seals, sterility tests, copies of autoclave maintenance details, etc

• a regular review of storage facilities for sterile packs, chemicals, protective clothing and waste

• management of exposure to blood and body fluids

• waste-disposal procedure.

ANAESTHETIC

The administering of local anaesthetic by injection, other than by a registered medical practitioner, is an offence under the 'Medicines act 1968'.

Administering of local anaesthetic creams, gels, sprays, etc, is not recommended. Piercers should not administer prescription-only topical creams (such as EMLA).

Ethyl chloride should not be used under any circumstances, as there is an appreciable risk due to flammability, cryogenic properties (frostbite) and respiratory sensitisation.

PREMISES

The following points shall be adhered to:

• all internal walls, doors, windows, partitions, floors, floor coverings, and ceilings, must be kept clean and in such good repair as to enable them to be effectively cleaned

• effective pest control measures, such as pest proofing, and appropriate treatments should be carried out, as necessary, and proper records kept

• the floor of the treatment area should have a smooth, impervious surface

• the treatment area must be solely used for giving treatments, and must be completely separated from all other rooms (for example, any room used for human habitation, catering establishment, hair salon, retail sales, or other) by full height walls or partitions

• there should be a minimum of 5m² of floor space for each operator in the establishment

• no animals of any kind should be permitted in a treatment area, except service animals used by persons with disabilities, for example, guide dogs for the blind

• suitable and sufficient means of heating to a reasonable room temperature, appropriate to the treatment offered, must be provided

• all furniture and fittings in the premises should be kept clean. Furniture in the treatment area (for example, tables, couches and seats) should be covered with a smooth, impervious surface, so that they can be effectively cleaned

• there should be an adequate, constant supply of clean hot and cold water at a hand basin, as well as sanitising soap or detergent and disposable towels. The wash basin should be easily accessible to the operator and be for his/her sole use. Taps should preferably be wrist- or foot-operated

• there should be suitable and sufficient sanitary accommodation for therapists and clients

• there must be adequate, clean, and suitable storage for all items, so as to avoid, as far as possible, the risk of contamination

• suitable screening to provide privacy must be provided

• the premises must be adequately ventilated.

TARIFF

A comprehensive tariff should be prominently displayed which can be easily seen by all persons entering the premises.

REGISTRATION CERTIFICATE

A current registration certificate should be conspicuously exhibited at all times to the satisfaction of the local authority. It must be clearly visible by all persons using the premises, and adequately protected against theft, vandalism or defacement.

RECORD KEEPING AND INFORMATION

A record must be kept of the establishment, including the name and address, hours of operation, and owner's name and address.

A record shall be kept of every practitioner, including the following details:

• full name and exact duties

• date of birth

• gender

• home address

• home/work telephone numbers

• identification photos.

A copy of this 'Best practice guidance' should be kept on public display.

Every client must read and sign a consent form, which contains details of name, address, age, medical history, etc; an example is attached at 'Appendix 6'. Confidential records, including name, address, date and type of treatment received should also be kept for all treatments for a period of at least three years after the treatment has finished so that alleged cases of infection can be epidemiologically studied, as well as conducting checks on the ages of clients. They must be made available to the authorised officer upon request, and with the client's written consent.

The following points should also be observed:

• a complete inventory of all instruments and body jewellery, all 'sharps', and all inks used for any and all body-art procedures should be kept, including names of manufacturers and serial or lot numbers, if applicable. Invoices or orders will satisfy this requirement

• autoclaves should be operated and maintained in accordance with the manufacturer's instructions

• a complete description of all body art procedures performed on each and every client should be kept

• any contra-indications; eg, heart conditions (such as a pacemaker), diabetes, epilepsy, etc, for each treatment will be discussed with the client prior to any treatment. Copies of referral letters from GPs etc should be kept with the client record

• users should be given written information to take away about the contra-indications and risks of tattooing/temptooing/piercing, together with aftercare advice. This should be noted on their record card, which should be signed and dated.

INFORMATION NOTICE

A notice should be prominently displayed on the premises informing potential clients of the risks associated with body art. These should include:

• allergic reaction to jewellery materials and antiseptics

• blood poisoning (septicaemia)

• jewellery embedding

• localised infection; eg, sepsis or urethritis

• localised severe swelling and trauma around the piercing site

• migration and rejection of jewellery

• scarring and keloid formation.

The notice should make clear that tattooing is only available to those aged 18 years or over.

The notice must also give the name, address, and phone number of the local health authority and environmental health department, so that the public can report complaints or seek additional information.

All infections, complications or diseases resulting from any body art procedure that become known to the operator must be reported to the local environmental health department within 24 hours. Any contra-indications, for example heart conditions (eg, use of a pacemaker), diabetes, epilepsy, etc for each treatment must be discussed with the client prior to any treatment. In cases of medical referral, the practitioner must keep a copy of the GP's letter with the client record.

The notification should be made as soon as practicable.

FIRST AID

There must be a first-aid kit on site that complies with the 'Health and safety (first aid) regulations 1981'. There are no specific mandatory items which must be included in a first-aid box.

The Health and Safety Executive has issued a recommended list of contents. Where the risk assessment as revealed no special hazards, a minimum stock of first-aid items includes:

• a leaflet giving general guidance on first-aid (for example, the HSE leaflet 'Basic advice on first aid at work')

• 20 individually-wrapped sterile adhesive dressings, of assorted sizes, appropriate to the type of work

• two sterile eye pads

• four individually-wrapped triangular bandages

• six safety pins

• six medium-sized individually-wrapped sterile, unmedicated wound dressings (approximately 120x120mm)

• two large sterile individually-wrapped unmedicated wound dressings (approximately 180x180mm)

• one pair of disposable gloves.

First-aid kits for travelling practitioners (ie, staff who frequently carry out domiciliary visits) would typically contain:

• a leaflet giving general guidance on first-aid (eg, HSE leaflet 'Basic advice on first aid at work')

• six individually-wrapped sterile adhesive dressings

• one large sterile individually-wrapped unmedicated wound dressing (approximately 180x180mm)

• two triangular bandages

• two safety pins

• individually-wrapped moist cleansing wipes

• one pair of disposable gloves.

Needle-stick injuries: first aid

Where a needle-stick injury occurs take the following steps:

• encourage the puncture to bleed

• wash under cold running water, without soap

• cover with a dry dressing

• seek medical advice as soon as possible (preferably within one hour) at the accident and emergency department of the local hospital - a protective injection can be given against hepatitis B (but not hepatitis C), but this must be done within 48 hours of the injury taking place. Treatment is also available to minimise risk of infection by HIV

• record any puncture wound or contamination of broken skin, mouth or eyes and report the incident to the employer (if applicable)

• the employer must record the details and investigate the incident to find out how it could have been prevented.

All persons working in the premises must be trained in procedure on how to prevent and deal with needle-stick injury.

If an infection occurs as a result of the incident, it should be reported to the environmental health officer (see RIDDOR regulations).

INSURANCE

The business must have third party liability, to cover claims for damages or negligence, as well as employer's liability insurance where appropriate.

WASTE STORAGE

The 'Environmental protection (duty of care) regulations 1991' impose a duty of care on waste producers to ensure that all refuse (especially clinical waste, such as used electrolysis needles, dressings and swabs) is collected and disposed of by a registered waste carrier at an approved incinerator.

To take care of waste properly:

• a contract should be arranged with a suitable company for safe and proper disposal of clinical waste; eg, used/damaged needles in a 'sharps' container, and swabs, etc, which have been in contact with the skin, in an approved plastic clinical waste sack, clearly marked 'Biohazard - clinical waste only to be incinerated'. All clinical waste (ie, dressings, swabs and used needles) is to be collected and disposed of by a registered waste carrier (ie, a specialist waste disposal company)

• a copy of the current contract for the removal of such waste, and contractor's licence and transfer notes, shall be available for inspection on the premises at all times

• the clinical-waste bags and 'sharps' containers should be coloured yellow, and be stored in a secure place while awaiting collection

• general rubbish should be stored in covered receptacles and arrangements should be made for regular collection and proper disposal.

LOCAL AUTHORITY AUTHORISED OFFICERS

Authorised officers carry written authorisations and proof of identity, which they will produce on request. They must be admitted during opening hours, and at any other reasonable time, to all parts of the premises. An officer may be accompanied by anyone else who is deemed necessary for the purposes of the inspection, for example, a medical practitioner.

APPENDICES

APPENDIX 1: BLOODBORNE AND OTHER INFECTIONS

Viral hepatitis

Viral Hepatitis is caused by several distinct viruses of which Hepatitis A, B and C are the most common and well known.

Hepatitis A

This was formerly known as infectious hepatitis. It is normally transmitted by the faecal-oral route, and is rarely transmitted by blood. It has an incubation period of about four weeks, and is a common infection in conditions of poor hygiene and sanitation or overcrowding.

Certain foodstuffs, notably shellfish, are also linked with this infection.

Hepatitis B

This is spread by contact via infected blood and body fluids.

The virus infects either by penetration of the skin via infected needles, razors, etc, or contact with broken skin from contaminated apparatus or surfaces. It has an incubation period of six weeks to six months.

Hepatitis B is extremely infectious; a small pin-prick with a contaminated instrument is sufficient to transmit infection. Blood does not need to be visible on an instrument for it to be capable of infection.

The disease can cause cancer of the liver, and has a significant mortality rate. It may also lead to a chronic carrier state, often with a fatal outcome. Absence of a history of hepatitis in a client will *not* guarantee zero risk to the practitioner, because of the possibility of the symptomless carrier state.

Business operators must have a high standard of infection-control technique to ensure that there is no danger of passing on infection.

Hepatitis C

This is a recently-described virus which, like hepatitis B, causes serious liver disease. It is also transmitted by blood, and infection can be avoided by using the same procedures as those used for Hepatitis B.

Practical implications

The following precautions should be noted:

- cover exposed cuts and abrasions, especially on the hands, with waterproof dressings
- take care to prevent puncture wounds, cuts and abrasions from used needles, razors or glassware. If such an accident take action as listed under 'needle-stick injuries'.
- *never* use needles, equipment, and instruments, etc on more than one client, unless sterilised between clients
- *never* use unsterilised needles on any client
- if you believe you are a carrier of hepatitis B, HIV or have AIDS it is recommended that you seek counselling from a public-health specialist. Further information should be sought from your doctor, or from one of the specialist information and support services.

If a risk assessment indicates it, consider using face shields or goggles, and eye-wash stations.

By carefully following these guidelines, risk of infection to practitioners and their clients will be reduced to an acceptable level.

APPENDIX 2: CONTRA-INDICATIONS AND AFTER-CARE ADVICE

Contra-indications

- allergic reaction to jewellery materials and antiseptics
- blood poisoning (septicaemia)
- jewellery embedding
- localised infection or condition; eg, sepsis or arthritis
- localised severe swelling and trauma around the piercing site
- migration of jewellery
- scarring
- aged less than 16 years for piercing and 18 years for tattooing.

Aftercare

New piercings are likely to become swollen and are susceptible to infection during the healing process. Many factors can affect wound healing, including:

- nutritional status
- piercing-related issues, including poor practice, rough handling, tight skin, or poor blood supply to the chosen piercing site
- presence of foreign material
- scar formation
- a moist environment around the piercing
- initial biological response - severity of inflammation, local infection, etc.

After-care treatment is entirely dependent on the location and type of body art. For instance, aftercare for the inside of the mouth will be different in detail to that suggested for an external, dry area like an earlobe or tattoo.

Here are a number of recommended practices common to aftercare of all forms of body-piercing:

- piercings should be kept dry, so far as practicable
- the aim is to prevent introduction of infection and help natural healing processes
- do not touch the piercing for at least 48 hours
- wash hands thoroughly before handling the piercing or jewellery
- do not use fingernails to move jewellery or manipulate the piercing
- to maintain mobility of the jewellery it should be turned no more frequently than once or twice a day with clean hands, handling the jewellery as little as possible - for example by using a clean tissue
- try not to remove encrustation as this protects the piercing from infection
- after a shower etc, dry the piercing using cotton swabs or tissue - do not use a towel or face cloth
- avoid restrictive clothing around navel and genital piercings.

It should be noted that usefulness of antiseptics and advice on frequency of cleansing versus risk of infection are still matters of custom and practice. There is disagreement on the usefulness of antiseptics in piercing aftercare.

Current medical advice strongly recommends that the piercing be handled as little as practicable; and that 70% alcohol (or other antiseptic in 70% alcohol) is used for antisepsis only if required. This is because alcohol has an important, beneficial drying effect on the piercing, and is unlikely to introduce infection into the wound.

There is a wide variety of healing times for piercings, which may not be completely healed for several months. Appropriate jewellery should always be worn in the piercing even when fully healed. Further advice should be obtained from the piercer or your doctor if removal of the jewellery is desired.

The following are indications of infection:

- prolonged redness and swelling (this may be normal in fresh piercings)
- sensation of heat at the site of the piercing
- pain, usually throbbing or spreading pain
- unusual discharge (yellow, green or grey pus).

In case of infection, consult your doctor as soon as possible.

APPENDIX 3: CONTINUING PROFESSIONAL DEVELOPMENT

Practitioners are responsible for ensuring that they give full attention to their own ongoing professional development by making a reasonable and realistic commitment to a range of continuing educational activities which can include:

- subscribing to, and reading relevant newsletters, journals and articles
- attending seminars, conferences, peer-group meetings and regional gatherings
- appreciating the need to collaborate in case studies, critical incident inquiry, service monitoring, audit studies, user focus groups and surveys.

Contacts

Association of Professional Piercers
PMB 286, 5446 Peachtree Industrial Boulevard, Chamblee, GA 30341, USA
E-mail: secretary@safepiercing.org

Association of Professional Tattoo Artists
157 Sidney Road, Muswell Hill, London N10 2NL
Tel: 020 8444 8779

British Tattoo Artists Federation
389 Cowley Road, Oxford OX4 2BS
Tel: 01865 716877

European Professional Piercers Association
201 Two Mile Road, Kingswood, Bristol BS15 1AZ
Tel: 0117 960 3923

Tattoo Club of Great Britain
389 Cowley Road, Oxford OX4 2BS
Tel: 01865 715253. Fax: 01865 775610
E-mail: tcgb@tattoo.co.uk

APPENDIX 4: SUPPORTING INFORMATION
Relevant legislation

Business operators should familiarise themselves with the following legislation:

- *Control of substances hazardous to health regulations 1999:* chemicals and biohazard substances, for example, disinfectants, body fluids, contaminated equipment and wastes, etc, shall be assessed in accordance with the requirements of these regulations (SI 1999/437 at the time of writing, but subject to regular update). The outcome of the risk assessment must be used to implement safe working practices.
- *Controlled waste regulations 1992:* requires that all clinical waste (used needles, soiled dressings, used swabs) is collected and disposed of by a licensed contractor in an approved incinerator.

- *Disability discrimination act 1995:* access should be provided for disabled people at the premises.
- *Electricity at work regulations 1989:* requires all portable electrical appliances used within the premises are to be maintained regularly.
- *Health and safety at work etc act 1974:* requires employers and self-employed people to ensure the health, safety and welfare of persons attending their businesses.
- *Management of health and safety at work regulations 1999:* the business operator shall carry out, and implement the findings of, a workplace risk assessment of the business. The outcome of the risk assessment must be used to implement safe working practices.
- *Provision and use of work equipment regulations 1998:* requires prevention or control of the risks to human health and safety from equipment used at work. Basically, work equipment must be suitable for its intended use; safe for use, maintained in a safe condition and, where necessary, inspected; only used by adequately informed, instructed and trained people; accompanied by suitable safety measures. The Regulations cover all equipment used by employees at work, regardless of whether it is supplied by the employer or employee. Powered equipment for use at work must have the 'CE marking', to demonstrate it conforms with relevant European safety standards.
- *Reporting of injuries, diseases, and dangerous occurrences regulations 1995:* requires employers to report certain categories of workplace accidents and serious incidents and infections which result from a work activity. The incident should be reported to the HSE's Incident Contact Centre, via the telephone (0845 300 9923) or fax (0845 300 9924), by post to Incident Contact Centre, Caerphilly Business Park, Caerphilly CF83 3GG, or e-mail to 'riddor@natbrit.com'. Further information is available on the website 'www.riddor.gov.uk'

Nuisance/complaints

The operator must ensure that there is no noise or other type of nuisance arising from the operation of the business.

Maintenance

All systems, for example, fire-safety equipment, boilers, electrical equipment, etc, housed in the premises must be maintained regularly by competent persons, and maintenance records kept.

All equipment used in connection with special treatments shall be serviced/maintained in accordance with the manufacturers/suppliers recommendations, and records kept.

Electricity

The business operator shall ensure that all portable electrical appliances used within the premises are checked regularly and maintained in accordance with the 'Electricity at work regulations 1989'; see 'Relevant legislation'. Records of maintenance checks must be available on the premises.

The business operator must also ensure that the fixed electrical installation is inspected by a competent electrical engineer, and that a copy of the current certificate is available at the premises.

Fire precautions

All fire exits, staircases and other means of escape must be kept unobstructed, immediately available, and clearly signed, in accordance with the council's requirements, and any requirements of the fire authority.

All fire-resistant and smoke-stop doors must be maintained self closing, and must not be secured open.

All exit doors must be available for access and egress whilst the public are on the premises.

A notice, or notices, reading 'No Smoking' should be prominently displayed within the treatment area.

APPENDIX 5: RECORD OF PRACTITIONERS

A record shall be kept of every practitioner as follows:

Name and address of establishment	
Tel no. of establishment	
Name of practitioner	
Address of practitioner	
Gender	
Home telephone number	
Mobile telephone number	
Exact duties	
Attach current passport photo	

APPENDIX 6: CONSENT FORM

Name of premises:

Address of premises:

Local authority registration no:

	✓ ✗ or n/a
I declare that I give (full name of client) my full consent to tattooing/body piercing. The information given below is true to the best of my knowledge. I have had/currently suffer from the following:	
Heart condition/pacemaker	
Epilepsy	
Haemophilia	
Hepatitis B or C	
Immuno-compromised	
Diabetes	
Skin condition; eg, psoriasis	

Best practice guidance
EAR PIERCING

Ear piercing by trained practitioners, in accordance with the practices described in this 'best practice guidance', is a low-risk procedure both for practitioners and their clients. The medical literature indicates an excellent health-and-safety record, justifying a distinct approach from other forms of body piercing.

This 'best practice guidance' permits piercing of the ear lobe and the flat part of the ear cartilage by trained workers, using proprietary ear-piercing systems and pre-sterilised jewellery of approved type.

The guidance is distinct from that offered on body art, which contains more detailed provisions on infection control and good practice. Similarly, it does not cover ear-piercing using needles or non-proprietary piercing systems and techniques.

SCOPE

For the purpose of this 'best practice guidance', ear piercing means the puncturing of the lobe or flat part of the ear cartilage using an ear-piercing system/instrument employing a pre-sterilised single-use stud and clasp which actually pierces the ear. Under no circumstances should ear-piercing studs and clasps be used anywhere on the body other than the outer perimeter and lobe of the ear.

Should business operators offer a service for piercing parts of the body other than the outer perimeter or lobe of the ear using any system, the 'best practice guidance' on body art will apply. Ear-piercers not using any of the approved instruments/systems to pierce the ear, should also be governed by the guidance on body art.

CONDUCT OF THE BUSINESS

The business operator should comply fully with this 'best practice guidance', and should follow the instructions of the manufacturer of the ear-piercing system. A record should be maintained of all staff competent to pierce ears in accordance with this guidance.

Anyone under 16 years of age should be accompanied by a parent/guardian who must sign a consent form; see Appendix 1.

Every client should read and sign a consent form, giving details of name, address, and age. These forms should be kept for a period of at least three years, and be available for inspection by an authorised officer (on presentation of written consent from the client), at all times. This allows alleged cases of infection to be studied epidemiologically with due urgency, and also enables checks to be carried out on clients' ages.

Users are to be given written information to take away about the risks of ear piercing, together with after-care advice; see Appendix 3. This should be noted on their record card, which they should sign and date.

All serious infections or complications resulting from any ear-piercing procedure, which occur within seven days of the ear piercing, and which become known to the operator should be reported (by the operator) to the local environmental health department. It is very important that clients suffering from an infection are also referred to their GP. There is no requirement to notify minor problems.

A notice should be conspicuously displayed near the ear-piercing station, giving the name, address, and phone number of the local health authority and environmental health department, so that the public can report complaints or seek additional information.

The operator must have public liability insurance cover.

RESPONSIBILITIES

The business operator must take all reasonably practicable precautions for the health and safety of employees and anyone visiting the premises. This includes providing training to ear-piercing practitioners; monitoring their performance to assure proper use, cleansing and storage of equipment; providing best advice and service to clients; and ensuring that ear-piercing instruments are stored in clean, fully-enclosed containers between uses.

RESPONSIBLE PERSON

The business operator must ensure that a 'responsible person' aged 18 years or more is in charge of the premises at all times during business hours. The responsible person must be familiar with, and implement, the requirements of the relevant 'best practice guidance'.

The responsible person must:

• be in charge of the premises

• be on site at all times when the public have access to the premises

• be assisted as necessary by suitable persons, aged 18 years or more, to ensure adequate supervision

• not be engaged in any other duties which will prevent him/her from exercising general supervision.

CLEANLINESS

For the purposes of cleanliness, the following points should be followed:

• all towels, materials and equipment used in the ear-piercing procedure must be appropriately cleaned, disinfected and/or sterilised

• ear-piercing instruments must be cleaned between uses, on each client, by thoroughly wiping down with an approved disinfectant immediately (for example, 70% alcohol)

• working surfaces of the ear-piercing station should be regularly wiped down with detergent and water, for example, once or twice a day, and should be thoroughly cleaned at the end of each working day

• there should be no smoking of cigarettes, etc before, during and after the ear-piercing procedure.

TRAINING/COMPETENCY

All persons carrying out ear-piercing ('practitioners') should be trained in the use of the relevant ear-piercing system, and must be able to demonstrate competency to the satisfaction of the local authority and/or the manufacturer of the system. The training should cover the following areas:

• the need for hygiene procedures

• cleaning routines

• provision of after-care advice to clients

• reporting procedures for incidents

• what to do in case of a failed piercing

• basic first-aid procedures, primarily in the areas of bleeding and fainting.

Novice ear piercers can learn how to pierce effectively by carefully following the instructions given by the manufacturers of approved instruments/systems.

Table 4. Choice of decontamination procedures

Agent	Preparation	Use
Hypochlorite (bleach)	Make up daily; dilute to 70% bleach/water	Cleaning up accidental blood spills
Benzalkonium chloride*	Do not dilute	Skin, ear-piercing instruments, table tops, metals
Chlorhexidine*	Do not dilute	Skin, ear-piercing instruments, table tops, metals
70% alcohol	Do not dilute	Skin, ear-piercing instruments, table tops, metals

* 70% alcoholic solutions only

PRACTITIONERS

Ear piercing should only be carried out by practitioners who satisfy the criteria for training and competency.

All practitioners should wear a badge clearly showing their name. The name should correspond with that shown on their record of training/competency.

EAR-PIERCING STATION

The ear-piercing station must be kept clean at all times. All furniture and fittings associated with the ear-piercing station should be covered with a smooth, impervious surface, to enable effective cleaning.

There must be suitable and sufficient sanitary accommodation for the operators.

There must be adequate clean and suitable storage for all ear-piercing material, so as to avoid, as far as possible, the risk of contamination.

Waste bins must be lined with a plastic liner.

TARIFF

A comprehensive tariff must be prominently displayed so that all persons entering the premises can easily see it.

RECORD KEEPING AND INFORMATION

A record must be kept on the premises of every ear-piercing practitioner, giving the following information:

- full name
- date of birth
- gender
- home address
- home/work telephone numbers
- exact duties

A copy of this 'best practice guidance' should be available on the premises.

REGISTRATION CERTIFICATE

The registration certificate issued by the local authority must be conspicuously exhibited at all times, and in such a way that it is clearly visible to all persons visiting the premises.

The certificate must be adequately protected against theft, vandalism or defacement.

EQUIPMENT REQUIRED

An ear-piercing system manufactured by one of the following companies:

- Blomdahl; via Poly (UK) Ltd
- Caress Manufacturing Ltd
- Coren; Dr Buylines
- Estelle ear-piercing system; Muller England Ltd
- Inverness (UK) Ltd
- Medisept (UK) Ltd
- Perfex or Caflon ear-piercing systems; Caflon (UK) Ltd
- Studex Manufacturing (UK) Ltd
- Trips sterile guard; H S Walsh & Sons Ltd
- VGK Cassette ear-piercing system; V G Keating Pty, South Africa

Only pre-sterilised single-use studs and clasps, taken from a previously-intact package, may be used to pierce ears.

Additional equipment

The following additional equipment is required:

- alcohol-based sterile cleaning swabs
- hand disinfectant containing chlorhexidine as an active ingredient
- marking pen or ink (recommend gentian violet ink)
- single-use disposable latex gloves.

HEALTH-AND-SAFETY PROTECTION
Hazards

The following hazards are recognised:

- infection of customer or operator due to faulty technique or dirty equipment
- contra–indications (eg, scar tissue, keloids) leading to medical complications
- damage to blood vessels, nerves, and tissues of the ear resulting in pain and/or scarring.

Anaesthetic

Use of local anaesthetic creams, gels, sprays, etc, is not recommended.

Ethyl chloride should not be used under any circumstances. It can have a damaging effect if too large a dose is administered and is a very flammable liquid.

Disinfectants

Disinfectants do not sterilise, they only reduce the number of some microbes. Disinfection is required for the ear-piercing instruments, tabletops, and general and working surfaces in the treatment area.

First aid

There must be a first-aid kit on site that complies with the 'Health and safety (first aid) regulations 1981', and it is recommended that at least one person on site holds an HSE approved 'basic first aid' qualification.

Ear-piercing practitioners must be trained in what to do in the event of dizziness and fainting after the ear-piercing procedure; complaints of pain and redness around the newly pierced ear, scratched face and/or nicked cheek; and failed piercing.

Such incidents should be reported to the 'responsible person', and written records kept of the episode.

Personal hygiene

Any person carrying out ear piercing must ensure that:

• any open boil, sore, cut or other open wound is effectively covered by an impermeable dressing

• ear piercing is not carried out if they are suffering from an acute respiratory infection

• hands are washed two/three times during each half-day, or that hands are scrubbed with chlorhexidine-containing surgical hand disinfectant

• a fresh set of latex gloves is worn before each ear-piercing procedure

• food or drink is not consumed during the course of the treatment

• no smoking takes place during the course of the treatment

However, if the ear stud needs adjustment, or if the pierced area is otherwise touched, hands must be washed and a fresh set of latex gloves must be worn by the ear-piercing practitioner for the adjustment procedure.

Infection control

The following precautions should be observed:

• all ear-piercing practitioners should wear clean, washable clothing

• hands and nails must be washed in soap and water or scrubbed with an approved surgical hand disinfectant prior to any procedures

• all work surfaces should be cleaned and disinfected at least daily

• all gowns, wraps or other protective clothing, paper or other covering, towel, cloth or other similar articles used for ear piercing must be clean, and in good repair

• the client's skin must always be appropriately cleansed using a skin-safe alcohol containing antiseptic solution prior to the ear piercing

• a 'no touch' technique (eg, using disposable gloves) should be used, as far as possible, to reduce the risk of infection.

Jewellery

Approved jewellery includes ear-piercing studs and clasps manufactured from hypo-allergenic material.

The ear-piercing studs and clasps must be pre-sterilised and stored in an intact manufacturer's package until the point of use.

Care must be taken not to contaminate sterile jewellery, for example by handling or by careless use of the sterile packs.

The post used for ear-piercing has a slightly larger diameter than a regular earring post. This is to allow for shrinkage that normally occurs during the healing process, thus facilitating an ample pathway for normal earrings.

HYGIENIC EAR-PIERCING PROCEDURE

The following procedures should be observed:

Cleanliness

• always work from a clean surface. Do not place open swabs or unpackaged sterile ear piercing cartridges directly onto the couch, linen, desk, etc

• explain the after-care procedure before piercing the ear; the client is more likely to pay full attention at this time

• wash your hands in hot soapy water, then dry them on a paper towel, or scrub hands with a surgical hand disinfectant

• wear single-use latex gloves

Consents

• ask the client to sign the consent form and after-care instructions (see 'Appendices 2 and 3'). If he/she is younger than 16 years old, the parent or guardian must sign the consent form in your presence, before the procedure takes place

• do not pierce anyone you suspect to be younger than 16 years old without the consent of their parent or guardian

Before piercing

• if the skin of piercing area is broken or covered with a rash, do not pierce

• check the ear for cysts or keloids by pinching the ear lobe and feeling for a hard lump that can be moved. You may pierce through scar tissue and around a keloid, but never through a keloid, as it may result in infection

• check that the size of the stud is suitable for the thickness of the ear lobe. Lobes more than 6mm thick need special care, as there is risk of compression and swelling from using studs which are too short. In such circumstances, use a 'long post' stud.

Piercing

• if marking points on the ear with a pen, always use water-soluble ink. Check that the customer is happy with the positioning

• if the client is a child under seven years of age, only pierce through the centre of the lobe to allow for future growth of the ear. Make sure you have the parent's written consent

• if more than one hole is required in the same ear, make sure the piercings are at least 9mm apart

• do not perform more than two piercings per ear in one session

• move hair away from the ear, using a hair clip if necessary, and remove any existing earrings

• clean the precise area to be pierced, front and back, with an alcohol-based sterile swab, and allow to dry

• piercings through the cartilage must be carried out through the flat part of the ear

• check carefully that the stud package has not been damaged

• seat one of the cartridges in the instrument, taking care not to touch any of the sterile parts with your fingers

• carefully ensure the piercing is at right-angles to the ear

• if you inadvertently drop the stud or butterfly, discard it and start again.

Afterwards

• keep the client seated for a few minutes and explain the after-care instructions again

• clean the ear-piercing gun according to manufacturers' instructions.

WASTE STORAGE

Waste materials that have come into contact with bodily fluids must be bagged separately from regular commercial waste and special arrangements made for their collection and disposal.

LOCAL AUTHORITY AUTHORISED OFFICERS

Authorised officers carry written authorisations and proof of identity, which they will produce on request. They must be admitted during opening hours, and at any other reasonable time, to all parts of the premises. An officer may be accompanied by anyone else who is deemed necessary for the purposes of the inspection, for example, a medical practitioner.

APPENDICES

APPENDIX 1: CLIENT CONSENT FORM

The recommended format for client consent forms is as follows:

Name of business:

Address of premises:

	✓ ✗ or n/a
I declare that: (initial) I am over 16 years old	
I am aware that ear-piercing may carry a health risk due to ineffective hygiene and after-care	
I have been given after-care instructions and understand the need to follow them carefully	
I am aware that piercing of the cartilage may carry a greater degree of risk of redness, swelling and infection if the after-care instructions are not carefully followed	
am aware that I should consult my doctor as soon as possible if redness, swelling and infection occurs.	
Should a problem occur, I should not remove the piercing stud until I have consulted with my GP	
Signature (if under 16 years, parent's or guardian's signature required)	Date

APPENDIX 2: RECORD OF TRAINED EAR PIERCERS

A record shall be kept of every practitioner, including the name and address of the of practitioner; his/her home and/or mobile telephone number; the name and address of the establishment; and the telephone number of establishment

APPENDIX 3: AFTER-CARE ADVICE

The customer should be informed as follows:

The aim of after-care advice is to ensure the piercing heals quickly, while minimising the risk of infection. Minor pain and/or redness is normal immediately after the ear-piercing.

• the jewellery or piercing should not be touched for at least 48 hours

• after 48 hours, jewellery should be turned twice a day with clean hands

• hands should be washed with soap and water or scrubbed with a surgical hand disinfectant before touching jewellery

• the wound should not be covered, and access to air should be allowed. The aim is to keep the piercing dry, as far as possible

• bathing and showering is permitted, but otherwise keep the pierced area dry. Gently use clean tissue to dry the area of the piercing after a bath or shower

• perfume, hair gel, aftershave and cosmetics should be kept well away from the newly-pierced ear.

The healing period for an ear lobe is at least six weeks, for cartilage, at least eight weeks:

• the piercing studs must stay in place for six weeks, after which other post earrings may be worn. Post earrings must be worn for five to six months to ensure the hole does not close or shrink

• fish hook style or wire-style earrings should not be worn for at least six months, to avoid risk of accidental damage to the piercing

• the family doctor should be consulted if pain, swelling and redness does not improve within 24 hours

• the jewellery should not be removed if pain or swelling occurs in the pierced area, but medical advice should be sought immediately

• for cartilage piercing, extra careful aftercare is necessary and any unexpected or continuing pain or redness should be reported immediately to a doctor.

The above instructions should also be in a leaflet for the customer. Be sure the customer retains a copy of these after-care instructions.

APPENDIX 4: SUPPORTING INFORMATION
Relevant legislation

Business operators should familiarise themselves with the following legislation:

• *Control of substances hazardous to health regulations 1999:* chemicals and biohazard substances, for example, disinfectants, body fluids, contaminated equipment and wastes, etc, shall be assessed in accordance with the requirements of these regulations (SI 1999/437 at the time of writing, but subject to regular update). The outcome of the risk assessment must be used to implement safe working practices.

• *Controlled waste regulations 1992:* requires that all clinical waste (used needles, soiled dressings, used swabs) is collected and disposed of by a licensed contractor in an approved incinerator.

• *Disability discrimination act 1995:* access should be provided for disabled people at the premises.

• *Electricity at work regulations 1989:* requires all portable electrical appliances used within the premises are to be maintained regularly.

• *Health and safety at work etc act 1974:* requires employers and self-employed people to ensure the health, safety and welfare of persons attending their businesses.

• *Management of health and safety at work regulations 1999:* the business operator shall carry out, and implement the findings of, a workplace risk assessment of the business. The outcome of the risk assessment must be used to implement safe working practices.

• *Provision and use of work equipment regulations 1998:* requires prevention or control of the risks to human health and safety from equipment used at work. Basically, work equipment must be suitable for its intended use; safe for use, maintained in a safe condition and, where necessary, inspected; only used by adequately informed, instructed and trained people; accompanied by suitable safety measures. The Regulations cover all equipment used by employees at work, regardless of whether it is supplied by the employer or employee. Powered equipment for use at work must have the 'CE marking', to demonstrate it conforms with relevant European safety standards.

• *Reporting of injuries, diseases, and dangerous occurrences regulations 1995:* requires employers to report certain categories of workplace accidents and serious incidents and infections which result from a work activity. The incident should be reported to the HSE's Incident Contact Centre, via the telephone (0845 300 9923) or fax (0845 300 9924), by post to Incident Contact Centre, Caerphilly Business Park, Caerphilly CF83 3GG, or e-mail to 'riddor@natbrit.com'. Further information is available on the website 'www.riddor.gov.uk'

Nuisance/complaints

The operator must ensure that there is no noise or other type of nuisance arising from the operation of the business.

Maintenance

All systems, for example, fire-safety equipment, boilers, electrical equipment, etc, housed in the premises must be maintained regularly by competent persons, and maintenance records kept.

All equipment used in connection with special treatments shall be serviced/maintained in accordance with the manufacturers/suppliers recommendations, and records kept.

Electricity

The business operator shall ensure that all portable electrical appliances used within the premises are checked regularly and maintained in accordance with the 'Electricity at work regulations 1989'; see 'Relevant legislation'. Records of maintenance checks must be available on the premises.

The business operator must also ensure that the fixed electrical installation is inspected by a competent electrical engineer, and that a copy of the current certificate is available at the premises.

Fire precautions

All fire exits, staircases and other means of escape must be kept unobstructed, immediately available, and clearly signed, in accordance with the council's requirements, and any requirements of the fire authority.

All fire-resistant and smoke-stop doors must be maintained self closing, and must not be secured open.

All exit doors must be available for access and egress whilst the public are on the premises.

A notice, or notices, reading 'No Smoking' should be prominently displayed within the treatment area.

Best practice guidance
ACUPUNCTURE

This guidance deals with acupuncture for therapeutic and cosmetic purposes, and includes the practice of marma puncture.

Registered medical practitioners or dentists, and practitioners of professions supplementary to medicine, who perform any of these procedures as part of recognised patient treatment are exempt from this best practice guidance. Such practitioners are bound by the codes of conduct of their professional bodies.

The British Medical Association recommends that acupuncturists do not alter the instructions or prescriptions given by a patient's medical practitioner without prior consultation and agreement with that doctor.

SCOPE
Acupuncture

Acupuncture is a system of healing which has been practised for thousands of years, and focuses on improving the overall well-being of the patient rather than the isolated treatment of specific symptoms. A variety of methods are used to stimulate acupuncture points. Usually needles are used, but electricity, magnetism, and heat may also be applied. A typical course of treatment for a chronic condition would be six to 12 sessions over a three-month period.

Acupuncture stimulates the body's own healing response. Conditions treated include physical and emotional ailments, and addictions such as smoking, alcohol and obesity. It can also be given for pain relief and is a technique used by midwives, obstetricians, orthopaedic specialists, physiotherapists and sports injury therapists.

The same conditions are treated by the various types of acupuncture, described below.

Auricular acupuncture

This was developed during the 1950s. All the body parts are mapped out on the ear, where acupuncture techniques are administered. Sometimes an 'indwelling needle' (it looks like a stud earring) is left in place for self-therapy, as well as for pain relief.

Electro acupuncture

This involves electrical stimulation of needles during acupuncture. The technique is used in both Western acupuncture, as well as traditional Chinese medicine (TCM).

Marma puncture

An element of Ayurveda (see 'Glossary'), a holistic therapy which involves skin piercing in a similar way to acupuncture. The same infection control standards shall apply as to acupuncturists.

Moxibustion

Moxibustion is the process of applying heat during acupuncture, using a 'moxa', a slow-burning substance produced from mugwort (*Artemisia vulgaris*) which is said to intensify and speed up the effects of acupuncture. The herbal product is burnt just above the surface of the skin.

Trigger point acupuncture

This is the application of acupuncture needles to the site of pain (trigger points).

Periosteal acupuncture

This is the deeper insertion of acupuncture needles, so that the tip of the needle touches the covering of the bone (the periosteum).

CONDUCT OF THE BUSINESS

The business operator should ensure full compliance of acupuncturists with the current edition of the British Acupuncture Council's Code of practice, and Code of ethics.

RESPONSIBILITIES

The responsibilities of the business operator include:

* taking all reasonable precautions for the safety of employees and clients using the premises

* carrying out a health-and-safety risk assessment of the business and implementing the findings, as required by the 'Management of health and safety at work regulations 1999'

* ensuring that a 'responsible person' (see 'Responsible person', below) is in charge of the premises at all times, and that they are familiar with, and implement, the requirements of the relevant codes of practice

* ensuring that all persons practising acupuncture are suitably qualified or trained, and are competent

* notifying the local authority in writing of any proposed change in his/her name or private address, of changes in the business address, or substantial changes in the nature of the treatments or procedures carried out on the premises.

RESPONSIBLE PERSON

The business operator should ensure that a responsible person is nominated, in writing, by the business operator, and this notification should be continuously available for inspection at the premises.

The responsible person must:

* be in charge of the premises, and be on site at all times when the public have access to the premises

* not be engaged in any other duties which prevent them from exercising effective supervision

* be assisted, where necessary, by suitable adult persons to ensure adequate supervision of the business.

PRACTITIONERS

Business operators shall implement the following points:

* acupuncture may only be given by practitioners who meet the criteria for training and competency (see 'Training', below)

* precautions should be taken against cross infection, especially in regard to avoiding contact with body fluids and cleaning-up spillages of blood, etc (see 'Appendix 1')

* it is recommended that acupuncturists and their staff involved in handling skin penetration instruments and equipment be vaccinated against Hepatitis B, and produce a medical certificate to that effect (see 'Appendix 6').

Table 5. Choice of decontamination procedures

Agent	Preparation	Use
Hypochlorite (bleach)	Make up daily; dilute to 30% bleach, 70% water	Corrodes metal. Excellent for other materials and for cleaning up accidental blood spills
70% alcohol	Do not dilute	Preparation on intact skin, and wiping table tops, metals, etc (not needles)
Liquid detergent	Dilute with hot water for each use. For handwashing, apply direct from a dispenser	Wiping down surfaces. Handwashing before and after a procedure

TRAINING/COMPETENCY

Business operators should be aware of the following:

- all persons practising acupuncture must successfully complete a relevant course and must be registered with a professional association (see 'Appendix 6')

- practitioners must demonstrate continuing professional development (see 'Appendix 4')

- full records must be kept on the premises of all practitioners' qualifications, courses attended (with dates, and the titles of the courses, and the venue). These details must be available for inspection at all times

- acupuncture must not be undertaken by anyone under the age of 18 years.

HAZARDS

- needle-stick injury. This is one of the most common causes of cross infection - practitioners must never test a needle for sharpness against their own skin. Use of re-usable needle-guide tubes is not recommended. Note that some single-use acupuncture needles are supplied complete in the sterile wrapping with a plastic guide tube ready for use; these are acceptable as there is no enhanced risk of needle-stick injury

- cross-infection

- trauma

- metal allergy

- forgotten needles

- transient abnormally-low blood pressure

- burn injury, such as caused by moxibustion

- ecchymosis (purple discoloration of the skin caused by passage of blood from ruptured blood vessels into subcutaneous tissue)

- over stimulation during electro-acupuncture may cause pain and burning

- malpractice leading to misdiagnosis or failure to refer or explain precautions.

INFECTION CONTROL

Detailed information on this topic is given in the 'Guide to infection control'. To avoid the dangers of cross infection:

- all gowns, wraps or other protective clothing, paper or other covering, towel, cloth, or other such articles used in treatment, must be clean, in good repair, and so far as is appropriate, sterile

- hands and nails must be washed in liquid detergent or anti-bacterial hand-wash prior to any treatment

- all hard surfaces should be cleaned and disinfected before and after each client (see 'Disinfectants')

- the skin in the area of needling must be cleansed with a skin preparation solution (for example, 70% alcohol) prior to treatment; single-use swabs are a convenient and hygienic means of complying with this requirement

- a 'no touch' needling technique should be used as far as practicable. The acupuncture needle should be held as far away from the tip as possible, while affording adequate control of the needle. The needle may be supported by the fingers only when using single-use gloves

- single-use needles are recommended. They should be disposed of immediately after use to a 'sharps' container complying with BS 7320

- re-usable needles are to be ultrasonically cleaned and autoclaved before re-use (see the guide to 'Infection control', for more details on procedure)

- immediately after the procedure, acupuncturists should wash their hands and wrists with liquid detergent and hot water, and dry with clean disposable paper towel.

There is disagreement over the need for routine use of disposable gloves by acupuncturists. The British Acupuncture Council, the British Medical Acupuncture Society and the Acupuncture Association of Chartered Physiotherapists take the view that: 'acupuncture safety is comprehensively dealt with in the respective safety guidelines of the above organisations who are the major providers of acupuncture in the UK. Contra-indications and precautions are listed and explained, from the perspective of both the patient and the therapist and deal with the possible problem of infection'.

There has been recent discussion as to whether disposable gloves should be worn when giving acupuncture treatment and this has not been included in any of the guidelines for the following reasons:

- it would not be of any additional benefit to the patient since correct acupuncture technique requires the use of sterile, single-use, disposable needles. The portion of the shaft of the needle likely to enter the patient should not be handled in any way when treatment is given

- use of cotton wool or an insertion tube only reinforces this lack of contact

- this type of technique is taught to all members of the three organisations

- it would not be of any additional benefit to the therapist, to whom the only risk lies in the possibility of needle-stick injury through careless handling of the needle. Gloves will not prevent this

- it is clearly indicated in the guidelines that any open areas of skin, which might come into contact with the body fluids of the patient, must be covered by sticking plaster before undertaking treatment

- in any case, all handling of contaminated needles is kept to an absolute minimum by the placing a 'sharps' disposal box beside the patient

- accuracy and skin and needle 'feel' would be seriously compromised by the use of gloves

- nervous patients could be made more anxious unnecessarily by the use of gloves'.

DISINFECTANTS

Disinfectants do not sterilise, they only reduce the number of some microbes to safer levels. Disinfection is required for table tops/general surfaces in the treatment area, and also for needles and other contaminated equipment and materials prior to disposal.

Sterilisation, the destruction of all microbes, is achieved by heating in an autoclave; see the guide on 'Infection control'. Glass bead sterilisers are no longer recommended for use.

STERILISATION

Details of good procedure are given in the guide to 'Infection control'.

Acupuncture needles, and utensils (eg, trays, dishes, etc) which come into contact with them, must be sterilised immediately before use. To sterilise such equipment, use an autoclave complying with BS 3970:Part 4:1990 'Sterilizing and disinfecting equipment for medical products: specification for transportable steam sterilizers for unwrapped instruments and utensils'.

Glass bead sterilisers may sterilise articles unreliably, owing to their method of operation. They have limited capability to deal with larger instruments, and their use is not recommended.

CLEANLINESS

To aid cleanliness the following points must be adhered to:

• all instruments, towels, materials and equipment used in the premises must be appropriately cleaned, disinfected and/or sterilised

• tables, couches and seats must be wiped down with a suitable disinfectant between the treatment of each client, and thoroughly cleaned at the end of each working day

• tables or couches must be covered with a disposable paper sheet, which should be changed for each client

• there should be no smoking in the treatment area(s).

PERSONAL HYGIENE

Any person carrying out acupuncture must ensure:

• any open boil, sore, cut or other open wound is effectively covered by an impermeable dressing

• they do not carry out acupuncture procedures if there is a likelihood of contamination of equipment, supplies or working surfaces with body substances or pathogenic organisms

• hands are kept clean and are washed immediately prior to carrying out any treatment

• he/she shall refrain from smoking or consuming food and drink during the course of the treatment.

EQUIPMENT REQUIRED FOR HYGIENIC PRACTICE

• alcohol impregnated swabs (pre-packed) or cotton wool swabs and 70% alcohol (BPC)

• disinfectants

• single-use pre-sterilised solid needles are recommended.

• autoclave complying with BS 3970:Part 4:1990 (where re-usable needles are in use)

• kidney-dish (autoclavable container for needles)

• single-use paper towels and tissues

• 'sharps' container complying with BS 7320:1990 'Specification for sharps containers for disposal of needles'.

HYGIENIC PROCEDURE

• always work from a clean surface. Do not place swabs or needles directly onto the couch, linen, desk, etc

• wash your hands with liquid detergent and hot running water; dry with paper towel

• if the client's skin is visibly dirty, wash with liquid soap or detergent and water, dry with clean paper towel, then swab with 70% alcohol and allow to dry

• a new alcohol swab should be used for each separate area of the body (eg, back and leg)

• after cleaning the acupuncture point, do not palpate unless it is cleaned again afterwards. Once a point has been pierced, do not re-palpate with a bare finger during that treatment session

• areas of the body where moisture or exudations may collect, such as the groin and genital area, ears, feet, under arms and the area below the breasts, should be swabbed with alcohol before needling

• do not touch the shaft of the needle; if necessary, support the needle with fingers protected by single-use gloves or a fresh wad of cotton wool

• the needle point must never be touched, and should be applied to the patient's skin before any guidance by the fingers. It is of the utmost importance that the tip of the needle is not guided through fingers held together above the skin

• if marking acupuncture points on the skin, always use water-soluble ink. Never use the pen on or near a point that has already been needled

• if applying moxa, use a swab or cotton wool moistened with clean water to moisten the skin beforehand. Always swab after applying moxa and before needling

• if the needle is to be left in place for more than one hour, wipe the skin with a solution of chlorhexidine in alcohol before inserting the needle

• to avoid causing local infection, do not needle directly on or near a pimple, sore or wound. Treat on the unaffected side of the body only

• if you inadvertently draw blood when needling, apply light to moderate pressure to the area with a clean swab (never use the bare finger for this). Continue with a new needle

• if 'sealing' the point afterwards, do this with a clean swab and never with a bare finger

• if patients are left alone with needles in-situ during a treatment, they must be cautioned about any movement that might bend or damage a needle

• if moxa is used on a needle in situ, the practitioner or other qualified person must remain with the patient at all times to avoid any risk of burn injury.

NEEDLES

The following points should be noted regarding the use of acupuncture needles:

• needles must be sterile before each use; disposable pre-sterilised solid needles are recommended. The packet should be opened in the patient's presence, used for one treatment only, and then discarded to a 'sharps' container

• re-usable needles must be sterilised by autoclave after each use. Plum Blossom needles (Seven Star Hammers), whether plastic or stainless steel, must be autoclaved after each use, or disposed of to a 'sharps' container

• as many reusable needles as are required for one day can be estimated and sterilised in advance, then kept in a sterile container until needed

• utensils used to contain or handle the needles - such as dishes, forceps, containers used for storing needles - must be sterile at the beginning of each session. These can be sterilised at the same time as each new batch of re-usable needles.

The practitioner should never continue to use a needle on a patient that may have penetrated the practitioner's skin.

CONTRA-INDICATIONS

The operator shall discuss the client's medical history and ask whether he has suffered from the following:

- conditions requiring concurrent drug treatments, such as antihistamines, which often have a depressant effect on the brain, steroids and aspirin

- haemorrhaging/haemophilia

- heart disease/pacemaker

- high blood pressure

- implants as a result of surgery/artificial joints

- radiotherapy

- immuno-compromised condition

- seizures; eg, epilepsy

- conditions requiring surgical procedures (which may alter the anatomical landmarks used by the acupuncturist to accurately identify the points for treatment).

Where any of the above conditions exist, or there is a past history, written authorisation from the client's doctor is required before the procedure can continue.

ANAESTHETICS

Administering of local anaesthetic creams, gels, sprays, etc, is not recommended. Prescription-only topical creams (such as EMLA) should not be administered.

Ethyl chloride should not be used under any circumstances, as there is an appreciable risk due to flammability, cryogenic properties (frostbite) and respiratory sensitisation.

The administering of local anaesthetic by injection, other than by a registered medical practitioner, is an offence under the 'Medicines act 1968'.

PREMISES

The following points should be observed:

- all internal walls, doors, windows, partitions, floors and floor coverings, and ceilings, should be kept clean and in such good repair as to enable them to be effectively cleaned

- the treatment area should be solely used for giving treatment, and must be completely separated from all other rooms (such as any room used for human habitation, catering establishment, hair salon, retail sales or other) by full-height walls or partitions

- effective pest control measures, such as pest proofing, and appropriate treatments must be carried out, as necessary, and proper records kept

- the floor of the treatment area must have a smooth, impervious surface

- there should be a minimum of 5m² of floor space for each operator in the establishment

- no animals of any kind should be allowed in an acupuncture establishment, except service animals used by persons with disabilities; eg, guide dog for the blind. Fish aquariums may be allowed in waiting rooms and non-procedural areas

- all furniture and fittings in the premises must be kept clean. Furniture in the treatment area (such as tables, couches and seats) must be covered with a smooth, impervious surface, so that they can be effectively cleaned

- there must be an adequate, constant supply of clean hot and cold water at a wash hand basin, liquid soap or detergent, and disposable towels, which is conveniently accessible to the practitioner and for his sole use. The taps should preferably be arm- or foot-operated

- there should be suitable and sufficient sanitary accommodation for operators and clients

- there should be adequate clean and suitable storage for all items, so as to avoid, as far as possible, the risk of contamination

- suitable and sufficient means of heating to a reasonable room temperature (16°C minimum), appropriate to the treatment provided must be provided

- suitable screening to provide privacy should be available

- adequate artificial lighting must be provided and maintained. A suitable overall standard of lighting would be 500 lux, with a higher level of 1,000 lux in all areas of the treatment room during the acupuncture procedure

- the premises must be effectively ventilated.

RECORD KEEPING/INFORMATION

A record should be kept of every practitioner, including full names and exact duties, date of birth, gender, home address, home/work telephone numbers, and identification photos. See 'Appendix 8'.

A record should be kept of the establishment, including name and address, hours of operation, and owner's name and address

The following should also be noted:

- a copy of this 'Best practice guidance' should be kept on public display

- clients must be over the age of 18 years

- anyone under 18 years of age must be accompanied by a parent/guardian who should sign a consent form

- every client must read and sign a consent form, which contains details of name, address, age, medical history, etc. An example is attached in 'Appendix 9'. These forms must be kept for a period of at least three years after the cessation of current treatment, and should be available for inspection at all times so that alleged cases of infection can be epidemiologically studied with due urgency, as well as conducting checks on the ages of clients

- confidential records should be maintained for all treatments, giving name, address, date and type of treatment received, for a period of at least three years after the treatment has finished. They must be made available to the authorised officer upon request, and with the written consent of the client

- any contra-indications; eg, heart conditions (such as a pacemaker), diabetes, epilepsy, etc, for each treatment must be discussed with the client prior to any treatment

- users should be given written information to take away about the contra-indications and risks of acupuncture, together with aftercare advice (see 'Appendix 3'). This should be noted on their record card, which they shall sign and date

- a notice must be prominently displayed giving the name, address, and phone number of the local health authority and environmental health department, so that the public can report complaints or seek additional information

- all infections and complications thought to result from an acupuncture procedure that become known to the operator must be reported to the local environmental health department within 24 hours.

FIRST AID

There must be a first-aid kit on site that complies with the 'Health and safety (first aid) regulations 1981'. There are no specific mandatory items which must be included in a first aid box.

The Health and Safety Executive has issued a recommended list of contents. Where the risk assessment as revealed no special hazards, a minimum stock of first-aid items includes:

- a leaflet giving general guidance on first aid (eg, HSE leaflet, 'Basic advice on first aid at work')

- 20 individually-wrapped sterile adhesive dressings (assorted sizes) appropriate to the type of work

- two sterile eye pads

- four individually-wrapped triangular bandages

- six safety pins

- six medium-sized, individually-wrapped, sterile, unmedicated wound dressings (approximately 120x120mm)

- two large sterile individually-wrapped unmedicated wound dressings (approximately 180x180mm)

- one pair of single-use disposable gloves.

First-aid kits for travelling acupuncturists (ie, staff who frequently carry out domiciliary visits) would typically contain:

- a leaflet giving general guidance on first aid (eg, HSE leaflet 'Basic advice on first aid at work')

- six individually-wrapped sterile adhesive dressings

- one large sterile individually-wrapped unmedicated wound dressing (approximately 180x180mm)

- two triangular bandages

- two safety pins

- individually-wrapped moist cleansing wipes

- one pair of single-use disposable gloves.

WASTE STORAGE

Detailed information on waste storage and disposal in the guide to 'Waste'. To take care of waste properly:

- all waste should be stored in covered receptacles and suitable arrangements should be made for its proper disposal

- there must be separation between non-hazardous commercial waste and clinical waste

- a contract should be arranged with a registered waste carrier to remove and dispose of clinical waste

- clinical waste should be stored in a yellow plastic sack, clearly marked 'Biohazard: clinical waste only to be incinerated'

- a copy of the current contract for the removal of such clinical waste, and contractor's licence and transfer notes, should be available for inspection on the premises at all times

- the clinical waste bags and 'sharps' containers shall be stored in a secure place while awaiting collection.

TARIFF

A comprehensive tariff should be prominently displayed which can be easily seen by all persons entering the premises.

REGISTRATION CERTIFICATE

The registration certificate should be conspicuously exhibited in the practice reception area. It must be clearly visible by all persons using the premises.

INSURANCE

The business must have third party liability cover to insure claims for damages or negligence, as well as employer's liability insurance where appropriate.

LOCAL AUTHORITY AUTHORISED OFFICERS

Authorised officers carry written authorisations and proof of identity, which they will produce on request. They must be admitted during opening hours, and at any other reasonable time, to all parts of the premises. An officer may be accompanied by anyone else who is deemed necessary for the purposes of the inspection, for example, a medical practitioner or other specialist practitioner.

APPENDICES

APPENDIX 1: VIRAL HEPATITIS

Viral hepatitis is caused by several distinct viruses of which hepatitis A, B and C are the most common and well known.

Hepatitis A

This was formerly known as infectious hepatitis. It is normally transmitted by the faecal-oral route, and is rarely transmitted by blood. It has an incubation period of about four weeks, and is a common infection in conditions of poor hygiene and sanitation or overcrowding.

Certain foodstuffs, notably shellfish, are also linked with this infection.

Hepatitis B

This is spread by contact via infected blood and body fluids.

The virus infects either by penetration of the skin via infected needles, razors, etc, or contact with broken skin from contaminated apparatus or surfaces. It has an incubation period of six weeks to six months.

Hepatitis B is extremely infectious; a small pinprick with a contaminated instrument is sufficient to transmit infection. Blood does not need to be visible on an instrument for it to be capable of infection.

The disease can cause cancer of the liver, and has a significant mortality rate. It may also lead to a chronic carrier state, often with a fatal outcome. Absence of a history of hepatitis in a client will not guarantee no risk to the practitioner, because of the possibility of the symptomless carrier state.

Acupuncturists must have a high standard of infection control technique to ensure that there is no danger of passing on infection.

Hepatitis C

This is a recently-described virus which, like hepatitis B, causes serious liver disease. It is also transmitted by blood, and infection can be avoided by using the same procedures as those used for hepatitis B.

APPENDIX 2: AIDS/HIV INFECTION

AIDS (acquired immune deficiency syndrome) or HIV infection results from the transfer of the HIV virus in the blood or serum of an HIV infected person. AIDS is the advanced form of HIV infection, when the virus severely damages the body's natural defence system. The body is then susceptible to other serious infections and cancers which may prove life threatening.

The risk arises from the accidental inoculation or contamination of a cut or abrasion with the blood or body fluids of an infected person. This can happen (for example) in acupuncture, through an HIV contaminated needle, the source being either a patient or the acupuncturist. Thus infection control is highly important, both of the hygienic practices of the acupuncturist, and the effective sterilisation of needles and equipment.

The HIV virus is not very robust and does not survive for long in the open. It cannot withstand heat or the recommended disinfectants. The same precautions of disinfection and sterilisation (in combination) which are used to combat hepatitis B (which is a more robust virus), are sufficient to prevent the spread of HIV infection.

Practical implications

The following precautions shall be noted:

- cover exposed cuts and abrasions, especially on the hands, with waterproof dressings
- take care to prevent puncture wounds, cuts and abrasions from used needles, razors or glassware. If such an accident does occur, treat immediately by encouraging bleeding and liberally washing with soap and water
- record any puncture wound or contamination of broken skin, mouth or eyes
- never use needles, equipment, instruments etc. on more than one client, unless sterilised between clients
- never use unsterilised needles on any client.

In the event of a needle-stick injury, the following procedure should be followed:

- encourage the puncture to bleed
- wash under cold running water, without soap
- cover with a dry dressing
- seek medical advice as soon as possible (preferably within one hour) at the accident and emergency department of the local hospital - a protective injection can be given against hepatitis B (but not hepatitis C). This must be done within 48 hours of the injury taking place. Treatment is also available to minimise risk of infection by HIV
- record any puncture wound or contamination of broken skin, mouth or eyes and report the incident to the employer (if applicable)
- the employer must record the details and investigate the incident to find out how it could have been prevented.

If you believe you have HIV infection (or hepatitis) it is recommended that you seek advice from a specialist public health doctor before continuing to practice as an acupuncturist. Further information should first be sought from your doctor, or one of the specialist AIDS information services.

APPENDIX 3: CONTRA-INDICATIONS AND AFTERCARE ADVICE
Contra-indications

- allergic reaction to antiseptics
- blood poisoning (septicaemia)
- localised infection and conditions, eg: sepsis or arthritis
- localised severe swelling and trauma around the needling site
- scarring.

Aftercare

Ensure that the needle sites are kept clean, and if blood is drawn, the site should be covered with a plaster.

APPENDIX 4: CONTINUING PROFESSIONAL DEVELOPMENT

Practitioners are responsible for ensuring that they give full attention to their own ongoing professional development by making a reasonable and realistic commitment to a range of continuing educational activities which can include:

- subscribing to and reading relevant newsletters, journals and articles
- attending seminars, conferences, peer group meetings and regional gatherings
- appreciating the need to collaborate in case studies, critical incident inquiry, service monitoring, audit studies, user focus groups and surveys.

APPENDIX 5: MOBILE ACUPUNCTURISTS/HOME VISITS

Acupuncturists who have a mobile practice should observe the following points:

- they have at least one room or office containing adequate facilities for sterilising equipment, the cleaning and disinfection of equipment, the storage of clean or sterile equipment, and temporary storage of soiled equipment and clinical waste

- this room or office, and all equipment must conform to the standards laid down in this best practice guidance, and relevant legislation

- the container(s) used to transport equipment from the base premises to the treatment site should be of sufficient size and design to store all the equipment needed, personal overclothing, and have sufficient space to ensure separation of sterile and soiled equipment

- the container(s) should be lockable and airtight when shut. Their internal and external surfaces should be smooth, impervious, and capable of being frequently and effectively cleaned and disinfected.

TREATMENT

At a patient's home the acupuncturist should ensure the following:

- treatment should be carried out in a well-lit, clean room with ready access to a wash hand basin

- antiseptic hand wash and disposable towels should be used, as well as clean, disposable coverings for the bed/couch

- pre-sterilised needles must be stored in suitable clean paper bags or other suitable, sterile box or container

- pre-sterilised needles shall be clearly marked as such

- a 'sharps' container should be used for disposable needles

- containers must be available to carry used (but re-usable) needles back to the base premises

- all other soiled items, whether disposable or reusable, must be placed into suitable polythene bags or containers, and removed from the patient's premises.

APPENDIX 6: RECOGNISED ASSOCIATIONS

British Acupuncture Council (BAcC)
63 Jeddo Road, London W12 9HQ
Tel: 020-8735 0400. Fax: 020-8735 0404
E-mail: info@acupuncture.org.uk

The British Acupuncture Council was formed in 1995 by the amalgamation of five separate organisations whose membership agreed that a single body should represent and govern its professionally qualified acupuncturists. The Council will become a statutory self-regulating body for acupuncture practitioners.

BAcC members have completed training of at least three years in traditional acupuncture and western medical sciences appropriate to the practice of acupuncture. They carry the letters MBAcC after their name. The BAcC maintains common standards of education, ethics, discipline and practice to ensure the health and safety of the public at all times. Members are covered by medical malpractice and public liability insurance.

The BAcC does not accept practitioners who have undertaken short weekend courses, regardless of or their other qualifications prior western medical training.

Relevant training bodies

Courses recommended by the BAcC are those offered by schools or colleges who have undergone the Accreditation process of the British Acupuncture Accreditation Board (BAAB), an independent body closely allied to the British Acupuncture Council. For further information about the work of the Board, they can be contacted on 020-8735 0466, or fax on 020-8735 0477.

The institutions listed below hold Accredited or Candidate status from the Board. Specific information about each college may be obtained by contacting the college directly.

Accredited colleges

Centre for Community Care & Primary Health Traditional Chinese Medicine
University of Westminster, 115 New Cavendish Street, London W1M 8JS
Tel: 020-7911 5000 ext 3776, or 020-7911 5066
Website: www.westminster.ac.uk

College of Integrated Chinese Medicine
19 Castle Street, Reading RG1 7SB
Tel: 0118 950 8880
Website: www.cicm.org.uk

College of Traditional Acupuncture (UK)
Tao e, Queensway, Royal Leamington Spa, Warwickshire CV31 3LZ
Tel: 01926-422121
Website: www.acupuncture-coll.ac.uk

International College of Oriental Medicine UK
Green Hedges House, Green Hedges Avenue, East Grinstead, West Sussex RH19 1DZ
Tel: 01342 313106
Website: www.orientalmed.ac.uk

London College of Traditional Acupuncture
HR House, 447 High Road, London N12 0AZ
Tel: 020-8371 0820
Website: www.lcta.com

Northern College of Acupuncture
124 Acomb Road, York YO2 4EY
Tel: 01904 785120 or 784828
Website: www.chinese-medicine.co.uk

Candidate college

School of Five Element Acupuncture
13 Mandela Street, London NW1 0DU
Tel: 020-7383 5553
Website: www.sofea.co.uk

Other contacts

Acupuncture Association of Chartered Physiotherapists Secretariat
Mere Complementary Practice, Castle Street, Mere, Wiltshire BA12 6JE
E-mail: sec@aacp.uk.com
Website: www.aacp.uk.com/

Association of Traditional Chinese Medicine (UK)
78 Haverstock Hill, London NW3 2BE
Tel: 020 7284 2898

Ayurevedic Medical Association UK
The Hale Clinic, 7 Park Crescent, London W1N 3HE
Tel: 020-7631 0156. Fax: 020-7637 3377

British Medical Acupuncture Society
12 Marbury House, Higher Whitley, Warrington, Cheshire WA4 4QW.
Tel: 01925 730727. Fax: 01925 730492
E-mail: Admin@medical-acupuncture.org.uk
Website: http://www.medical-acupuncture.co.uk/index.shtml

College of Ayurveda
20 Annes Grove, Great Linford, Milton Keynes MK14 5DR
Tel: 01908 664518. Fax: 01908 698371

APPENDIX 7: SUPPORTING INFORMATION

Relevant legislation

Business operators should familiarise themselves with the following legislation:

• *Control of substances hazardous to health regulations 1999:* chemicals and biohazard substances, for example, disinfectants, body fluids, contaminated equipment and wastes, etc, shall be assessed in accordance with the requirements of these regulations (SI 1999/437 at the time of writing, but subject to regular update). The outcome of the risk assessment must be used to implement safe working practices.

• *Controlled waste regulations 1992:* requires that all clinical waste (used needles, soiled dressings, used swabs) is collected and disposed of by a licensed contractor in an approved incinerator.

• *Disability discrimination act 1995:* access should be provided for disabled people at the premises.

• *Electricity at work regulations 1989:* requires all portable electrical appliances used within the premises are to be maintained regularly.

• *Health and safety at work etc act 1974:* requires employers and self-employed people to ensure the health, safety and welfare of persons attending their businesses.

• *Management of health and safety at work regulations 1999:* the business operator shall carry out, and implement the findings of, a workplace risk assessment of the business. The outcome of the risk assessment must be used to implement safe working practices.

• *Provision and use of work equipment regulations 1998:* requires prevention or control of the risks to human health and safety from equipment used at work. Basically, work equipment must be suitable for its intended use; safe for use, maintained in a safe condition and, where necessary, inspected; only used by adequately informed, instructed and trained people; accompanied by suitable safety measures. The Regulations cover all equipment used by employees at work, regardless of whether it is supplied by the employer or employee. Powered equipment for use at work must have the 'CE marking', to demonstrate it conforms with relevant European safety standards.

• *Reporting of injuries, diseases, and dangerous occurrences regulations 1995:* requires employers to report certain categories of workplace accidents and serious incidents and infections which result from a work activity. The incident should be reported to the HSE's Incident Contact Centre, via the telephone (0845 300 9923) or fax (0845 300 9924), by post to Incident Contact Centre, Caerphilly Business Park, Caerphilly CF83 3GG, or e-mail to 'riddor@natbrit.com'. Further information is available on the website 'www.riddor.gov.uk'

Nuisance/complaints

The operator must ensure that there is no noise or other type of nuisance arising from the operation of the business.

Maintenance

All systems, for example, fire-safety equipment, boilers, electrical equipment, etc, housed in the premises must be maintained regularly by competent persons, and maintenance records kept.

All equipment used in connection with special treatments shall be serviced/maintained in accordance with the manufacturers/suppliers recommendations, and records kept.

Electricity

The business operator shall ensure that all portable electrical appliances used within the premises are checked regularly and maintained in accordance with the 'Electricity at work regulations 1989'; see 'Relevant legislation'. Records of maintenance checks must be available on the premises.

The business operator must also ensure that the fixed electrical installation is inspected by a competent electrical engineer, and that a copy of the current certificate is available at the premises.

Fire precautions

All fire exits, staircases and other means of escape must be kept unobstructed, immediately available, and clearly signed, in accordance with the council's requirements, and any requirements of the fire authority.

All fire-resistant and smoke-stop doors must be maintained self closing, and must not be secured open.

All exit doors must be available for access and egress whilst the public are on the premises.

A notice, or notices, reading 'No Smoking' should be prominently displayed within the treatment area.

APPENDIX 8: RECORD OF PRACTITIONERS

A record must be kept of every practitioner as follows:

Name and address of establishment	
Telephone number of establishment	
Name of practitioner	
Address of practitioner	
Gender	
Home telephone number	
Mobile telephone number	
Exact duties	
Attach current passport photo	

APPENDIX 9: CONSENT FORM

Name of premises:

Address of premises:

Local authority registration no:

	✓ ✗ or n/a
I declare that I give (full name of practitioner) my full consent to acupuncture. The information given below is true to the best of my knowledge. I have had/currently suffer from the following infections or conditions:	
Heart condition/pacemaker	
Epilepsy	.
Haemophilia	
Immuno-compromisation	
High blood pressure	
Diabetes	
Skin condition eg: psoriasis	
Allergies i.e. plasters	
Taking blood thinning medication, eg: aspirin	
Concurrent drug treatments, such as antihistamines, which often have a depressant effect on the brain, steroids and aspirin	
Implants, as a result of surgery/artificial joints	
Psychiatric disorders	

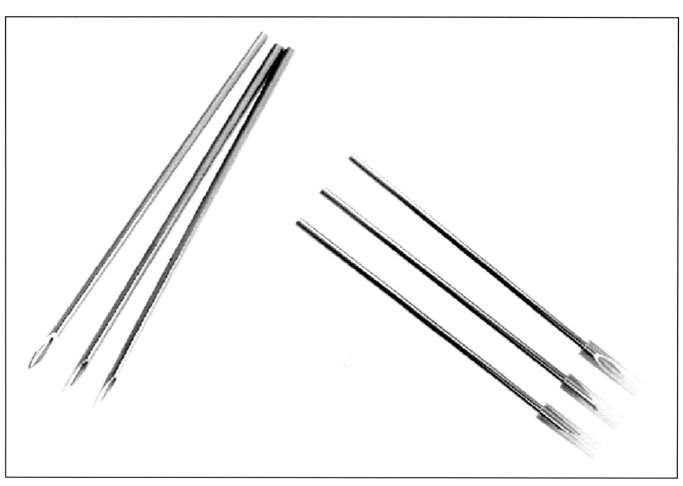

Pre-sterilised, single-use hollow disposable needles used for body piercing

The Studex System 75 uses disposable sterile cartridge for ear lobe and ear cartilage piercing

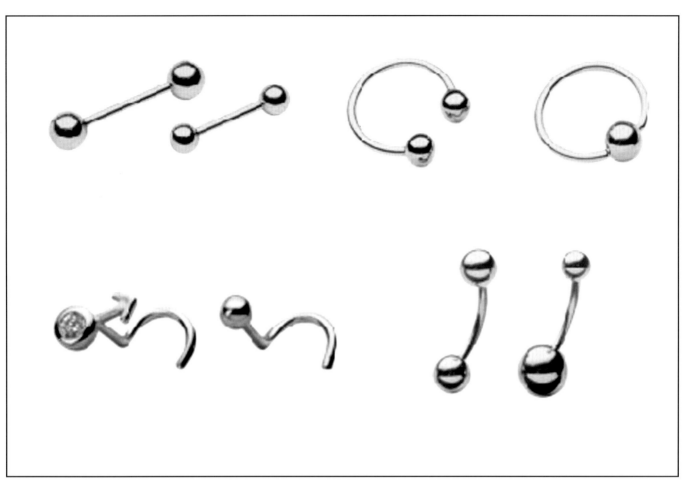

Examples of piercing jewellery. It should be inert, non-toxic and smooth, and capable of being autoclaved

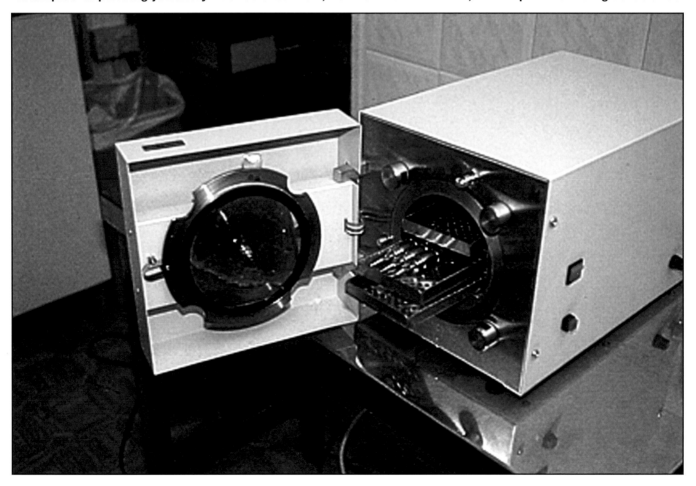

Front loading, bench autoclave

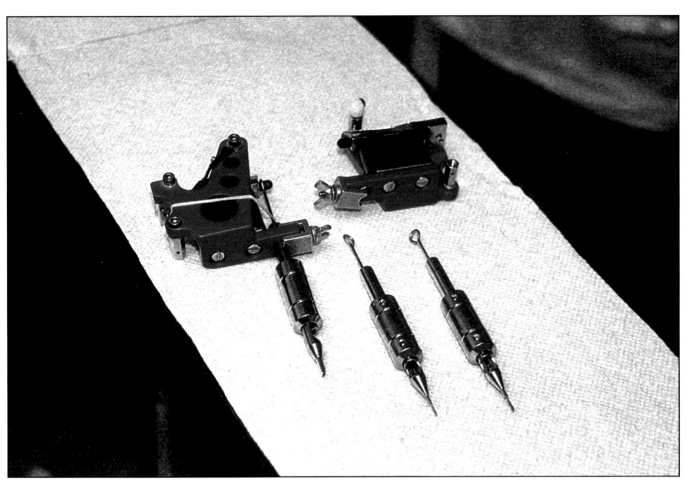

Assembled and disassembled tattoo gun

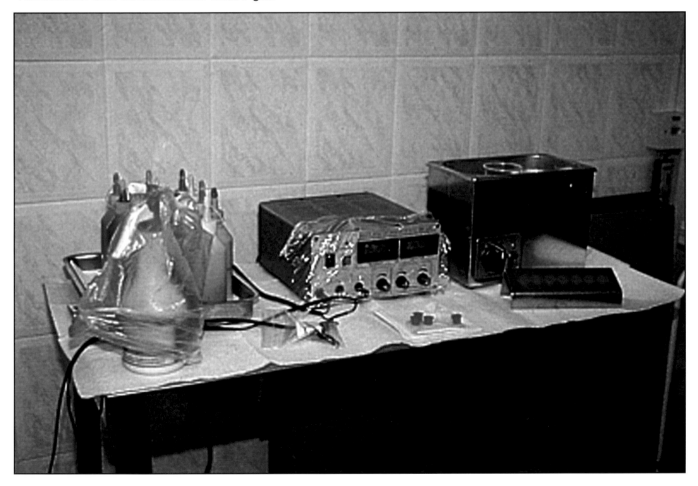

A tattooist's work bench

Tattooist's chair covered in single-use bin liner

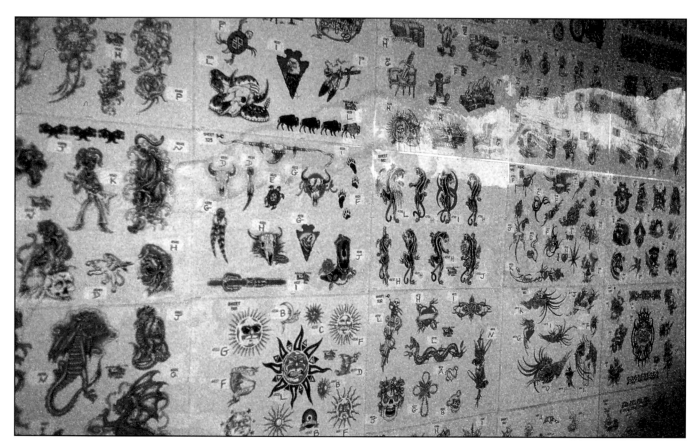

Display of tattoo designs

ELECTROLYSIS AND BEAUTY THERAPY

This 'Best practice guidance' covers many of the popular beauty therapy and hair treatments found in salons and clinics. It includes facial and body enhancement, hand and foot treatments, make-up, and eye and hair treatments. In qualified, experienced hands these treatments are safe when performed according to safe procedures or product manufacturers' instructions.

Many different types of products/preparations are used. Some rely on electrical currents passed through specific parts of the body, others rely on practical skills and knowledge of anatomy and physiology. Any hazards arising from these treatments are highlighted throughout.

CONDUCT OF THE BUSINESS

The responsible person must ensure the following:

• good order and moral conduct in the premises

• no poster, advertisement, etc shall be displayed which is unsuitable for general exhibition

• no part of the premises is used by persons for soliciting or other immoral purposes

• additional custom will not be sought through solicitation outside, or in the vicinity of the premises

• all clients in any part of the premises shall be decently and properly attired, unless receiving treatment in accordance with this 'Best practice guidance'

• neither the operator nor the client shall be under the adverse influence of drugs, alcohol or other substances.

RESPONSIBILITIES

The business operator must:

• take all reasonable precautions for the safety of all persons using the premises, ensuring compliance at all times with the relevant provisions of the 'Health and safety at work etc act 1974', and associated legislation

• carry out, and implement the findings of, a risk assessment of the business as required by the 'Management of health and safety at work regulations 1999'

• ensure that a 'responsible person' is in charge of the premises at all times, and that they are familiar with, and implement, the requirements of the relevant codes of practice

• notify the Council in writing of any proposed change in his name or private address, of changes in the business address, of major changes in the treatments provided, or in the nature of the business carried on at the premises.

RESPONSIBLE PERSON

The business operator must ensure that a 'responsible person' aged 18 years or more is in charge of the premises at all times during business hours. The responsible person must be nominated, in writing, by the business operator, and this notification should be continuously available for inspection at the premises.

The responsible person must be familiar with, and implement, the requirements of the relevant 'best practice guidance', and must:

• be in charge of the premises

• be on site at all times when the public have access to the premises

• be assisted as necessary by suitable persons, aged 18 years or more, to ensure adequate supervision

• not be engaged in any other duties which will prevent him/her from exercising general supervision.

CLEANLINESS

For the purposes of cleanliness, the following points should be observed:

• all instruments, towels, materials and equipment used on the premises must be appropriately cleaned, disinfected and/or sterilised

• tables, couches and seats should be covered with a disposable paper sheet, which must be changed for each client

• a 'no smoking' notice(s) should be displayed in the treatment area(s).

PERSONAL HYGIENE

Any person carrying out any special treatment must ensure that:

• any open boil, sore, cut or other open wound is effectively covered by a waterproof dressing

• they do not carry out any special treatment if suffering from an acute respiratory infection

• hands are kept clean, and washed immediately prior to carrying out any treatment

• they refrain from smoking or consuming food and drink during the course of the treatment.

INFECTION CONTROL

All operators must wear clean, washable clothing.

Hands and nails should be washed with soap under running water prior to any treatment.

Single-use sterile needles (probes) and lances are recommended. One needle may be used repeatedly on an individual client during an individual session, and then discarded to a 'sharps' box. A new single-use needle is to be used on the next client.

Re-usable equipment (eg, forceps or manicure implements) must be effectively sterilised, using the following procedure:

• pre-soak in water

• put through an ultrasonic cleaner, using the reccomended detergent

• rinse

• air dry

• sterilise in a bench-top autoclave, making sure items of equipment do not overlap each other and that hinged items are in the open position

• store in sterile conditions and covered for use

• items not used within two to three hours to be re-sterilised

• wooden items (such as spatulas), and disposable materials and equipment to be disposed of after single use

• any razors used on a client to be disposed of as a 'sharps'.

Only autoclaves which are CE marked or which comply with BS 3970:Part 4:1990 are suitable.

All gowns, wraps or other protective clothing, paper or other covering, towel, cloth or other such articles used in treatment shall be clean, in good repair, and so far as is appropriate, sterile. Where these materials are not single-use consumables, they should be laundered after single use.

All hard surfaces must be cleaned and disinfected before and after each client.

Table 6. Choice of decontamination procedures

Agent	Preparation	Use
Hypochlorite (bleach)	Make up daily; dilute to 70% bleach/ 30% water	Corrodes metal. Excellent for other materials and essential for cleaning-up body fluid spillages
70% alcohol	Do not dilute	Skin (applied via swab), table tops, metals

Recommended hygienic epilation procedure

• wash hands, and nails before the session

• clean the area of skin to be treated with an alcohol swab

• open the pre-sterilised needle packet carefully, taking care not to touch the needle

• insert the needle into the electrolysis machine

• at the conclusion of the procedure, place the used needle in the 'sharps' box

• carefully wipe the treated area of skin with an antiseptic, moisturising swab

• keep the treated skin dry.

DISINFECTANTS

Disinfectants do not sterilise, they only reduce the number of some microbes. Disinfection is needed for table tops, and general and working surfaces in the treatment area.

Sterilisation, the complete destruction of all microbes, is achieved by heating in an autoclave.

See the guide to 'Infection control', for more details of cleaning and disinfection.

THERAPISTS

Treatment should only be given by therapists who meet the criteria for training and competency.

TRAINING/COMPETENCY

All persons carrying out professional beauty therapy and hair-removal treatments must have completed a recognised course, and have documented evidence of their success.

If performing treatments, preparations and techniques acquired since their initial training, a relevant course must be successfully completed by the practitioner. There must be recognition of the course by a professional association, and documented evidence of the training.

All persons carrying out such treatments should regularly attend recognised training workshops and seminars to improve their techniques and skills to the latest therapy standards, and should also be appropriately supervised during their first year following qualification.

See 'Appendix 6'.

PREMISES

The following points shall be adhered to:

• all internal walls, doors, windows, partitions, floors, floor coverings, and ceilings, must be kept clean and in such good repair as to enable them to be effectively cleaned

• effective pest control measures, such as pest proofing, and appropriate treatments should be carried out, as necessary, and proper records kept

• the floor of the treatment area should have a smooth, impervious surface

• the treatment area must be solely used for giving treatments, and must be completely separated from all other rooms (for example, any room used for human habitation, catering establishment, hair salon, retail sales, or other) by full height walls or partitions

• there should be a minimum of 5m² of floor space for each operator in the establishment

• no animals of any kind should be permitted in a treatment area, except service animals used by persons with disabilities, for example, guide dogs for the blind

• suitable and sufficient means of heating to a reasonable room temperature, appropriate to the treatment offered, must be provided

• all furniture and fittings in the premises should be kept clean. Furniture in the treatment area (for example, tables, couches and seats) should be covered with a smooth, impervious surface, so that they can be effectively cleaned

• there should be an adequate, constant supply of clean hot and cold water at a hand basin, as well as sanitising soap or detergent and disposable towels. The wash basin should be easily accessible to the operator and be for his/her sole use. Taps should preferably be wrist- or foot-operated

• there should be suitable and sufficient sanitary accommodation for therapists and clients

• there must be adequate, clean, and suitable storage for all items, so as to avoid, as far as possible, the risk of contamination

• suitable screening to provide privacy must be provided

• the premises must be adequately ventilated.

TARIFF

A comprehensive tariff should be prominently displayed which can be easily seen by all persons entering the premises.

REGISTRATION CERTIFICATE

A current registration certificate should be conspicuously exhibited at all times to the satisfaction of the local authority. It must be clearly visible by all persons using the premises, and adequately protected against theft, vandalism or defacement.

RECORD KEEPING AND INFORMATION

A record must be kept of the establishment, including the name and address, hours of operation, and owner's name and address.

A copy of this 'Best practice guidance' should be kept on public display.

A complete description of all electrolysis and beauty therapy procedures performed should be kept.

Anyone under 16 years of age must be accompanied by a parent/guardian who must sign a consent form.

Every client should read and sign a consent form, which gives details of name, address, age, medical history, etc (see 'Appendix 2'). These consent forms must be kept for a period of at least three years after the cessation of current treatment, and should be available for inspection at all times so that alleged cases of infection can be epidemiologically studied.

Confidential records, including name, address, date and type of treatment received should also be kept for all treatments for a period of at least three years after the treatment has finished. They must be made available to the authorised officer upon request, and with the client's written consent.

Any contra-indications, for example heart conditions (eg, use of a pacemaker), diabetes, epilepsy, etc for each treatment must be discussed with the client prior to any treatment. In cases of medical referral, the practitioner must keep a copy of the GP's letter with the client record.

Clients should be given written information to take away about the contra-indications and risks of treatment, together with aftercare advice; see 'Appendix 3'. This should be noted on their record card, which they should sign and date.

There should be a prominently-displayed notice giving the name, address, and phone number of the local health authority and environmental health department, so that the public can report complaints or seek additional information.

All infections, complications or diseases involving medical intervention and resulting from any treatment under this best practice guidance that become known to the operator must be reported to the client's doctor and local environmental health department.

The notification shall be made as soon as practicable.

FIRST AID

There must be a first-aid kit on site that complies with the 'Health and safety (first aid) regulations 1981'. There are no specific mandatory items which must be included in a first-aid box.

The Health and Safety Executive has issued a recommended list of contents. Where the risk assessment as revealed no special hazards, a minimum stock of first-aid items includes:

- a leaflet giving general guidance on first-aid (for example, the HSE leaflet 'Basic advice on first aid at work')
- 20 individually-wrapped sterile adhesive dressings, of assorted sizes, appropriate to the type of work
- two sterile eye pads
- four individually-wrapped triangular bandages
- six safety pins
- six medium-sized individually-wrapped sterile, unmedicated wound dressings (approximately 120x120mm)
- two large sterile individually-wrapped unmedicated wound dressings (approximately 180x180mm)

- one pair of disposable gloves.

First-aid kits for travelling practitioners (ie, staff who frequently carry out domiciliary visits) would typically contain:

- a leaflet giving general guidance on first-aid (eg, HSE leaflet 'Basic advice on first aid at work')
- six individually-wrapped sterile adhesive dressings
- one large sterile individually-wrapped unmedicated wound dressing (approximately 180x180mm)
- two triangular bandages
- two safety pins
- individually-wrapped moist cleansing wipes
- one pair of disposable gloves.

WASTE

The 'Environmental protection (duty of care) regulations 1991' impose a duty of care on waste producers to ensure that all refuse (especially clinical waste, such as used electrolysis needles, dressings and swabs) is collected and disposed of by a registered waste carrier at an approved incinerator.

A copy of the current contract for the removal of such waste, and contractor's licence and transfer notes, must be available for inspection on the premises at all times.

Rubbish should be stored in covered receptacles and suitable arrangements should be made for its proper disposal. 'Sharps' (eg, electrolysis needles) must be stored in a 'sharps' box prior to removal by a registered waste carrier.

Clinical waste bags and containers should be coloured yellow, and be stored in a secure place whilst awaiting collection.

INSURANCE

The business must have third party liability, to cover claims for damages or negligence, as well as Employer's Liability insurance, where appropriate.

Operators shall display their current certificate of insurance.

LOCAL AUTHORITY AUTHORISED OFFICERS

Authorised officers carry written authorisations and proof of identity, which they will produce on request. They must be admitted during opening hours, and at any other reasonable time, to all parts of the premises. An officer may be accompanied by anyone else who is deemed necessary for the purposes of the inspection, for example, a medical practitioner.

FACE AND BODY-HAIR TREATMENTS

Face and body-hair treatments are designed to disguise unwanted hair growth or remove it completely.

There are two basic categories of hair removal: temporary and permanent. 'Depilation' is the accepted term for temporary hair removal, that is, removal of hair from the skin's surface. Professional treatments would include tweezing, waxing, threading, and sugaring.

'Epilation' refers to electrolysis techniques which are known to have permanent effects. Permanency can be achieved in most cases unless there are underlying medical conditions that have not been uncovered or if the client is not committed to the long term treatment plan.

Temporary hair treatments

Bleaching

This is a camouflage technique in which cosmetic products are applied to lighten hair growth. The active ingredient is hydrogen peroxide, which may give rise to skin irritation and prominence of bleached hair against a tanned skin.

The treatment lasts for approximately one month.

Manufacturers' instructions on contact timing and concentration of peroxide and lightening agent must be accurately followed.

Hazards:

• allergic reaction

• chemical burn

• ineffective

• skin irritation

• swelling

Waxing and sugaring

Temperature of wax/sugar must be checked before application and aftercare lotion and instructions for care of the skin given.

Hazards:

• bleeding/ bruising

• burning/ scarring

• folliculitis

• ineffective

• painful

Waxing

There are two basic types of wax treatment: 'cool/warm/honey' applied at skin temperature, and 'hot'. They are made of different resins and waxes, and are used to remove hair from the legs. The wax solidifies and hairs become embedded in the hardening sheet of wax; as it is stripped off, the hairs break at the surface of the skin.

'Cool' wax is applied at approximately blood temperature with a disposable spatula or roller system, covered with a cotton strip, and removed manually. 'Hot' wax is heated and applied hot with a disposable spatula and then removed manually.

The effect of waxing lasts about four to six weeks. It is generally not tolerated on the face.

Sugaring

Sugaring consists of a sugar-based paste, which is heated and spread onto the area and removed manually by pulling against the direction of the hair. It is less painful than waxing as the sugar does not stick to the skin, only to the hair.

The effect of sugaring lasts for between four and six weeks.

Tweezing and threading

Both methods involve pulling the hair from the follicle either singly with forceps, or en-mass with a thread that is moved quickly over the surface of the skin. The hair is caught around the thread and dislodged from its follicle.

Hazards:

• bleeding

• hyper-pigmentation of the skin

• ineffective for permanent hair removal.

• infection

• ingrown hairs

• painful

Forceps (tweezers) must he sterilised and skin sanitised before treating (plucking) the area. Care should be taken not to nick the skin with forceps.

Friction should be kept to a minimum in threading.

Laser hair removal

This category of treatment is dealt with in the best practice guidance on 'Electrotherapy'.

Permanent hair removal

In the UK there are three popular methods of permanently removing hair using electrical currents: galvanic (electrolysis), diathermy (electro-epilation) and a combination of the two currents, described as 'blend'.

All three methods employ a fine needle inserted into each hair follicle (not the skin), to discharge minute amounts of electrical current with the aim of eliminating the blood supply to the base of the follicle. This prevents new hair from growing and takes repeated attempts, as hair grows in cycles and does not all appear on the surface at the same time.

Success also depends on skill, accuracy and current intensity to the follicle.

Galvanic hair removal

This is now a dated treatment and may be referred to as 'DC' (direct current). The galvanic hair-removal machine passes current from the anode, the electrode held by the client, to the cathode - the active electrode, which is the electrolysis needle. The tissue fluids are recomposed to form sodium hydroxide, a strong alkali which dissolves areas it comes into contact with.

This is a slow method of epilation, as it takes several seconds for the chemical reaction to take place. However long term it produces effective results.

Diathermy (electro-epilation)

The most common treatment; may be referred to as AC (alternating current) or SWD (short wave diathermy). The diathermy machine produces very-high frequency alternating currents at very-low current intensity.

The needle tip delivers the high-frequency current, locally raising the temperature of the body tissues. This cauterises and coagulates the surrounding tissue within the follicle and is aimed at the hair root.

Diathermy removes hair quickly per session, but must be performed accurately throughout in order to achieve efficient results. This is a very popular method in salons and clinics.

Blend

This is a combination of the above two currents, using the best aspects of each method, and is increasingly popular. Diathermy is used to warm the follicle and act as a catalyst for the chemical reaction of the galvanic current. The combined reaction leads to a speeding up of the time needed to discharge the galvanic current.

Hazards:

• burning

• ineffective

• infection -folliculitis -swelling inflammation

• painful

• scarring

Safety precautions for all methods of epilation

Pre-packed, single-use sterilised needles of the correct type and diameter should used at each treatment and afterwards disposed of in 'sharps' boxes. Single-use needles should not be re-sterilised for further use.

Single-use gloves should be worn when epilating.

Knowledge of the chosen machine, technical skill and experience are essential in this treatment.

Skin preparation, topical after-care lotion and post-treatment care are vital.

SKIN APPENDAGE REMOVAL AND TELANGECTASIA

The aim is to remove unwanted appendages of the skin (papillomas, skin tags, etc) and reduce thread vein or broken veins (telangectasia). A papilloma is a small benign epithelial tumour (such as a wart), consisting of an overgrowth of cells on a core of smooth connective tissue.

The treatment is carried out by directly inserting a fine needle into the skin of the area and causing a cauterisation with short-wave diathermy of the tissue. Without a blood supply to nourish the area it will wither, or in the case of dilated capillaries, will no longer transport blood along the affected capillary network.

Treatment of skin appendages and facial telangectasia is effective, but leg areas should be assessed for the degree of expected permanency.

Emphasis should he placed on experience of observing skin healing and diathermy dosage for various types of skin.

Re-treatment of an area should not be attempted in under six weeks, to allow for tissue healing.

OTHER COSMETIC TREATMENTS

Exfoliation

The purpose of the treatment is to remove dead skin cells, smooth fine wrinkles and rough skin. It is also known as body polishing. The cosmetic product (whether a simple paste of crushed nut kernels or alpha hydroxy acids) is applied to the area, then manually or mechanically massaged.

Exfoliation prevents the formation of pimples and improves skin texture.

Hazards:

• allergic response to the cosmetic product (client and practitioner)

• excessive rubbing or strength of chemicals on a delicate area, such as under the eyes, may develop broken blood vessels

• skin and/or eye irritation from acid or caustic cosmetic products

• some skin conditions (such as severe acne) may be spread further through cross-infection

• susceptibility to damage through UV exposure while using cosmetic products containing alpha-hydroxy acids.

Safety precautions:

• avoid contact of cosmetics with the eyes

• protect skin treated with alpha-hydroxy acids from exposure to UV light (alternatively, remove such cosmetics before exposure to UV light)

• COSHH risk assessment to establish a safe working environment.

Brush cleansing

An electric motor rotates a brush, which is used on the face and body to loosen and remove dead skin cells from the skin surface. It also causes erythema (reddening of the skin), due to the increased blood flow to the skin.

The treatment involves wetting the area, applying the cosmetic product, followed up with the brush treatment.

Safety precautions:

• the brush should be disinfected with a hypochlorite solution and be thoroughly rinsed before each treatment

• the brush head should be firmly in place, so that it will not fly off during treatment

• the brush should be moistened with sufficient detergent solution, but not enough to cause spraying

• the entire brush surface should be in contact with the skin to give uniform pressure

• the brush size and texture should be suitable for the area of skin being treated.

Body bronzing/self tan

The purpose of the treatment is cosmetic improvement to produce a temporary tanned appearance.

The area to be treated (may be complete body or face, neck and shoulders) is prepared by exfoliation and moisturising, then sprayed with a fine mist (lighter to darker shades). The effect lasts for approximately four to five days.

Hazards:

• skin irritation from corrosive cosmetic products

• allergic reaction

• uneven appearance.

Safety precautions:

• COSHH risk assessment to establish a safe working environment.

Eyelash and eyebrow treatments

This treatment involves the colouring of eyelashes and eyebrows.

After thoroughly cleansing the area, tinting is done to enhance fair eyelashes by darkening them with cosmetic products - usually vegetable dyes - taking care to remove any surplus from the eye lashes. Patch testing of the dye for allergic reaction is essential and should be undertaken at least 24 hours before the treatment.

Hazards:

• skin irritation

• allergic reaction

• infection.

Safety precautions:

• COSHH risk assessment to establish a safe working environment.

Manicure and pedicure

Treatment of the hands, feet, fingernails and toenails which may include a scrub and massage, and cutting, filing, soaking, and varnishing the nails, as well as cuticle removal. Uses a variety of conventional beauty products and nail care equipment (nail file, scissors, etc).

The purpose of treatment is a cosmetic effect and to strengthen the nails.

Hazards:

• damage from clippers and knives

• allergic response to chemicals

• local infection via nail care equipment and foot/hand baths.

Nail extensions

The application of nail extensions made from gel, glassfibre, acrylic, which are then abraded and buffed into shape. The purpose of treatment is cosmetic improvement of the nails.

Hazards:

- volatile solvents – fire and respiratory sensitisation

- damage or local infection from scissors and other equipment

- dust hazard during abrasion or buffing of the extensions.

Safety precautions:

- COSHH risk assessment to establish a safe working environment.

Wrapping/enveloping

The objective is to detoxify and improve body shape.

The application of a body wrap consists of covering the part to be treated with hot or cold seaweed, clay or other suitable mud or gel. The part is then bandaged with single-use textile, alternatively the bandages must be laundered after each use.

Hazards:

- local infection

- skin irritation or allergy.

CELLULITE TREATMENT

The aim is to reduce the amount of cellulite in an area by massage and by applying cosmetic products and electrotherapy.

Hazards:

- local infection

- skin irritation.

Safety precautions:

- risk assessment to establish a safe working environment.

APPENDICES

APPENDIX 1: BLOODBORNE AND OTHER INFECTIONS

Viral hepatitis

Viral hepatitis is caused by several distinct viruses, of which Hepatitis A, B and C are the most common and well known.

As a safe working practice, it is best to assume that any client or employee may be infected with hepatitis virus, and that appropriate infection control is required. Risk assessment will identify what specific action is required.

Hepatitis A

This was formerly known as infectious hepatitis. It is normally transmitted by the faecal-oral route, and is rarely transmitted by blood. It has an incubation period of about four weeks, and is a common infection in conditions of poor sanitation and overcrowding. Certain foods, notably shellfish, have also been linked with this infection.

Hepatitis B

This is spread by contact via infected blood and body fluids. The virus infects either by penetration of the skin with infected needles, razors, etc, or contact with broken skin from contaminated apparatus or surfaces. It has an incubation period of six weeks to six months.

Hepatitis B is extremely infectious; a small pin-prick with a contaminated instrument is sufficient to transmit infection. Blood does not need to be visible on an instrument for it to be infectious.

It has a significant mortality rate, and can cause cancer of the liver. It also can lead to a chronic carrier state, often with a fatal outcome. Lack of history in a client will not therefore mean no risk to the practitioner, because of the carrier state.

Hepatitis B infection is reportable to the local authority EHO, if infection occurs during the course of work.

Hepatitis C

This is a recently-described virus which, like hepatitis B, causes acute hepatitis and may lead to chronic liver disease and death. It is also transmitted by blood, and can be avoided by using the same procedures as those used for hepatitis B. Recent medical research indicates considerable frequency of asymptomatic carriers of hepatitis C.

HIV and AIDS

AIDS (acquired immune deficiency syndrome) and HIV infection results from the transfer of the HIV virus in the blood or serum of an HIV infected person. The virus severely damages the body's natural defence system, and the body is susceptible to other infections and cancers which rarely affect other people.

HIV is difficult to pass from person to person; the manner of transmission is similar to hepatitis B. The risk comes, therefore, from the accidental inoculation or contamination of a cut or abrasion with the blood or body fluids of an infected person. This can happen in any skin-piercing treatment through an HIV-contaminated needle, the source being either a patient or the therapist. Thus, infection control is highly important, both of the hygienic practices of the practitioner, and the effective sterilisation of needles and equipment.

The HIV virus is not very robust and does not survive for long in the open. It cannot withstand heat or the recommended disinfectants. The same precautions of disinfection and sterilisation (in combination) which are used to combat hepatitis B (which is a stronger virus), are sufficient to prevent the spread of AIDS.

Practical implications

The following precautions shall be noted:

- cover exposed cuts and abrasions, especially on the hands, with waterproof dressings

- never use needles, equipment, instruments. etc. on more than one client, unless sterilised between clients

- never use unsterilised needles on any client

- if you believe you are a carrier of hepatitis B, HIV or have AIDS it is recommended that you cease this type of work. Further information should be sought from your doctor, or from one of the specialist information and support services

- take care to prevent puncture wounds, cuts and abrasions from used needles, razors or glassware

- record any puncture wound or contamination of broken skin, mouth or eyes.

Needle-stick injuries: first aid

Where a needle-stick injury occurs take the following steps:

- encourage the puncture to bleed

- wash under cold running water, without soap

- cover with a dry dressing

- seek medical advice as soon as possible (preferably within 1hr) at the accident and emergency department of the local hospital - a protective injection can be given against hepatitis B (but not hepatitis C). This must be done within 48 hours of the injury taking place. Treatment is also available to minimise risk of infection by HIV

- record any puncture wound or contamination of broken skin, mouth or eyes and report the incident to the employer (if applicable)

- the employer must record the details and investigate the incident to find out how it could have been prevented.

If an infection occurs as a result of the incident, it should be reported to the environmental health officer (see 'RIDDOR regulations').

APPENDIX 2: CONSENT FORM

Name of premises:

Address of premises:

Local authority registration no:

I declare that I give (full name of therapist) my full consent to (treatment).

The information given below is true to the best of my knowledge.
I have had/currently suffer from the following infections or conditions:

Condition	✓✗ or n/a	When
Heart condition/pacemaker		
Epilepsy		
Haemophilia		
HIV/Hepatitis		
High blood pressure		
Diabetes		
Skin condition; eg psoriasis		
Allergies; eg, nickel, plasters		
Taking blood-thinning medication; eg, aspirin		
(Concurrent) drug treatments, such as antihistamines, which often have a depressant effect on the brain, steroids and aspirin		
Implants, as a result of surgery/artificial joints		
Psychiatric disorders		
Radiotherapy		
Seizures; eg, epilepsy		
Surgical procedures		
Pregnancy		

I understand that no form of anaesthetic will be used in the procedure
I will follow the verbal and written aftercare instructions, which have been given to me.

Print full name	Address	Age	Signature of client	Date

APPENDIX 3: RECORD OF PRACTITIONERS

A record must be kept of every practitioner as follows:

Name and address of establishment	
Telephone number of establishment	
Name of practitioner	
Address of practitioner	
Gender	
Home telephone number	
Mobile telephone number	
Exact duties	
Qualifications	
Attach current passport photo	

APPENDIX 4: CONTRA-INDICATIONS

Electrical beauty therapy treatments

The operator shall discuss the client's medical history and ask whether he has suffered from the following:

- abnormal pulse rates
- asthma
- cancer sufferers or those in remission
- dentures
- diabetes
- epilepsy
- excessively loose, fragile or hypersensitive skins
- facial treatments
- haemophilia
- heart disorders, such as angina
- high or low blood pressure
- migraine
- much metalwork in teeth
- neuralgia
- neuritis
- pacemaker
- sinus disorders
- skin lesions such as: bruises, scar tissue, inflammation, pustules, or other communicable skin disorders
- taking regular medication
- undiagnosed swelling or pain in an area
- varicose veins and highly vascular skin conditions.

Where any of the above conditions exist, or there is a past history, written authorisation from the client's doctor before treatment is offered.

APPENDIX 5: AFTERCARE ADVICE

For epilation, waxing, tweezing, threading, sugaring and skin appendage removal

After treatment, the following advice is to be given:

- use a freshly made-up antiseptic lotion after treatment, which should be left undisturbed for the rest of the day
- apply the lotion with clean cotton wool each time, to avoid cross infection
- avoid other treatments, applications or make-up on the treated area for at least 48 hours after treatment
- avoid heat treatment for at least 48 hours after treatment, ie: hot baths, sauna, sunbeds or sunbathing
- a shower is preferable to a bath, dab the treated area dry (rather than rubbing with a towel)
- avoid smoking, strenuous exercise and swimming for several hours after the treatment.

APPENDIX 6: RECOGNISED ASSOCIATIONS

British Association of Beauty Therapy and Cosmetology
Administration office, BABTAC House, 70 Eastgate, Gloucester GL1 1NQ
Tel: 01452 421114

British Association of Electrolysists Ltd,
2A Tudor Way, Hillingdon, Uxbridge UB10 9AB
Tel: 01895-239966

Guild of Complementary Practitioners
Liddell House, Liddell Close, Finchampstead, Berkshire RG40 4NS
tel: 0118-973-5757

Guild of Professional Beauty Therapists Ltd
Guild House, PO Box 310, Derby DE23 9BR
Tel: 01332 771714. Fax: 01332 771742

Hairdressing and Beauty Industry Authority
Fraser House, Nether Hall Road, Doncaster DN1 2PH
Tel: 01302 380000. Fax: 01302 380028
Email: enquiries@habia.org.uk
Website: http://www.habia.org/

Institute of Electrolysis Ltd
PO Box 5187, Milton Keynes MK4 2ZF
Tel: 01908 521511
E-mail: institute@electrolysis.co.uk

Recognised qualifications

There is a wide variety of qualifications, at different levels. These include:

- BTEC Higher national diploma in beauty therapy
- BTEC National diploma in science and beauty therapy
- NVQ level 3 in beauty therapy

Examination boards include:

Confederation of International Beauty Therapy and Cosmetology (CIBTAC) via the British Association of Beauty Therapy and Cosmetology
Administration office, BABTAC House, 70 Eastgate, Gloucester GL1 1NQ
Tel: 01452 421114

The City and Guilds of London Institute
1 Giltspur Street, London EC1A 9DD
Tel: 020 7294 2468. Fax: 020 7294 2400
Website: app1.city-and-guilds.co.uk/default0.htm

APPENDIX 7: SUPPORTING INFORMATION
Relevant legislation

Business operators should familiarise themselves with the following legislation:

- *Control of substances hazardous to health regulations 1999:* chemicals and biohazard substances, for example, disinfectants, body fluids, contaminated equipment and wastes, etc, shall be assessed in accordance with the requirements of these regulations (SI 1999/437 at the time of writing, but subject to regular update). The outcome of the risk assessment must be used to implement safe working practices.

- *Controlled waste regulations 1992:* requires that all clinical waste (used needles, soiled dressings, used swabs) is collected and disposed of by a licensed contractor in an approved incinerator.

- *Disability discrimination act 1995:* access should be provided for disabled people at the premises.

- *Electricity at work regulations 1989:* requires all portable electrical appliances used within the premises are to be maintained regularly.

- *Health and safety at work etc act 1974:* requires employers and self-employed people to ensure the health, safety and welfare of persons attending their businesses.

- *Management of health and safety at work regulations 1999:* the business operator shall carry out, and implement the findings of, a workplace risk assessment of the business. The outcome of the risk assessment must be used to implement safe working practices.

- *Provision and use of work equipment regulations 1998:* requires prevention or control of the risks to human health and safety from equipment used at work. Basically, work equipment must be suitable for its intended use; safe for use, maintained in a safe condition and, where necessary, inspected; only used by adequately informed, instructed and trained people; accompanied by suitable safety measures. The Regulations cover all equipment used by employees at work, regardless of whether it is supplied by the employer or employee. Powered equipment for use at work must have the 'CE marking', to demonstrate it conforms with relevant European safety standards.

- *Reporting of injuries, diseases, and dangerous occurrences regulations 1995:* requires employers to report certain categories of workplace accidents and serious incidents and infections which result from a work activity. The incident should be reported to the HSE's Incident Contact Centre, via the telephone (0845 300 9923) or fax (0845 300 9924), by post to Incident Contact Centre, Caerphilly Business Park, Caerphilly CF83 3GG, or e-mail to 'riddor@natbrit.com'. Further information is available on the website 'www.riddor.gov.uk'

Nuisance/complaints

The operator must ensure that there is no noise or other type of nuisance arising from the operation of the business.

Maintenance

All systems, for example, fire-safety equipment, boilers, electrical equipment, etc, housed in the premises must be maintained regularly by competent persons, and maintenance records kept.

All equipment used in connection with special treatments shall be serviced/maintained in accordance with the manufacturers/ suppliers recommendations, and records kept.

Electricity

The business operator shall ensure that all portable electrical appliances used within the premises are checked regularly and maintained in accordance with the 'Electricity at work regulations 1989'; see 'Relevant legislation'. Records of maintenance checks must be available on the premises.

The business operator must also ensure that the fixed electrical installation is inspected by a competent electrical engineer, and that a copy of the current certificate is available at the premises.

Fire precautions

All fire exits, staircases and other means of escape must be kept unobstructed, immediately available, and clearly signed, in accordance with the council's requirements, and any requirements of the fire authority.

All fire-resistant and smoke-stop doors must be maintained self closing, and must not be secured open.

All exit doors must be available for access and egress whilst the public are on the premises.

A notice, or notices, reading 'No Smoking' should be prominently displayed within the treatment area.

Best practice guidance
CHIROPODY

This 'best practice guidance' covers chiropody and podiatry, but not pedicure (which is covered in the 'best practice guidance', Electrolysis and beauty therapy).

The terms 'chiropody' and 'podiatry' are synonymous. The former is more commonly used in the UK, although recently 'podiatry' is increasingly used to denote the activity undertaken by chiropodists. 'Podiatry' and 'podologie' are terms in common use internationally.

Chiropody involves the diagnosis and management of the feet and lower limb, and includes any systemic conditions which have an effect on the foot and lower limb. 'Chiropody' is therefore the practical care of patients who may present with problems affecting their feet. In addition, chiropody includes the maintenance and care of corns, calluses, and nail conditions, and the treatment of verrucae. It may also include management of sports injuries and sports-related biomechanical defects and alterations of posture resulting in altered mechanics of the foot and lower limb, affecting the spine and whole-person posture.

Chiropodists ('practitioners') use a variety of techniques, such as biomechanics and gait analysis, and the practice involves the examination of the whole patient, especially the detailed examination of the lower limbs and feet. Other techniques used may include caustics; cryotherapy, including use of liquid nitrogen; electrosurgery; and casting of the feet for prescription insoles (functional and non-functional foot orthoses).

Orthotics may be useful in the alleviation of foot, knee, back and hip pain, callosities and other sports or overuse syndromes. They may also help prevent foot-posture problems in children and adults, such as bunions, flat feet or strain in the arch of the foot.

Local anaesthetics may be applied for minor surgery or for more-complex day-care surgery. Minor surgery includes techniques to eradicate in-growing toenails and resistant verrucae. State Registered Practitioners who have undertaken further extensive surgical training may also undertake more invasive surgery.

Pedicure involves treatment of feet and toenails for cosmetic rather than therapeutic purposes. It may include a foot scrub, massage, and some dry-skin removal, as well as cutting, filing, soaking, cuticle removal, and varnishing of the toenails. A variety of conventional beauty products and nail care equipment (nail file, scissors, etc) are used in pedicure. The purpose is a cosmetic effect to strengthen nails, and to prevent in-growing toe nails. These procedures are described in the 'best practice guidance', Electrolysis and beauty therapies.

In chiropody/podiatry, the following hazards to clients are recognised:

- infection from un-sterilised instruments
- dust and debris from human nail or skin tissue as a result of debridement (usually by a drill)
- reaction to drugs used as part of the treatment for conditions such as verrucae
- effects of air contamination by cryosurgical equipment
- electrocution from electrical equipment
- anaphylactic reaction to drugs
- damage of the foot or lower leg during minor surgery or manipulations owing to malpractice
- failure to refer infections or conditions owing to malpractice.

RESPONSIBILITIES

The business operator shall:

- take all reasonable precautions for the health and safety of all persons using or being affected by the activities of the premises
- ensure compliance with the relevant provisions of the 'Health and safety at work etc act 1974', and associated legislation (see 'Law')
- carry out and implement the findings of a suitable and sufficient risk assessment of the premises and activities undertaken by the business
- ensure that a responsible person is in charge of the premises at all times, and that he/she is familiar with, and implements the requirements of this code and those of any professional and statutory bodies
- take out employer's liability insurance cover (where appropriate), and public liability insurance cover (see Insurance)
- ensure that any persons conducting special treatments are suitably qualified or trained, and are competent (see 'Training and competency')
- notify the local authority in writing of any proposed change in the name or private address of the individual, or the change in the business address, of changes to treatments provided, or to the nature of the business carried out on or at the premises.

RESPONSIBLE PERSON

The business operator must ensure that a 'responsible person' is in charge of the premises at all times, and that he/she is familiar with and implements the requirements of all relevant codes of practice. The business operator shall nominate responsible persons in writing and this notification shall be continuously be available for inspection at the premises.

The responsible person must:

- be in charge of the premises
- be on site at all times when the public have access to the premises
- be assisted as necessary by suitable persons, aged 18 years or more, to ensure adequate supervision
- not be distracted by other duties which will prevent him/her from exercising effective supervision.

CONDUCT OF THE BUSINESS

The business operator shall ensure the following:

- good order and moral, professional and ethical conduct on the premises
- no poster, advertisement, etc, should be displayed which is unsuitable for general exhibition
- all clients in any part of the premises must be decently and properly attired, unless receiving treatment in accordance with this best practice guidance
- the practitioner should not be under the adverse influence of drugs, alcohol or other substance
- all treatments must be undertaken in conditions of appropriate privacy.
- treatment areas should offer privacy and comfort

- the client should be acknowledged and respected as an individual

- practitioners must acknowledge the social, cultural, religious and gender issues relevant to their client or patient. It may be necessary in certain circumstances to ensure that a chaperone is present during any examination and or treatment

- all flammable products must be stored in a metal cupboard, separate from other drugs and dressings

- all drugs, needles and syringes must be stored in a locked cupboard.

CLEANLINESS

For the purposes of cleanliness, the following shall be observed:

- all instruments, towels, materials and equipment used on the premises should be appropriately cleaned, disinfected and/or sterilised

- tables, couches or trolleys, and seats must be wiped down with a suitable disinfectant between the treatment of each client, and thoroughly cleaned at the end of each working day

- where tables, couches or trolleys are used they should be covered with a disposable paper sheet, which should be changed for each client

- 'No smoking' notices should be displayed in the treatment areas

- 'No eating or drinking' notices should be displayed in the treatment areas.

PERSONAL HYGIENE

Any person conducting any treatment must ensure that:

- any open sore, cut or boil or other open wound on the practitioner is effectively covered with a waterproof impermeable dressing

- they do not conduct any treatment if they are suffering from an acute respiratory infection, unless they have taken adequate precautions to minimise or reduce cross-infection

- hands are kept clean and are washed immediately before conducting any form of treatment

- they refrain from smoking or consuming food and drink during the course of any treatment.

INFECTION CONTROL

These points relate particularly to chiropodists. More advice is contained in the 'Guide on infection control'.

To assure adequate infection control, the following should be noted:

- all practitioners should wear clean, freshly laundered, special purpose clothing

- hands and nails should be washed in liquid detergent and hot running water, or antibacterial hand wash immediately before and after any procedure

- single-use gloves should be worn while carrying out any procedure

- all hard surfaces should be cleaned and disinfected before and after each client

- all instruments must be cleaned of all visible soil before sterilisation

- all instruments must be sterilised between patients

- all chiropodists must be immunised against hepatitis B, and produce documentary evidence of the titre level demonstrating vaccination status.

All gowns, wraps or other protective clothing, paper or other covering, towel, cloth or other such articles used in treatment shall be clean, in good repair and where practically possible, sterile.

MINOR SURGERY

Before undertaking any form of minor surgery, the practitioner must be competent and have received appropriate and suitable training to undertake the procedure.

In every case, skin in the area being treated must be appropriately cleansed using a skin-safe antiseptic solution before undertaking minor surgery.

A non-touch or sterile technique should be used, for example, using sterilised forceps or sterile disposable gloves, to reduce the risk of cross-infection and injury to the skin and soft tissue.

The surgical procedure to be undertaken must be explained to the client. Informed written consent for the procedures must be obtained from the client before any treatment is given. The client must be given sufficient information (in a way they understand) about the proposed treatment, and any alternatives to enable them to give informed consent.

The client, or their guardian, should be given written information and advice relating to post-operative care, including actions to avoid immediately after surgery.

All appropriate clinical pre- and post-operative protocols must be observed. Accurate legible and detailed records must be completed to include dosage and duration of local anaesthetic, and length of time any tourniquet was in place.

DISINFECTANTS

Disinfectants do not sterilise, they only reduce the number of some microbes. Disinfection is required for tabletops, and general surfaces in the treatment areas.

Sterilisation involves destruction of all microbes and for practical purposes is only achieved in an autoclave.

Disinfectant preparation

Agent: hypochlorite (bleach).

Preparation: make up daily; dilute to 30% bleach/70% water.

Uses: excellent for floor or work surfaces where blood has been spilt; corrodes metal.

Agent: 70% alcohol.

Preparation: do not dilute.

Use: suitable for intact skin, table tops, metals.

WASTE DISPOSAL

Waste generated by a chiropody practice is categorised into two types: commercial waste and clinical waste.

Commercial waste (general non-hazardous materials, such as paper, waste foodstuffs, etc) should be stored in suitable covered receptacles and disposed of via a registered waste carrier.

Clinical waste includes all human tissue, (whether the tissue is infected or not), all swabs and soiled surgical dressings, and other soiled waste from treatment areas. The waste should be stored in closed yellow plastic bags before collection by a registered waste carrier (See the guide on 'Waste', for more details of storage, handling and disposal).

It is recommended that contaminated needles are not removed from disposable syringes, nor that the needle is re-capped before disposal. The syringe, with the needle attached, should be disposed of in a 'sharps' container complying with BS 7320:1990. Where dental syringes are used, an appropriate needle-guard system should be used.

TRAINING AND COMPETENCY

Treatment shall be given by qualified chiropodists who have met the criteria for training and competency, as acknowledged by professional and statutory organisations.

PROFESSIONAL ORGANISATIONS

British Chiropody and Podiatry Association
New Hall, 149 Bath Road, Maidenhead, Berkshire SL6 4LA
Tel: 01628 621100/632449/632440. Fax: 01628 674483
E-mail: smae_institute@compuserve.com

Institute of Chiropodists and Podiatrists
27 Wright Street, Southport, Merseyside PR9 0TL
Tel: 01704 546141. Fax: 01704 500477
E-mail: secretary@inst-chiropodist.org.uk
Website: http://www.inst-chiropodist.org.uk/

Society of Chiropodists and Podiatrists
1 Fellmonger's Path, Tower Bridge Road, London SE1 3LY
Tel: 020 7234 8620
Website: http://www.scpod.org/

STATE REGISTERED CHIROPODIST

State registered chiropodists are entitled to use the designatory letters SRCh after their name.

The Chiropodists Board of the Council for Professions Supplementary to Medicine is the statutory body responsible for ensuring the quality and standards of professional training. This usually involves a full-time course of three years duration leading to an award of a BSc (Hons) in podiatry and subsequent state registration.

The names of state registered chiropodists are held on a national register at:

Council for Professions Supplementary to Medicine
Registration Department (Chiropody)
Park House, 184 Kennington Park Road, London SE11 4BU
Tel: 020 7840 9802. Fax: 020 7820 9684
Website: http://www.cpsm.org.uk/chiropodists/index.htm

CONTRA-INDICATIONS

The chiropodist shall discuss the client's medical history and ask whether he/she has suffered from any of the following:

- allergic response; for example, to nuts, drugs or dressings, anaesthetic agents, adhesive plaster, metals
- arthritis
- blood dyscrasias
- circulatory problems
- conditions involving compromise of the immune system
- diabetes
- haemorrhagic disorders
- heart problems
- hepatitis B or C
- impetigo
- kidney disease
- liver disease
- seizures, such as epilepsy
- any illness requiring medication to control blood viscosity
- any other medical or surgical condition.

Where any of the above exists, or there is a past history, these should be clearly identified in the client's medical record kept by the practitioner Accurate, legible and detailed records must be completed, which will include presenting conditions, signs and symptoms and medical, social, family and surgical histories.

AFTER-CARE ADVICE

A wide variety of treatments are offered by chiropodists, and the advice of the practitioner should be followed for each specific treatment.

PREMISES

The following is required:

- all internal walls, doors, windows and partitions, floors, floor coverings, and ceilings shall be kept clean and in good repair so that they can be effectively cleaned
- effective pest control measures such as pest proofing and appropriate treatments should be carried out as necessary, and proper records kept
- the floor of the treatment area should have a smooth, impervious surface
- there should be a minimum of 11m³ of space for each operator in the establishment
- no animals of any kind should be allowed onto the premises, except service animals used by persons with disabilities, for example, guide dogs for the blind
- suitable and sufficient means of heating to a reasonable temperature (minimum of 16°C after one hour of operation), appropriate to the treatment provided, should be provided
- all furniture and fittings in the premises should be kept clean. Furniture in the treatment area (for example, tables, couches, seats) should be covered with a smooth, impervious surface, so that they can be effectively cleaned
- there should be an adequate, constant supply of clean hot and cold water at a wash basin, as well as detergent available from a dispenser, and disposable towels. The wash basin should be easily accessible to the practitioners and for their sole use. Taps should preferably be wrist- or foot-operated
- there should be suitable and sufficient sanitary accommodation for clients and practitioners
- there must be adequate, clean and suitable storage for all items, so as to avoid, as far as possible, the risk of contamination
- the premises must be adequately lighted and ventilated.

Suitable screening to provide privacy should be provided.

REGISTRATION CERTIFICATE

A current registration certificate should be conspicuously displayed at all times, clearly visible by all persons using the premises, and adequately protected against theft, vandalism or defacement.

RECORD KEEPING AND INFORMATION

A record must be kept of the establishment including the name and address, hours of operation, and the operator's name and address.

A copy of this 'best practice guidance' should be available on the practice premises.

Anyone under 16 years of age should normally be accompanied by a parent/guardian who must give written consent/permission for treatment. A single consent form can be obtained for a course of treatment. It is recommended that when treating minors they are always accompanied by a parent/guardian.

Informed consent for assessment/examination of an individual should be obtained prior to commencing any treatment. The practitioner should explain the nature and purpose of any procedure; to include any potential risks and any expected outcomes.

Every client should read and sign a consent form which gives details of their name, address, age, and relevant medical history (see 'Appendix 1'). These consent forms will form part of the medical record for that client and must be kept for a minimum of eight years after that client's last appointment.

Records must be available for inspection by appropriate authorities at all times.

Similarly, all treatment records (see 'Appendix 2') should include the clients name, address, date and type of treatment, along with a clinical assessment, a diagnosis wherever possible, the treatment plan, and possible outcomes agreed with the client.

All diagnostic indicators and past medical history must be identified in the clinical record together with the treatment plan. These records should be retained for a period of eight years after the clients last appointment. Records relating to children and to young people must be kept until the client's 25th birthday, or for eight years after the last entry, if that is longer.

Where client's records are maintained, they must be stored in a locked area, which does not allow access by unauthorised persons. Practitioners should be aware of client's rights under the 'Data protection act 1998' and the 'Access to medical records act 1990'. Records should be maintained in an appropriate manner.

Changes in a client's medical and personal information should be recorded on their record cards and updated at regular intervals as appropriate. The changes should be dated and signed by the practitioner concerned.

Clients should be given written after-care information indicating contra-indications and risks of any treatment performed (see 'Appendix 3'). This should be noted in the client medical record.

The name, address and phone number of the local health authority, professional or statutory body and environmental health department should be clearly displayed so that the public can report complaints or seek additional information.

FIRST AID

There must be a first-aid kit on site that complies with the 'Health and safety (first aid) regulations 1981'. There are no specific mandatory items which must be included in a first-aid box.

The Health and Safety Executive has issued a recommended list of contents. Where the risk assessment has revealed no special hazards, a minimum stock of first-aid items includes:

- a leaflet giving general guidance on first-aid (for example, the HSE leaflet 'Basic advice on first aid at work')

- 20 individually-wrapped sterile adhesive dressings, of assorted sizes, appropriate to the type of work

- two sterile eye pads

- four individually-wrapped triangular bandages

- six safety pins

- six medium-sized individually-wrapped sterile, unmedicated wound dressings (approximately 120x120mm)

- two large sterile individually-wrapped unmedicated wound dressings (approximately 180x180mm)

- one pair of disposable gloves.

First-aid kits for travelling practitioners (ie, staff who frequently carry out domiciliary visits) would typically contain:

- a leaflet giving general guidance on first-aid (eg: HSE leaflet Basic advice on first aid at work);

- six individually-wrapped sterile adhesive dressings

- one large sterile individually-wrapped unmedicated wound dressings (approximately 180x180mm)

- two triangular bandages

- two safety pins

- individually-wrapped moist cleansing wipes

- one pair of disposable gloves.

Needle-stick injuries: first aid

Where a needle-stick injury occurs take the following steps:

- encourage the puncture to bleed

- wash under cold running water, without soap

- cover with a dry dressing

- seek medical advice as soon as possible, preferably within one hour, at the accident and emergency department of the local hospital - a protective injection can be given against hepatitis B (but not hepatitis C). This must be done within 48 hours of the injury taking place. Treatment is also available to minimise risk of infection by HIV

- record any puncture wound or contamination of broken skin, mouth or eyes and report the incident to the employer (if applicable)

- the employer must record the details and investigate the incident to find out how it could have been prevented.

If an infection occurs as a result of the incident, it should be reported to the environmental health officer (see RIDDOR regulations).

INSURANCE

The business must have third party liability insurance, to cover claims for damages due to malpractice or negligence, as well as employer's liability insurance where appropriate.

LOCAL AUTHORITY AUTHORISED OFFICERS

Authorised officers carry written authorisations and proof of identity, which they will produce on request. They must be admitted during opening hours, and at any other reasonable time, to all parts of the premises. An officer may be accompanied by anyone else who is deemed necessary for the purposes of the inspection, for example, a medical practitioner.

APPENDICES

APPENDIX 1: CONSENT FORM

Name of premises:

Address of premises:

Local authority registration no:

	✓ ✗ or n/a
I declare that I give (full name of therapist) my full consent to (describe treatment) The information given below is true to the best of my knowledge. I have had/currently suffer from the following:	
heart condition/pacemaker	
epilepsy	
haemophilia	
immuno-compromising conditions	
high blood pressure	
diabetes	
skin conditions, eg: psoriasis	
allergies; eg, plasters	
taking blood thinning medication, eg: aspirin	
concurrent drug treatments, such as antihistamines, steroids and aspirin	
implants, as a result of surgery/artificial joints	
psychiatric disorders	
radiotherapy	
seizures, eg: epilepsy	
surgical procedures	
pregnancy	
I will follow the verbal and written aftercare instructions, which have been given to me.	

Full name	Address	Age	Date of birth	Signature of client	Date

APPENDIX 2: TREATMENT RECORD INFORMATION

Client name	
Address	
Tel: work/home	
Date of birth	
General health	
Contra-indications	
Date consent for treatment obtained (and signed for consent card)	
GP's name and address	
Is GP's consent required	
Date GP's consent obtained if necessary	
Any special medical/other information	
Treatment details	
Date of treatment(s)	
Name of therapist/operator	
Treatment history	
Date contra-indications/aftercare advice leaflet signed for	
Signature/date of client	
Signature/date of therapist/operator	

APPENDIX 3: CONTRA-INDICATIONS AND AFTERCARE ADVICE

Contra-indications

The operator shall discuss the client's medical history and ask whether he/she has suffered from the following:

• allergic responses to anaesthetics, adhesive plasters and jewellery metals

• diabetes

• haemorrhaging/haemophilia

• heart disease/pacemaker

• hepatitis B or C

• high blood pressure

• immuno-compromising conditions

• impetigo

• seizures; eg, epilepsy

• any condition requiring blood thinning medication; eg, aspirin

• any other relevant medical condition; eg, where steroid treatment was required.

Aftercare advice

Invasive treatment requires that infection be prevented at the site of treatment. As a wide variety of treatments are offered by chiropodists, the advice of the practitioner should be followed for each specific treatment.

APPENDIX 4: SUPPORTING INFORMATION

Relevant legislation

Business operators should familiarise themselves with the following legislation:

• *Control of substances hazardous to health regulations 1999:* chemicals and biohazard substances, for example, disinfectants, body fluids, contaminated equipment and wastes, etc, shall be assessed in accordance with the requirements of these regulations (SI 1999/437 at the time of writing, but subject to regular update). The outcome of the risk assessment must be used to implement safe working practices.

• *Controlled waste regulations 1992:* requires that all clinical waste (used needles, soiled dressings, used swabs) is collected and disposed of by a licensed contractor in an approved incinerator.

• *Disability discrimination act 1995:* access should be provided for disabled people at the premises.

• *Electricity at work regulations 1989:* requires all portable electrical appliances used within the premises are to be maintained regularly.

• *Health and safety at work etc act 1974:* requires employers and self-employed people to ensure the health, safety and welfare of persons attending their businesses.

• *Management of health and safety at work regulations 1999:* the business operator shall carry out, and implement the findings of, a workplace risk assessment of the business. The outcome of the risk assessment must be used to implement safe working practices.

• *Provision and use of work equipment regulations 1998:* requires prevention or control of the risks to human health and safety from equipment used at work. Basically, work equipment must be suitable for its intended use; safe for use, maintained in a safe condition and, where necessary, inspected; only used by adequately informed, instructed and trained people; accompanied by suitable safety measures. The Regulations cover all equipment used by employees at work, regardless of whether it is supplied by the employer or employee. Powered equipment for use at work must have the 'CE marking', to demonstrate it conforms with relevant European safety standards.

• *Reporting of injuries, diseases, and dangerous occurrences regulations 1995:* requires employers to report certain categories of workplace accidents and serious incidents and infections which result from a work activity. The incident should be reported to the HSE's Incident Contact Centre, via the telephone (0845 300 9923) or fax (0845 300 9924), by post to Incident Contact Centre, Caerphilly Business Park, Caerphilly CF83 3GG, or e-mail to 'riddor@natbrit.com'. Further information is available on the website 'www.riddor.gov.uk'

Nuisance/complaints

The responsible person must ensure that there is no noise or other type of nuisance arising from the operation of the business.

Maintenance

All systems, for example, fire-safety equipment, boilers, electrical equipment, etc, housed in the premises must be maintained regularly by competent persons, and maintenance records kept.

All equipment used in connection with special treatments shall be serviced/maintained in accordance with the manufacturers/suppliers recommendations, and records kept.

Electricity

The business operator shall ensure that all portable electrical appliances used within the premises are checked regularly and maintained in accordance with the 'Electricity at work regulations 1989'; see 'Relevant legislation'. Records of maintenance checks must be available on the premises.

The business operator must also ensure that the fixed electrical installation is inspected by a competent electrical engineer, and that a copy of the current certificate is available at the premises.

Fire precautions

All fire exits, staircases and other means of escape must be kept unobstructed, immediately available, and clearly signed, in accordance with the council's requirements, and any requirements of the fire authority.

All fire-resistant and smoke-stop doors must be maintained self closing, and must not be secured open.

All exit doors must be available for access and egress whilst the public are on the premises.

A notice, or notices, reading 'No Smoking' should be prominently displayed within the treatment area.

ELECTROTHERAPIES

This 'Best practice guidance' includes the following electrotherapy treatments: infrared, ultraviolet, laser, ultrasound, electromotor stimulation (EMS) and a variety of other treatments for cosmetic purposes.

The treatments described here are distinct from those offered by physiotherapists, who may use similar equipment and techniques for therapeutic purposes. The Council for Professions Supplementary to Medicine ensures good standards of competence and conduct among its registrant physiotherapists.

HEAT TREATMENT

There are two common types of heat treatment, using far-infrared (non-visible) lamps and radiant (luminous) heat lamps.

Far-infrared treatment

Far-infrared is electromagnetic radiation on a wavelength of 4,000nm, which is longer than visible light, hence the familiar name of 'non-visible heat lamps'. The aim is to stimulate circulation and relax the muscles, so enabling posture improvement and joint mobility.

The lamp takes between five and 15 minutes to become fully active, and the heat emission does not penetrate below the skin surface (epidermis); heat absorbed at the surface spreads by conduction and via blood circulation. Far-infrared rays are non-irritant and treatments up to 30-minutes duration can be tolerated, as can treatment of the face.

Radiant heat treatment

Radiant heat rays are a complex of near-infrared wavelengths (1,000nm), some visible light, and a small amount of ultraviolet (UV) light. They are produced in a lamp which heats up immediately after it is switched on. The heat rays penetrate more deeply into the body, reaching the muscles via conduction and circulation.

Sweating increases and muscles relax, relieving tension at the joints. Burning will occur if the lamp is applied too close and/or for too long. If too much exposure is given there is a possibility of fainting due to overheating.

Use

Heat treatment is used by beauty therapists to relieve tension.

During treatment it is important to hold the lamp at least 600mm from the skin surface and to ensure the radiation reaches the skin perpendicularly (so far as reasonably practicable) to minimise the risk of local burning. The infra-red light bulb must be guarded to capture any glass should the bulb break during use.

Contra-indications

The following clients *must* avoid heat treatment:

* pregnant women
* those with cardio-vascular disorders (high/low blood pressure, or angina)
* those suffering from epilepsy, asthma and migraine
* diabetics, who have a reduced sensitivity to heat, and may not therefore be aware that the skin was burning
* clients taking medication such as HRT or anti-depressants
* clients who are menstruating
* those on a low-calorie diet
* those who have consumed a heavy meal or alcohol.

Safety precautions

Radiant heat:

* the glass bulb inside the lamp becomes very hot in use and will burn the skin if touched
* the bulb must not be dropped, knocked or splashed with water when hot or the glass will break; the bulb will then implode due to the partial vacuum inside it
* the client's skin must be clean and free from grease, which could increase the likelihood of burning
* the distance of the lamp from the client should be such that erythema (reddening of the skin) does not occur until ten minutes after the treatment starts
* the application time should be short, or the skin will burn
* the lamp face should be parallel to the skin surface being irradiated, so that a uniform heating effect is produced
* the client's eyes should be protected by goggles to prevent cataract.

Far-infrared treatment:

* care must be taken in using this lamp because it is impossible to tell by its appearance whether it is switched on or off. There is thus the danger of burns due to touching the hot lamp
* over-frequent use of these lamps can cause cataracts by damaging the eye lens, and mottling of the skin with a network of dark brown lines
* goggles must be worn to protect the eyes when the lamp is used on the face
* treatment should never be continued for longer than 30 minutes or burning of the skin may occur.

LIGHT TREATMENT

Ultraviolet light is a form of electromagnetic radiation: it has a range of wavelengths shorter than that of visible light, and is therefore invisible. UV can be divided into three regions, called UVA, UVB, and UVC, each of which has its own properties and hazards:

* UVA (wavelength 400-320nm). Will pass through ordinary glass, quartz glass and plastic. These penetrate the skin most deeply, reaching to the lower dermis. Can produce premature ageing of the skin
* UVB (wavelength 320-290nm). Will pass through quartz glass and plastic, but not through ordinary glass. The wavelengths penetrate only as far as the deepest layers of the epidermis (stratum basale)
* UVC (wavelength 290-100nm). Will pass through quartz glass but not through ordinary glass or plastic. These wavelengths only penetrate the outermost layers of the epidermis.

The purpose of UV light treatment in beauty-therapy treatments is to acquire a tanned appearance. The melanin in the epidermis protects underlying tissues from radiation damage by UV rays. Sunburn, conjunctivitis and possibly cataracts may result from overexposure to all types of UV light. Skin cancer is also associated with excess exposure to UV light (including sunlight) by those with sensitive skins.

Hazards

The following serious conditions may develop as a result of over- or chronic exposure to UV light:

• skin cancers

• ageing of the skin and thickening of the epidermis

• short term burning and blistering

• conjunctivitis and cataracts (if eye protection not used).

Operators must not claim that the use of sunbeds has a health benefit. The Chartered Institute of Environmental Health has advised leisure-centre operators to phase out the use of sunbeds owing to increasing caution over exposure to UV light and its link with increasing incidence of skin cancer.

Use of UV light

UV light is applied in beauty treatment to produce a 'suntan', either over the whole body (solarium/sunbed) or for the face (individual tanning unit).

The length of time that a user is allocated to use the solarium/sunbed must be controlled by the operator, based on:

• the user's type of skin

• power of the solarium/sunbed

• current age of the UV light tubes.

All treatments must be recorded.

First-time exposure must be limited to the minimum time and only increased gradually on subsequent exposures, provided no adverse reaction is experienced.

Contra-indications

UV tanning is inadvisable for the following categories of client:

• fair, sensitive skin

• lots of freckles or moles, often associated with red hair

• people with a family history of skin cancer

• pregnant women

• hypersensitive skin prone to sunburn

• susceptible to cold sores (*Herpes simplex* infection)

• clients taking drugs which cause photosensitivity, eg: tetracycline

• clients using skin cosmetics.

Safety precautions

• the length of the treatment should be related to previous exposure to UV radiation and to the client's skin type. The HSE recommends a maximum of 20 solarium/sunbed sessions per year. Users should be advised when they have reached this number and no further treatment provided

• minimum of 24 hours between treatments

• keep records of individual client usage

• remove contact lenses

• goggles should be worn by both the client and the operator. Cotton wool pads or sunglasses provide insufficient protection from reflected radiation. The goggles should be cleaned between clients

• wash-off cosmetics and deodorants before using the sunbed

• clean the surface of horizontal beds between clients, or provide a single-use sheet. Vertical booths should be provided with single-use mats to stand on

• UV light sources (tubes) should be changed at the intervals recommended by the manufacturer

• users of solariums/sunbeds should have access to an immediately-audible emergency alarm device, and the responsible person should ensure an immediate response to such alarms

• HSE guidelines on UV tanning (publication IND(G) 209) should be displayed in each solarium/sunbed cubicle.

LASER

Laser equipment has electromagnetic-radiation output of specific frequency in a highly collimated coherent beam. The equipment generally used in beauty therapy has similar frequency to that of visible light, and presents substantial hazards to the eye owing to its high intensity.

Lasers are classified into four groups according to the level of hazard they present, with Class 1 the least, and Class 4 the most hazardous. Class 3 and Class 4 lasers may be encountered in use for cosmetic laser epilation - in studios and at beauty-therapy exhibitions.

Other hazards include:

• blistering

• burning

• damage to non-targets, such as sebaceous glands

• erythema

• hyper- and hypo pigmentation

• re-growth of hair

• scarring.

Use

Pulsed lasers are increasingly used for cosmetic epilation treatments, as well as anti-wrinkle treatments and dermabrasion.

Laser radiation is used to cause selective thermal damage to a pigmented target ('selective photothermolysis'). A number of proprietary hair-removal systems are available, as follows:

• ruby laser (694nm)

• alexandrite laser (755nm)

• diode laser (800nm)

• Nd:YAG laser (1064nm) used in conjunction with a carbon suspension applied to the area for epilation

• intense pulsed-light source (590-1200nm). Strictly speaking, this is not a laser treatment, as it relies on incoherent light produced by a xenon source. Its effectiveness appears to rely also on a photothermolytic process.

The natural pigment ('chromophore') these treatments rely on is melanin; this is present in the hair follicles and the epidermis. The objective is to irradiate the follicle without causing damage to the epidermis, and this is said to be accomplished by carefully choosing the laser wavelength to enable deeper penetration to the germinative hair cells.

The proprietary systems vary in their wavelength, pulse time, intensity and spot (beam) size. Systems using Nd:YAG lasers also require use of a topical carbon suspension, which is applied and then allowed to penetrate the follicle to act as a target for the laser radiation. Some systems also require use of a cool (~0°C) transparent gel to protect the skin.

Clients should be informed as to the likely effectiveness and permanence of the treatment in their individual circumstances, as the medical literature indicates highly-variable response rates to laser treatment.

There is a probability of laser treatment being offered as a cosmetic treatment for tattoo removal, and other forms of cosmetic surgery. This aspect of treatment should be restricted to dermatologists or other medically qualified specialists.

Contra-indications

Laser epilation is not likely to be effective on unpigmented hair.

Treatment of the following *must* be prevented:

- tumerous or pre-tumerous tissues on the grounds that cell stimulation may result in further cancerous growth
- the unclosed fontanelle of infants and over the pregnant uterus
- the heart of patients with pacemakers
- areas of venous thrombosis, phlebitis and arterial disease
- suntanned skin.

Safety precautions

- safety and treatment protocols to be implemented, in accordance with BS IEC 60825:Part 8. Use of Class 3B or Class 4 lasers requires provision of secure treatment areas
- the eye is the critical organ for laser hazards, and the operator's actions are crucial to their safe operation. Laser radiation should only be applied to the chosen tissue site, in accordance with an agreed treatment protocol
- specific safety training on laser treatment is a requirement
- the eyes of both operator and client must be protected with suitable goggles provided for the specific type of laser in use. Shining a laser into the eye or looking directly into the laser beam (even by accidental reflection or diffuse scattering) must be prevented. Risk assessment will identify the precautions required
- the laser beam should only be switched on when the applicator is in contact with the skin
- in addition to the use of eye protection, treatment in a brightly-lit area is recommended to ensure constriction of the pupil and thus to diminish the amount of radiation that could enter the eye
- if the laser applicator is in contact with infected or otherwise contaminated skin it must be cleaned and disinfected with a suitable solution afterwards.

ULTRASOUND

Ultrasound refers to airborne or tissue-borne mechanical vibrations, which are essentially the same as sound (sonic) waves, but of higher frequency (0.5-3MHz), and therefore inaudible.

Ultrasound energy is provided through a treatment device, which is continuously moved across the skin surface of the treatment area using a lubricant. This may be a gel, such as KY Jelly or special creams, or water. The lubricant or 'couplant' is required to allow the treatment device to move smoothly across the skin and to provide coupling between the ultrasound generator and the client's tissue. It is important that there is a steady movement of the ultrasound head over a very-local treatment area to ensure a uniform dose to the target tissues, and to eliminate the risks of damage due to local high intensity 'hot spots'.

Heating is reduced by 'pulsing', and therefore higher intensities can be safely used in a pulsed treatment because the average heating produced is reduced. Pulsing also reduces the risk of damage due to the formation of tiny gas bubbles (cavitation).

Use

Mild heating due to ultrasound can reduce pain and muscle spasm, and promote healing processes. It may produce a form of micro-massage which could reduce swelling. Ultrasound is also used to assist the penetration of drugs through the skin (phonophoresis).

The treatment dose is calculated in terms of energy density (not the same as energy output), frequency and time. The position of the patient is chosen so that the area to be treated is accessible and supported. The surface of the skin to be treated is cleaned with an alcohol wipe, before application of the gel.

Contra-indications

The following *must* be avoided with ultrasound:

- treatment during pregnancy
- the genitalia or tumours or tissue in pre-cancerous states, due to the increase in cellular division
- implants such as a pacemaker, or hearing aid, due to possible disruption of the body's electrical balance
- infected areas or tuberculous regions, due to the possibility of spreading infection or reactivating encapsulated lesions
- circumstances where haemorrhaging may be provoked, or in areas of recent venous thrombosis, to avoid the possibility of an embolus forming.

Safety precautions

It is important that the treatment head is moved continuously across the treatment area for the following reasons:

- ensuring the uniformity of the ultrasound beam over the treatment area
- improving the energy absorption of the tissues
- reducing the likelihood of formation of standing waves, which may damage tissue and lead to thrombus formation.

FARADIC TREATMENT

Also known as electromotor stimulation (EMS), there are two main categories of faradic machines, producing a pulsated direct current, or low-frequency current.

In both, the current passes through two electrodes applied at different points on the skin over the muscle being treated. Both are used as a passive muscle exerciser for toning very specific areas. EMS is used in cases where taking active exercise may not be possible for medical reasons. The low-frequency current, in particular, is used for facial muscle toning, and for line and wrinkle elimination.

Hazards include:

- muscle fatigue
- electrocution
- local infection
- chemical burns
- allergy to pads
- heat burn can be caused by currents of sufficient intensity, leading to heating in the tissues
- powerful and/or prolonged muscle contraction can occur, including damage to the heart muscle, which could stop the circulation.

Contra-indications

General precautions for electrotherapy include prevention of strong muscle contraction, which might cause joint or muscle damage, detachment of a thrombus, spread of infection, and haemorrhage; and stimulation of autonomic nerves that might cause altered cardiac rhythm or other autonomic effects.

Currents might be unduly localised due to open wounds or skin lesions (eg, eczema), and might provoke undesirable metabolic activity in cancerous tissue or in healed tuberculous infections. Currents which are not evenly biphasic can lead to possible skin damage or irritation, especially if there is loss of sensation.

Treatment during pregnancy, or treatment of patients with implants, such as a pacemaker, should be avoided.

Practitioners must be professionally qualified before attempting such treatments.

Safety precautions

- the electrode pads must be placed correctly and strapped securely

- the current must not change in intensity too rapidly or the pain receptors of the skin may be stimulated, in addition to the muscle

- the treatment is ineffective in the case of obese clients, as the electrical current cannot penetrate the thick layer of subcutaneous fat to reach the muscle

- between uses, the electrode pads must be disinfected in hypochlorite solution, and thoroughly rinsed. The securing straps should also be washed.

GALVANIC SKIN TREATMENT

The galvanic machine produces a direct current, which travels through the skin across two electrodes. It is used on the face to introduce cosmetic products into the intact skin during iontophoresis, and for deep skin cleansing during desincrustation.

The galvanic current produces a chemical effect within the skin. Around the negative electrode (cathode) there is increased alkalinity, which is used to reduce the oiliness of the skin, and to break down the keratin of the dead skin cells. These effects are used in desincrustation.

When used for iontophoresis, positive and negative ions may be driven into the skin to hydrate facial tissues or soften areas of cellulite.

Safety precautions

The size of the current should be changed gradually, and electrodes must stay in contact with the skin while the machine is operating:

- the electrode pad should be strapped securely, and evenly soaked with the electrolyte solution to prevent local galvanic burns

- the intensity of the current should be reduced where bony regions of the face are being treated - the absence of softer tissues causes reduced resistance to the current and local galvanic burns may occur

- if the current is too strong, a galvanic burn may be produced in the skin due to high alkalinity

- if the two electrodes are allowed to touch while the machine is operating, short circuiting may occur.

Clients' skin should be washed immediately after the treatment to remove the alkaline solution produced by the treatment, which will soften the skin and cause redness in the vicinity of the electrode.

MISCELLANEOUS TREATMENTS
Audiosonic vibrator

The purpose of the treatment is to increase the rate of blood flow to the skin, connective tissue and muscles.

Audible vibrations are created by a coil moving to and fro, the effect of which is transferred to an applicator placed on the skin. The vibration penetrates to the muscles lying below the skin, where they produce heat (for treating fibrositis), and increase blood flow. As there is no surface effect from the audiosonic vibrator, it can be used on the face and on more mature skins.

Safety precautions

- powder should be used as a lubricant when plastic applicators are used

- sponge applicators should be used where gentler stimulation is necessary; eg, over bony areas of the face

- applicators should be disinfected before use.

Belt massager (heavy vibrator)

The purpose of the treatment is to increase the rate of blood flow to the skin and muscles, especially the thighs and the hips.

An electric motor rotates a disc causing the end of a canvas belt (to which it is attached) to produce vibratory movements along the length of the belt. This vibration stimulates the muscles of the thighs and hips, and improves the drainage of tissue fluid. It may cause some erythema due to frictional heating of the skin.

Safety precautions

- the belt should be disinfected before use

- clients with rheumatic conditions who are likely to bruise easily, or those with back problems should not have this treatment.

Gyratory vibrator

An applicator, driven by an electric motor, is used on the body to increase the rate of blood flow to the skin and muscles.

The friction between the vibrator and the skin produces heat and may result in erythema.

Safety precautions

- the applicator heads must be parallel with the skin surface during the treatment to give uniform pressure

- a powder lubricant should be applied to the skin before starting the treatment

- after use, the applicator heads should be washed with hot water and detergent, and dried with a paper towel. Alternatively, a 70% alcohol or ethanol/chlorhexidine wipe may be used for disinfection

- bruising may occur if the treatment is prolonged, or an unsuitable applicator is used.

Percussion vibrator

This treatment is used to mechanically-massage localised areas of the body.

An applicator, driven by an electric motor, applies a tapping motion on the skin surface. Different types of applicator are used for different body regions; eg, a sponge applicator is used for facial work. The tapping movements cause frictional heat, which dilates the blood vessels in the skin. This increases the rate of blood flow, and the activity of the sebaceous glands. Superficial dead skin scales are loosened and removed.

Safety precautions

- the applicator heads must be parallel with the skin surface during the treatment to give uniform pressure.

- a powder lubricant should be applied to the skin before starting the treatment.

- after use, the applicator heads should be washed with hot water and detergent, and dried with a paper towel. Alternatively, a 70% alcohol or ethanol/chlorhexidine wipe may be used for disinfection

- bruising can occur if the treatment is prolonged or an unsuitable applicator is used

- percussion vibration should only be used on a client's face with great care.

High-frequency machine

The high-frequency machine is used in facial treatments, by two methods. The direct method of treatment is used on oily skins to dry spots and leave a barrier over the infected area. This is done by very short pulses of electrical current flash across a spark gap inside the glass electrode which is placed on the client's skin.

The indirect method is used on mature or dehydrated skin to stimulate circulation and improve the texture and colour of the skin. The client is part of the electrical circuit, and holds a glass electrode (saturator) which is connected to the machine.

The machine transforms the frequency of the current from the 50Hz of the mains electric supply to above 100,000Hz. The voltage is also increased to 2,000V by a transformer, but the current is small and remains on the surface of the skin - it does not penetrate into the deeper tissues.

Safety precautions

- metal objects, such as jewellery, should be removed as they may heat-up and cause burning

- electrodes should be disinfected before and after use; 70% alcohol may be used for this purpose

- the intensity should be reduced to zero and the current switched off before the electrode, or the therapist's hand, is lifted from the skin. Sudden breaks in the circuit may cause the client to feel discomfort.

Shorter treatment times are required for dry or mature skins. The ozone produced by the electric arcing (sparking) is toxic at higher concentrations. The sparking itself may cause alarm in some clients.

Interferential machine

The interferential machine contains two oscillators which produce currents of slightly-different frequencies. As these two currents flow through the same region of tissue, they mix to provide an interferential current, whose frequency is the difference between the frequencies of the currents actually supplied ('beat' frequency), in the region of 0-100Hz.

Low-frequency interferential currents cause muscle contraction. Higher-frequency interferential currents (close to 100Hz), do not cause muscle contraction, but increase the rate of blood and lymph flow and have an analgesic effect - the desired effect.

Vacuum suction

An electric motor drives a vacuum pump, which is attached to a suction cup, placed on the client's skin surface. The partial vacuum produced beneath the skin causes it to arch upwards into the cup. This stimulation brings an increased blood circulation and lymph movement to the treated area of the skin.

Safety precautions

- the cup should be disinfected before use with 70% alcohol

- the skin should be lubricated with massage cream or oil so that the suction cup will slide easily over the skin

- the intensity of the vacuum pump should be tested first, and the glass applicator should not be more than one third full of flesh

- suction should not be applied to lymph glands, but only over lymph vessels

- too rapid increase in vacuum will increase suction, to the extent that bruising and tearing of the skin may occur.

RESPONSIBILITIES

The business operator must:

- take all reasonable precautions for the safety of all persons using the premises, ensuring compliance at all times with the relevant provisions of the 'Health and safety at work etc act 1974', and associated legislation

- carry out, and implement the findings of, a risk assessment of the business as required by the 'Management of health and safety at work regulations 1999'

- ensure that a 'responsible person' is in charge of the premises at all times, and that they are familiar with, and implement, the requirements of the relevant codes of practice

- notify the Council in writing of any proposed change in his name or private address, of changes in the business address, of major changes in the treatments provided, or in the nature of the business carried on at the premises.

RESPONSIBLE PERSON

The business operator must ensure that a 'responsible person' aged 18 years or more is in charge of the premises at all times during business hours. The responsible person must be nominated, in writing, by the business operator, and this notification should be continuously available for inspection at the premises.

The responsible person must be familiar with, and implement, the requirements of the relevant 'best practice guidance', and must:

- be in charge of the premises

- be on site at all times when the public have access to the premises

- be assisted as necessary by suitable persons, aged 18 years or more, to ensure adequate supervision

- not be engaged in any other duties which will prevent him/her from exercising general supervision.

CLEANLINESS

For the purposes of cleanliness, the following points should be observed:

- all instruments, towels, materials and equipment used on the premises must be appropriately cleaned, disinfected and/or sterilised

- tables, couches and seats should be covered with a disposable paper sheet, which must be changed for each client

- a 'no smoking' notice(s) should be displayed in the treatment area(s).

PERSONAL HYGIENE

Any person carrying out any special treatment must ensure that:

- any open boil, sore, cut or other open wound is effectively covered by a waterproof dressing

- they do not carry out any special treatment if suffering from an acute respiratory infection

- hands are kept clean, and washed immediately prior to carrying out any treatment

- they refrain from smoking or consuming food and drink during the course of the treatment.

INFECTION CONTROL

All operators must wear clean, washable clothing.

Hands and nails should be washed with soap under running water prior to any treatment.

Single-use sterile needles (probes) and lances are recommended. One needle may be used repeatedly on an individual client during an individual session, and then discarded to a 'sharps' box. A new single-use needle is to be used on the next client.

Re-usable equipment (eg, forceps or manicure implements) must be effectively sterilised, using the following procedure:

• pre-soak in water

• put through an ultrasonic cleaner using the recommended detergent

• rinse

• air dry

• sterilise in a bench-top autoclave, making sure items of equipment do not overlap each other and that hinged items are in the open position

• store in sterile conditions and covered for use

• items not used within two to three hours to be re-sterilised

• wooden items (such as spatulas), and disposable materials and equipment to be disposed of after single use

• any razors used on a client to be disposed of as a 'sharps'.

Only autoclaves which are CE marked or which comply with BS 3970:Part 4:1990 are suitable.

All gowns, wraps or other protective clothing, paper or other covering, towel, cloth or other such articles used in treatment shall be clean, in good repair, and so far as is appropriate, sterile. Where these materials are not single-use consumables, they should be laundered after single use.

All hard surfaces must be cleaned and disinfected before and after each client.

LOCAL AUTHORITY AUTHORISED OFFICERS

Authorised officers carry written authorisations and proof of identity, which they will produce on request. They must be admitted during opening hours, and at any other reasonable time, to all parts of the premises. An officer may be accompanied by anyone else who is deemed necessary for the purposes of the inspection, for example, a medical practitioner.

CONDUCT OF THE BUSINESS

The responsible person shall ensure full compliance with the latest version of the relevant trade association's code of ethics and best practice guidance, where available. The minimum standards of conduct are produced in 'Appendix 1'.

REGISTRATION CERTIFICATE

The registration certificate shall be conspicuously displayed at all times in the public area of the premises. It must be clearly visible by all persons using the premises. It shall be adequately protected against theft, vandalism or defacement.

INSURANCE

The business must have third party liability, to cover claims for damages or negligence, as well as Employer's Liability insurance, where appropriate.

Operators shall display their current certificate of insurance.

OPERATORS

Treatment shall only be given by operators who have met the criteria for training and competency. All operators shall display a name badge in a manner approved by the council. The name shall correspond with that shown on their record of training/competency.

TRAINING/COMPETENCY

All persons carrying out treatments shall hold a relevant qualification as recognised by the relevant professional association and national examination boards. They must be able to demonstrate competency (see 'Appendix 2').

Details of qualifications, apprenticeship period, and any other training must be available for inspection at all times.

PREMISES

The following points shall be adhered to:

• all internal walls, doors, windows, partitions, floors, floor coverings, and ceilings, must be kept clean and in such good repair as to enable them to be effectively cleaned

• effective pest control measures, such as pest proofing, and appropriate treatments should be carried out, as necessary, and proper records kept

• the floor of the treatment area should have a smooth, impervious surface

• the treatment area must be solely used for giving treatments, and must be completely separated from all other rooms (for example, any room used for human habitation, catering establishment, hair salon, retail sales, or other) by full height walls or partitions

• there should be a minimum of 5m^2 of floor space for each operator in the establishment

• no animals of any kind should be permitted in a treatment area, except service animals used by persons with disabilities, for example, guide dogs for the blind

• suitable and sufficient means of heating to a reasonable room temperature, appropriate to the treatment offered, must be provided

• all furniture and fittings in the premises should be kept clean. Furniture in the treatment area (for example, tables, couches and seats) should be covered with a smooth, impervious surface, so that they can be effectively cleaned

• there should be an adequate, constant supply of clean hot and cold water at a hand basin, as well as sanitising soap or detergent and disposable towels. The wash basin should be easily accessible to the operator and be for his/her sole use. Taps should preferably be wrist- or foot-operated

• there should be suitable and sufficient sanitary accommodation for therapists and clients

• there must be adequate, clean, and suitable storage for all items, so as to avoid, as far as possible, the risk of contamination

• suitable screening to provide privacy must be provided

• the premises must be adequately ventilated.

TARIFF

A comprehensive tariff should be prominently displayed which can be easily seen by all persons entering the premises.

REGISTRATION CERTIFICATE

A current registration certificate should be conspicuously exhibited at all times to the satisfaction of the local authority. It must be clearly visible by all persons using the premises, and adequately protected against theft, vandalism or defacement.

RECORD KEEPING AND INFORMATION

A record must be kept of the establishment, including the name and address, hours of operation, and owner's name and address.

A copy of this 'Best practice guidance' should be kept on public display.

A complete description of all electro therapy procedures performed should be kept.

No person under 16 years of age should be permitted to use a solarium or sunbed.

Confidential records, including name, address, date and type of treatment received should also be kept for all treatments for a period of at least three years after the treatment has finished. They must be made available to the authorised officer upon request, and with the client's written consent.

Any contra-indications, for example heart conditions (eg, use of a pacemaker), diabetes, epilepsy, etc for each treatment must be discussed with the client prior to any treatment. In cases of medical referral, the practitioner must keep a copy of the GP's letter with the client record.

Clients should be given written information to take away about the contra-indications and risks of treatment. This should be noted on their record card, which they should sign and date.

There should be a prominently-displayed notice giving the name, address, and phone number of the local health authority and environmental health department, so that the public can report complaints or seek additional information.

The notification shall be made as soon as practicable.

FIRST AID

There must be a first-aid kit on site that complies with the 'Health and safety (first aid) regulations 1981'. There are no specific mandatory items which must be included in a first-aid box.

The Health and Safety Executive has issued a recommended list of contents. Where the risk assessment as revealed no special hazards, a minimum stock of first-aid items includes:

• a leaflet giving general guidance on first-aid (for example, the HSE leaflet 'Basic advice on first aid at work')

• 20 individually-wrapped sterile adhesive dressings, of assorted sizes, appropriate to the type of work

• two sterile eye pads

• four individually-wrapped triangular bandages

• six safety pins

• six medium-sized individually-wrapped sterile, unmedicated wound dressings (approximately 120x120mm)

• two large sterile individually-wrapped unmedicated wound dressings (approximately 180x180mm)

• one pair of disposable gloves.

First-aid kits for travelling practitioners (ie, staff who frequently carry out domiciliary visits) would typically contain:

• a leaflet giving general guidance on first-aid (eg, HSE leaflet 'Basic advice on first aid at work')

• six individually-wrapped sterile adhesive dressings

• one large sterile individually-wrapped unmedicated wound dressing (approximately 180x180mm)

• two triangular bandages

• two safety pins

• individually-wrapped moist cleansing wipes

• one pair of disposable gloves.

WASTE

The 'Environmental protection (duty of care) regulations 1991' impose a duty of care on waste producers to ensure that all refuse, particularly clinical waste such as used swabs which have been in contact with the skin, is collected and disposed of by a registered waste carrier at an approved incinerator.

A copy of the current contract for the removal of such waste, and contractor's licence and transfer notes, must be available for inspection on the premises at all times.

Rubbish should be stored in covered receptacles and suitable arrangements should be made for its proper disposal.

APPENDICES

APPENDIX 1: CODE OF CONDUCT

The responsible person must ensure the following:

• good order and moral conduct in the premises

• no poster, advertisements, etc, shall be displayed which is unsuitable for general exhibition

• no part of the premises is used by persons for soliciting or other immoral purposes

• additional custom will not be sought through solicitation outside, or in the vicinity of the premises

• all clients in any part of the premises shall be decently and properly attired, unless receiving treatment in accordance with the relevant codes of practice

• neither the operator nor the client shall be under the influence of drugs, alcohol or other substances.

APPENDIX 2: TRAINING AND COMPETENCY

The NVQ/SVQ Level 2 in Beauty Therapy is the accepted minimum starting qualification for a beauty therapist. However, NVQ/SVQ Level 3 is the more usual level of qualification.

Other qualifications include BTEC Higher national diploma in beauty therapy, and BTEC National diploma in science and beauty therapy.

Training organisations

Confederation of International Beauty Therapy and Cosmetology (CIBTAC)
British Association of Beauty Therapy and Cosmetology Limited
Administration Office, BABTAC House, 70 Eastgate, Gloucester GL1 1NQ
Tel: 01452 421114

The City and Guilds of London Institute
1 Giltspur Street, London EC1A 9DD
Tel: 020 7294 2468. Fax: 020 7294 2400
Web site: app1.city-and-guilds.co.uk/default0.htm

Other organisations

British Association of Beauty Therapy and Cosmetology Limited
Administration Office, BABTAC House, 70 Eastgate, Gloucester GL1 1NQ
Tel: 01452 421114

Guild of Professional Beauty Therapists
Guild House, PO Box 310, Derby DE23 9BR
Tel: 01332 771714. Fax 01332 771742
Web site: www.beauty-guild.co.uk/

Hairdressing And Beauty Industry Authority
Fraser House, Nether Hall Road, Doncaster DN1 2PH
Tel: 01302 380000
E-mail: enquiries@habia.org.uk
Web site: www.habia.org.uk/

For sunbed etc use:

Institute of Leisure and Amenity Management
ILAM House, Lower Basildon, Reading RG8 9NE
Tel: 01491 874800. Fax: 01491 874801
Email: info@ilam.co.uk
Website: http://www.ilam.co.uk/about.htm

Institute of Sport and Recreation Management
Giffard House, 36/38 Sherrard Street, Melton Mowbray LE13 1XJ
Tel: 01664 565531
Website: http://www.isrm.co.uk/

APPENDIX 3: SUPPORTING INFORMATION
Relevant legislation

Business operators should familiarise themselves with the following legislation:

• *Control of substances hazardous to health regulations 1999:* chemicals and biohazard substances, for example, disinfectants, body fluids, contaminated equipment and wastes, etc, shall be assessed in accordance with the requirements of these regulations (SI 1999/437 at the time of writing, but subject to regular update). The outcome of the risk assessment must be used to implement safe working practices.

• *Controlled waste regulations 1992:* requires that all clinical waste (used needles, soiled dressings, used swabs) is collected and disposed of by a licensed contractor in an approved incinerator.

• *Disability discrimination act 1995:* access should be provided for disabled people at the premises.

• *Electricity at work regulations 1989:* requires all portable electrical appliances used within the premises are to be maintained regularly.

• *Health and safety at work etc act 1974:* requires employers and self-employed people to ensure the health, safety and welfare of persons attending their businesses.

• *Management of health and safety at work regulations 1999:* the business operator shall carry out, and implement the findings of, a workplace risk assessment of the business. The outcome of the risk assessment must be used to implement safe working practices.

• *Provision and use of work equipment regulations 1998:* requires prevention or control of the risks to human health and safety from equipment used at work. Basically, work equipment must be suitable for its intended use; safe for use, maintained in a safe condition and, where necessary, inspected; only used by adequately informed, instructed and trained people; accompanied by suitable safety measures. The Regulations cover all equipment used by employees at work, regardless of whether it is supplied by the employer or employee. Powered equipment for use at work must have the 'CE marking', to demonstrate it conforms with relevant European safety standards.

• *Reporting of injuries, diseases, and dangerous occurrences regulations 1995:* requires employers to report certain categories of workplace accidents and serious incidents and infections which result from a work activity. The incident should be reported to the HSE's Incident Contact Centre, via the telephone (0845 300 9923) or fax (0845 300 9924), by post to Incident Contact Centre, Caerphilly Business Park, Caerphilly CF83 3GG, or e-mail to 'riddor@natbrit.com'. Further information is available on the website 'www.riddor.gov.uk'

Nuisance/complaints

The operator must ensure that there is no noise or other type of nuisance arising from the operation of the business.

Maintenance

All systems, for example, fire-safety equipment, boilers, electrical equipment, etc, housed in the premises must be maintained regularly by competent persons, and maintenance records kept.

All equipment used in connection with special treatments shall be serviced/maintained in accordance with the manufacturers/suppliers recommendations, and records kept.

Electricity

The business operator shall ensure that all portable electrical appliances used within the premises are checked regularly and maintained in accordance with the 'Electricity at work regulations 1989'; see 'Relevant legislation'. Records of maintenance checks must be available on the premises.

The business operator must also ensure that the fixed electrical installation is inspected by a competent electrical engineer, and that a copy of the current certificate is available at the premises.

Fire precautions

All fire exits, staircases and other means of escape must be kept unobstructed, immediately available, and clearly signed, in accordance with the council's requirements, and any requirements of the fire authority.

All fire-resistant and smoke-stop doors must be maintained self closing, and must not be secured open.

All exit doors must be available for access and egress whilst the public are on the premises.

A notice, or notices, reading 'No Smoking' should be prominently displayed within the treatment area.

WATER TREATMENTS

This 'best practice guidance' covers treatments involving facial steamers, steam baths, saunas, flotation tanks and spa baths (also known by the trade name 'Jacuzzis').

RESPONSIBILITIES

The business operator must:

- take all reasonable precautions for the safety of all persons using the premises. He/she will ensure compliance at all times with the relevant provisions of the 'Health and safety at work etc act 1974', and associated legislation; see 'Relevant legislation'

- carry out and implement the findings of a risk assessment of the business as required by the 'Management of health and safety at work regulations 1999'

- ensure that a 'responsible person' (see 'Responsible person', below) is in charge of the premises at all times, and that he/she is familiar with and implements the requirements of the relevant codes of practice

- ensure that all persons carrying out treatments covered by this code are suitably qualified or trained, and are competent (see 'Training/competency')

- notify the local authority in writing of any proposed change in his/her name or private address, of changes in the business address, or substantial changes in the nature of the treatments or procedures carried out on the premises.

RESPONSIBLE PERSON

The business operator must ensure that:

- a responsible person is nominated, in writing, by the business operator, and that this notification is continuously available for inspection at the premises

- the responsible person is in charge of the premises, and is on site at all times when the public have access to the premises

- the responsible person is not engaged in any other duties which prevent them from exercising effective supervision

- the responsible person is assisted, where necessary, by suitable adult persons to ensure adequate supervision of the business.

CONDUCT OF THE BUSINESS

The business operator shall ensure the following:

- good order and moral conduct in the premises

- all clients in any part of the premises are decently and properly attired, unless receiving treatment in accordance with this 'best practice guidance'

- neither the operator nor the client shall be under the adverse influence of drugs, alcohol or any other substance.

TREATMENTS AND RELATED HAZARDS

Spa bath

Clients relax in a bath of warm water at 32-40°C, recirculating under pressure, into which air is pumped to give a massage effect. Benefits are said to include relaxation and softening/cleansing of the skin.

Hazards

- Legionellosis: *Legionella pneumophila* proliferates in water at temperatures between 20°C and 45°C, but is killed at higher temperatures

- drowning, through loss of consciousness or falling asleep

- scalding

- poor hygiene, leading to local infections

- slipping, tripping and falling.

Safety precautions

Management of the spa to avoid risk of infection by *Legionella pneumophila* (Legionellosis) involves:

- maintaining effective water pH and residual disinfectant levels (see note below)

- emptying and re-filling the spa regularly (at least every 8-12 weeks)

- operating the water circulation system for at least three hours every day, and preferably continuously

- operating all water jets for at least one hour per day

- draining the pool if it is to remain unused for five days or more.

Disinfection should be continuous and automatic, with regular testing of the water for residual disinfectant and pH. The standards are (based on free chlorine): pH, between 7.4-7.6, within the acceptable range of 7.2-7.8; chlorine residual, 1.0-3.0mg/l, with 1.5-2.0mg/l preferred.

High bathing loads imply short recirculation periods of the spa water (between five and 30 minutes), increased frequency of emptying and re-filling of between one and seven days, and effective control of bathing loads, including intervals between sessions to allow water quality to recover. It is important to prevent formation of a biofilm (slime) in the water circulation system. This is achieved through effective disinfection and regular cleaning of the system.

Entry to the pool should be by easily-graded steps, and tiling should be non-slip and sympathetic to wet skin.

Where clients may be left unattended, there must be an easily accessible, non-verbal means of summoning help, which can be readily heard by the responsible person.

Those under the influence of alcoholic drink should be excluded from the spa pool.

Sauna

Saunas are available for indoor or outdoor use. Clients relax in a heated wooden cabin, with an air temperature in the approximate range 80-100°C for a ~10-minute treatment. The cabin contains a stove with an electric element, which heats rocks; water is poured onto the hot rocks to produce steam. Clients sit or lie on wooden benches. The sauna cabin may require a 60-90 minutes warm-up period to reach the required operating temperature.

The heat increases the rate of blood and lymph flow due to vasodilation. There is a fall in blood pressure, the pulse rate rises, and sweating increases.

Hazards

• stove heating elements can cause fires and burns, so must be effectively guarded and protected by an earth-leakage circuit breaker of no more than 30mA sensitivity

• clients often overestimate their tolerance of heat. BS EN 563:1994 indicates a surface temperature (eg, wooden seat) of 48°C is the human skin burn threshold for contact with smooth wood, although it is noted this threshold is subject to a large degree of uncertainty

• electrocution (see note above on use of an earth-leakage circuit breaker)

• slipping, tripping and falling.

Safety precautions

The responsible person shall ensure:

• clients are observed for signs of faintness during the sauna

• clients rest for at least half-an-hour after treatment

• a cool shower is available

• the temperature control is under their control

• thermometer and relative humidity gauge are provided within the sauna cabin (mercury thermometers are *not* suitable)

• clients are observed periodically through a viewing panel

• where clients may be left unattended, there must be an easily accessible, non-verbal means of summoning help, which can be readily heard by the responsible person

• clients are advised as to a good bathing regime.

Clients should be able to see a clock in order to monitor the time that has elapsed in the sauna cabin.

Those under the influence of alcoholic drink should be excluded from the sauna.

Steam bath/Turkish bath

Clients sit in a cabinet, in which warm air with a relative humidity of 95% circulates around the body. This preheats the body prior to massage, deep cleanses the skin, and promotes relaxation. In other cases, the 'steam' is experienced in a room fitted with benches on which the clients recline. The air temperature is regulated by a thermostat to an absolute maximum of 50°C.

In steam cabinets, the water tank is thermally insulated and surrounds the entire body, except for the head which projects from the top of the tank. In Turkish baths, the steam is generated externally in a boiler or cartridge. There is a thermal cut-out device in case the water level in the tank falls below the level of the heating element.

The heat increases the blood flow rate due to vasodilation. Sebaceous gland activity increases, and the muscles relax.

Hazards

• fainting may be induced in clients with low blood pressure or those following a low-calorie diet regime

• electrocution: electric steam generators should be fitted with a dedicated earth-leakage circuit breaker of no more than 30mA sensitivity.

Safety precautions

The operator should discuss the client's medical history to discover whether they have experienced:

• diabetes

• heart disease

• high or low blood pressure

• seizures; eg, epilepsy

• conditions requiring blood thinning medication; eg, aspirin or other anti-coagulant drug.

Where any of the above conditions exist, or there is a past history, written authorisation from the client's doctor is required. Clients under the influence of alcohol, or those who have recently eaten a meal should be excluded from steam baths.

Other general precautions include:

• where the client may be left unattended, there must be an easily accessible, non-verbal means of summoning help, which can be readily heard by the responsible person

• a towel soaked in cold water should be placed around the client's neck to keep steam away from the head

• the slatted seat over the water tank should be covered with a towel to protect the skin of the buttocks

• there should be an internal handle to allow the client to exit the cabinet immediately, should he/she feel any discomfort

• the responsible person must make regular temperature and pulse checks throughout the treatment

• a cool shower is available, or a cooling-down period of at least half-an-hour following treatment, before the client leaves the premises.

Those under the influence of alcoholic drink should be excluded from the Turkish bath.

Facial steamer

A facial steamer is used for heating the skin to increase the absorption of cosmetics, such as masks or face packs; it is also used for deep-cleansing of the skin. Water vapour is directed onto the face, where it increases sweating, vasodilation, and the rate of blood flow.

The steaming equipment is a boiler using distilled water to avoid problems of scaling. The steamer may contain a source of ultraviolet radiation with the aim of producing small quantities of ozone. Exposure to ozone in moderation is said to have health benefits, however the current occupational exposure standard for ozone is 0.2ppm in air (15-minute reference period) and a COSHH risk assessment must be carried out for anyone exposed in this way.

Hazards

• electrocution

• scalding

• exposure to ozone and/or high-intensity ultraviolet light.

Flotation tanks

Clients float on their backs in a closed flotation tank (approximately 2.5x2.0x1.5m) containing a 25% solution of Epsom salts (magnesium sulphate), in a warm, dark and silent environment. The tank contains water at normal skin temperature (~34°C) and is around 250mm deep. The concentration of salts is such as to assure buoyancy of the client, and the effects of gravity are almost completely eliminated.

Benefits are said to arise from depriving the body and mind of all external stimuli. The experience also inspires a deep sense of well-being and relaxation.

Hazards
- drowning, through loss of consciousness or falling asleep
- scalding
- infections through poor water quality.

Safety precautions

There must be an easily accessible, non-verbal means of summoning help, which can be readily heard or seen by the responsible person.

- provide an inflatable neck and head cushion to help the client be certain of remaining on their back while floating
- maintain the 25% salt concentration in the solution, which should be run continuously through a filter, or (at minimum) cycles the flotation tank water three times between uses
- bromine may be used as a sanitising agent, with a constant 2-4ppm of total residual bromine available in the solution. An ultraviolet-light sanitising unit provides disinfection in the solution recirculation (many clients find the characteristic odour of chlorine intrusive)
- it is important to prevent formation of a biofilm (slime) in the water circulation system. This is achieved through effective continuous disinfection and regular cleaning of the system
- a remote-control unit monitoring the water temperature and filtration should be provided outside the float room to enable the responsible person to monitor and control the tank's systems at all times, while preserving the total privacy of the customer during the float session
- locate a light switch inside the float room
- the door of the flotation tank should not be equipped with a locking device
- make a shower available to wash away the flotation tank salts

Floating is not suitable for children, and those under the influence of alcoholic drink should be excluded from the flotation tank.

PREMISES

The following points must be observed:

- internal walls, doors, windows, partitions, floors, floor coverings, and ceilings must be kept clean and in such good repair as to enable them to be effectively cleaned
- effective pest-control measures, such as pest proofing, and appropriate treatments should be carried out as necessary, and proper records kept
- the floor of the treatment areas should be provided with a smooth, impervious surface
- no animals of any kind should be allowed in a premises providing any of the special treatments covered in this 'best practice guidance', except service animals used by persons with disabilities (eg, guide dogs for the blind)

- all furniture and fittings in the premises should be kept clean; furniture in the treatment area (such as tables, couches and seats) should be covered with a smooth, impervious surface, to enable effective cleaning
- there must be suitable and sufficient sanitary accommodation for clients and staff
- the premises must be adequately lighted and ventilated
- there must be suitable and sufficient means of heating to a reasonable room temperature, appropriate to the treatment provided
- suitable screening to enable privacy must be provided.

CLEANLINESS

For the purposes of cleanliness, the following points should be adhered to:

- all towels, materials and equipment used in the premises must be appropriately cleaned, disinfected and/or sterilised as appropriate
- 'No Smoking' notices should be displayed in all treatment areas
- pool, flotation tank, steam bath and sauna areas should be cleaned daily, and cleaned weekly using a solution containing at least 200mg/l of free chlorine
- 'Clean' and 'dirty' areas should be established on the premises; only suitable footwear should be worn in the clean area. A marked container should be provided for used overshoes
- where cubicles, benches, tables or couches are used, they must be thoroughly cleaned at the end of each working day.

WASTE

Waste must be stored in covered receptacles, and arrangements made for its proper disposal via a registered waste carrier.

TRAINING AND COMPETENCY

All persons carrying out any of these special treatments must attend a relevant course, for example, one run by a recognised trade organisation or local authority (see below).

All persons carrying out any of these special treatments must be able to demonstrate continuing training or improvement of their competency in line with changes in the types of treatment offered.

Full records must be kept on the premises of all qualifications, courses attended, including dates, titles of courses, and venues. These details must be available for inspection at all times.

PROFESSIONAL ORGANISATIONS

British Association of Beauty Therapy and Cosmetology Limited
Administration Office, BABTAC House, 70 Eastgate, Gloucester GL1 1NQ
Tel: 01452 421114

City and Guilds of London Institute
1 Giltspur Street, London EC1A 4DD
Tel: 020-7294 2800
Web: http://www.city-and-guilds.co.uk

Guild of Complementary Practitioners
Liddell House, Liddell Close, Finchampstead, Berkshire RG40 4NS
Tel: 0118 973 5757. Fax: 0118 973 5767
E-mail: info@gspnet.com.
Website: http://www.gcpnet.com

Institute of Leisure and Amenity Management
ILAM House, Lower Basildon, Reading RG8 9NE
Tel: 01491 874800. Fax: 01491 874801
E-mail: info@ilam.co.uk.
Website: http://www.ilam.co.uk/about.htm

Institute of Sport and Recreation Management
Giffard House, 36/38 Sherrard Street, Melton Mowbray LE13 1XJ
Tel: 01664 565531
Website: http://www.isrm.co.uk/

TARIFF

A comprehensive tariff should be prominently displayed so that it can be easily seen by all persons entering the premises.

REGISTRATION CERTIFICATE

The registration certificate must be conspicuously exhibited at all times to the satisfaction of the local authority. It should be clearly visible by all persons using the premises, and adequately protected against theft, vandalism or defacement.

RECORD KEEPING AND INFORMATION

A record must be kept of the establishment, including the name and address, hours of operation, owner's name and address, and a complete description of all special treatments provided.

A copy of this 'best practice guidance' should be available on the practice premises.

Every client must read and sign a consent form, which contains details of name, address, age, medical history, etc, (see 'Appendix 1'). These forms should be kept for a period of at least three years, after the cessation of current treatment, and be available for inspection at all times in order that alleged cases of infection can be epidemiologically studied. It also enables checks on clients' ages.

Similarly, records including name, address, date and type of treatment received should be confidentially kept for all treatments, for a period of at least three years after the treatment has finished. They should be made available to the authorised officer (see 'Authorised officer').

Any contra-indications, eg heart conditions, diabetes, epilepsy, etc, for each treatment should be discussed with the client prior to any treatment.

FIRST AID

There must be a first-aid kit on site that complies with the 'Health and safety (first aid) regulations 1981'. There are no specific mandatory items which must be included in a first-aid box.

The Health and Safety Executive has issued a recommended list of contents. Where the risk assessment as revealed no special hazards, a minimum stock of first-aid items includes:

- a leaflet giving general guidance on first-aid (for example, the HSE leaflet 'Basic advice on first aid at work')

- 20 individually-wrapped sterile adhesive dressings, of assorted sizes, appropriate to the type of work

- two sterile eye pads

- four individually-wrapped triangular bandages

- six safety pins

- six medium-sized individually-wrapped sterile, unmedicated wound dressings (approximately 120x120mm)

- two large sterile individually-wrapped unmedicated wound dressings (approximately 180x180mm)

- one pair of disposable gloves.

INSURANCE

The business must have third party liability insurance, to cover claims for damages due to malpractice or negligence, as well as employer's liability insurance where appropriate.

LOCAL AUTHORITY AUTHORISED OFFICERS

Authorised officers carry written authorisations and proof of identity, which they will produce on request. They must be admitted during opening hours, and at any other reasonable time to all parts of the premises. An officer may be accompanied by anyone else who is deemed necessary for the purposes of the inspection, for example, an electrician or other specialist adviser.

APPENDICES

APPENDIX 1: CONSENT FORM

Name of premises:

Address of premises:

Local authority registration no:

	✓ ✗ or n/a
I declare that I give (full name of therapist) my full consent to (describe treatment) The information given below is true to the best of my knowledge. I have had/currently suffer from the following:	
heart condition/pacemaker	
epilepsy	
high or low blood pressure	
diabetes	
conditions requiring blood-thinning medication; eg, aspirin	
conditions requiring concurrent drug treatments, such as antihistamines, steroids and aspirin	
pregnancy	

I will follow the safety instructions, which have been given to me.					
Full name	Address	Age	Date of birth	Signature of client	Date

APPENDIX 2: TREATMENT RECORD INFORMATION

Client name	
Address	
Tel: work/home	
Date of birth	
General health	
Any contra-indications	
Date consent for treatment obtained (and signed for consent card)	
GPs name and address	
Is GP's consent required	
Date GP's consent obtained if necessary	
Any special medical/other information	
Treatment details	
Date of treatment(s)	
Name of practitioner	
Treatment history	
Signature/date of client:	
Signature/date of therapist/operator:	

COLON HYDROTHERAPY

This 'Best practice guidance' permits the practice of colon hydrotherapy (colonic irrigation), a form of water treatment for the elimination of waste from (and exercise of) the colon. It aims to restore and maintain the colon's proper function, as well as promoting health and well-being of the person concerned.

The treatment involves warm, filtered water being introduced into the client's colon via a speculum (a shaped tube) which is inserted about 50mm into the client's anus. The speculum remains in place throughout the treatment. Two tubes are connected to the external part of the speculum:

- a smaller-diameter tube which passes water under gravity from a feed tank, positioned no more than 1300mm above the surface of the mattress on which the client lies. This distance also applies to an enema bucket for implants, although the bucket is likely to be placed at a lower level

- a larger-diameter tube through which the colon contents are passed to a soil pipe via a water trap and anti-siphon valve. A section of this tube is transparent to enable the therapist to monitor the type and quantity of matter being removed from the colon.

While receiving the treatment, the client's abdomen is massaged by the practitioner to help loosen faecal impaction. The client holds the volume of water for a time period according to individual tolerance. Eventually, peristaltic contraction in the colon is naturally induced, and the client begins to expel faecal matter.

Hazards of bad practice

- infection

- trauma to the client's colon

- risk of indecency.

SAFE WORKING METHOD
Infection control

All operators must wear clean clothing. All gowns, wraps or other protective clothing, paper or other covering, towel, cloth or other such articles used in treatment must be clean, and in good repair.

Single-use, latex examination gloves should be used for treatments. Latex finger cots should be used over these for rectal examinations and discarded immediately after use.

A suitable lubricant should be used for insertion of the speculum or finger, with extra care given to prevent cross-contamination.

Disposable specula, obturators (a device serving to close an opening in the body) and any piping should be cleaned of any obvious soiling and disposed of safely as clinical waste.

Non-disposable specula and obturators must be cleaned thoroughly of gross contamination, rinsed and disinfected with a disinfectant according to the manufacturer's instructions before re-use.

All hard surfaces must be cleaned and disinfected before and after each client, especially surfaces subject to soiling, such as door knobs and toilet handles.

Water temperature

The temperature of the water delivered through the speculum should normally be between 33 and 40°C; it should *never* exceed 40°C.

Equipment

A suitable water filter should be fitted to all colonic-irrigation systems, and should be capable of reducing/removing particulate matter, dissolved organic and inorganic matter from irrigation water *before* it enters the client's colon. The filter element must be replaced at the manufacturer's recommended intervals.

Colonic machines should not have pumps or other pressure-enhancing devices, but should be equipped with non-return (to protect the water supply) and pressure-reducing valves. There should be a mechanical break between the mains water supply and the client.

Disinfectants

Disinfectants do not sterilise, they only reduce the number of some microbes. Disinfectants are needed for:

- cleansing the colonic machine

- wiping down the treatment couch

- table tops and general surfaces in the treatment area, including door knobs and toilet handles.

Recommended disinfectants include bleach for dealing with spillages of body fluids, and detergent-and-water for general cleaning and wiping down.

Where proprietary disinfectants are used to disinfect specula, obturators and other re-usable equipment, they should be used strictly according to their manufacturers' instructions.

See the Guide 'Infection control', for more details of cleaning and disinfection.

Faecal matter, vomit, etc, pose a health risk and must be cleaned up immediately using the following procedure:

- put on disposable gloves

- cover spillage with paper towels

- pour bleach on the spillage

- wipe up with towels and dispose of in a clinical waste (yellow plastic) sack

- discard gloves in a clinical waste (yellow plastic) sack

- wash hands thoroughly.

Personal hygiene

Any person carrying out any special treatment must ensure that:

- any open boil, sore, cut or other open wound is effectively covered by an impermeable dressing

- treatment is not carried out if they are suffering from an acute respiratory infection

- hands are kept clean, and washed immediately prior to carrying out any treatment

- they refrain from smoking or consuming food and drink during the course of the treatment

- they do not carry out any treatment if there is a likelihood that they will contaminate colonic irrigation equipment, supplies or working surfaces with body fluids or pathogenic organisms.

First aid

There must be a first-aid kit on site that complies with the 'Health and safety (first aid) regulations 1981'. There are no specific mandatory items which must be included in a first aid box.

The Health and Safety Executive has issued a recommended list of contents. Where the risk assessment as revealed no special hazards, a minimum stock of first-aid items includes:

- a leaflet giving general guidance on first aid (eg, HSE leaflet, 'Basic advice on first aid at work')
- 20 individually-wrapped sterile adhesive dressings (assorted sizes) appropriate to the type of work
- two sterile eye pads
- four individually-wrapped triangular bandages
- six safety pins
- six medium-sized individually wrapped sterile, unmedicated wound dressings (approximately 120x120mm)
- two large, sterile, individually-wrapped unmedicated wound dressings (approximately 180x180mm)
- one pair of disposable gloves.

CONDUCT OF THE BUSINESS

The business operator should ensure full compliance with this 'Best practice guidance'.

RESPONSIBILITIES

The responsibilities of the business operator include:

- taking all reasonable precautions for the safety of employees and clients using the premises
- carrying out a health-and-safety risk assessment of the business and implementing the findings, as required by the 'Management of health and safety at work regulations 1999'
- notifying the local authority in writing of any proposed change in his/her name or private address, of changes in the business address, of significant changes to the treatments provided, or to the nature of the business carried out on the premises.

RESPONSIBLE PERSON

The business operator should ensure that a responsible person is nominated, in writing, by the business operator, and this notification should be continuously available for inspection at the premises.

The responsible person must:

- be in charge of the premises, and be on site at all times when the public have access to the premises
- be familiar with, and implement, the requirements of the relevant codes of practice
- be assisted as necessary by suitable persons aged 18 years or over to ensure adequate supervision
- not be engaged in any other duties which will prevent him/her from exercising general supervision.

PRACTITIONERS

Treatment should only be given by practitioners who satisfy the criteria for training and competency.

TRAINING/COMPETENCY

All persons carrying out colonic irrigation must have successfully completed a relevant training course in colon hydrotherapy (see 'Appendix 3). Generally, they will already be qualified doctors, nurses or complementary medicine practitioners.

All persons must be able to demonstrate competency to the satisfaction of the local authority.

Full records must be kept on the premises of all qualifications, courses attended (with dates, and the titles of the courses, and awarding bodies) of all practitioners. These details must be available for inspection at all times. See 'Appendix 1'.

The following organisation holds a national register of practitioners and can advise on ethics and standards of practice:

Colonic International Association
16 Drummond Ride, Tring, Hertfordshire, HP23 5DE
Tel: 01442 827687
Website: http://www.colonic-association.com/

CLEANLINESS

All instruments, towels, materials and equipment used in the premises must be appropriately cleaned, disinfected and/or sterilised.

Tables, couches and seats should be wiped down with a suitable disinfectant between the treatment of each client, and thoroughly cleaned at the end of each working day.

A notice/s should be displayed to the effect that there is no smoking in the treatment area(s).

PREMISES

The following points should be observed:

- all internal walls, doors, windows, partitions, floors and floor coverings, and ceilings, should be kept clean and in such good repair as to enable them to be effectively cleaned
- the treatment area should be solely used for giving treatment, and must be completely separated from all other rooms (such as any room used for human habitation, catering establishment, hair salon, retail sales or other) by full-height walls or partitions
- effective pest control measures, such as pest proofing, and appropriate treatments must be carried out, as necessary, and proper records kept
- the floor of the treatment area must have a smooth, impervious surface
- there should be a minimum of 5m² of floor space for each operator in the establishment
- no animals of any kind should be allowed in an acupuncture establishment, except service animals used by persons with disabilities; eg, guide dog for the blind. Fish aquariums may be allowed in waiting rooms and non-procedural areas
- all furniture and fittings in the premises must be kept clean. Furniture in the treatment area (such as tables, couches and seats) must be covered with a smooth, impervious surface, so that they can be effectively cleaned
- there must be an adequate, constant supply of clean hot and cold water at a wash hand basin, liquid soap or detergent, and disposable towels, which is conveniently accessible to the practitioner and for his sole use. The taps should preferably be arm- or foot-operated
- there should be suitable and sufficient sanitary accommodation for operators and clients
- there should be adequate clean and suitable storage for all items, so as to avoid, as far as possible, the risk of contamination
- suitable and sufficient means of heating to a reasonable room temperature (16°C minimum), appropriate to the treatment provided must be provided
- suitable screening to provide privacy should be available
- adequate artificial lighting must be provided and maintained. A suitable overall standard of lighting would be 500 lux, with a higher level of 1,000 lux in all areas of the treatment room during the acupuncture procedure
- the premises must be effectively ventilated.

TOILET FACILITIES

A toilet should be conveniently located near the treatment room and reserved exclusively for clients' use during working hours. A waste bin, for the disposal of sanitary towels and soiled articles should be provided.

It is essential that the toilet facilities are regularly cleaned and disinfected.

A bidet, whilst not essential, is desirable; wet wipes should otherwise be provided.

RECORD KEEPING/INFORMATION

A record should be kept of every practitioner, including full names and exact duties, date of birth, gender, home address, home/work telephone numbers, and identification photos. See 'Appendix 1'.

A record should be kept of the establishment, including name and address, hours of operation, and owner's name and address

The following should also be noted:

- a copy of this 'Best practice guidance' should be kept on public display

- clients must be over the age of 18 years

- anyone under 18 years of age must be accompanied by a parent/guardian who should sign a consent form

- every client must read and sign a consent form, which contains details of name, address, age, medical history, etc. An example is attached in 'Appendix 4'. These forms must be kept for a period of at least three years after the cessation of current treatment, and should be available for inspection at all times so that alleged cases of infection can be epidemiologically studied with due urgency, as well as conducting checks on the ages of clients

- confidential records should be maintained for all treatments, giving name, address, date and type of treatment received, for a period of at least three years after the treatment has finished. They must be made available to the authorised officer upon request, and with the written consent of the client

- a notice must be prominently displayed giving the name, address, and phone number of the local health authority and environmental health department, so that the public can report complaints or seek additional information

- all infections and complications thought to result from an acupuncture procedure that become known to the operator must be reported to the local environmental health department within 24 hours.

A notice shall be prominently displayed giving the name, address, and phone number of the local Health Authority and Environmental Health Department, so that the public can report complaints or seek additional information.

All infections, complications or diseases resulting from any colonic irrigation procedure that become known to the business operator shall be reported to the local Environmental Health Department within 24 hours.

WASTE STORAGE

Refuse should be stored in covered receptacles and suitable arrangements should be made for its regular collection.

A copy of the current contract for the removal of such waste, including any clinical waste, together with a copy of the contractor's licence and transfer notes, must be available for inspection on the premises at all times.

TARIFF

A comprehensive tariff should be prominently displayed which can be easily seen by all persons entering the premises.

REGISTRATION CERTIFICATE

The registration certificate should be conspicuously exhibited in the practice reception area. It must be clearly visible by all persons using the premises.

INSURANCE

The business must have third party liability cover to insure claims for damages or negligence, as well as employer's liability insurance where appropriate.

LOCAL AUTHORITY AUTHORISED OFFICERS

Authorised officers carry written authorisations and proof of identity, which they will produce on request. They must be admitted during opening hours, and at any other reasonable time, to all parts of the premises. An officer may be accompanied by anyone else who is deemed necessary for the purposes of the inspection, for example, a medical practitioner or other specialist practitioner.

APPENDICES

APPENDIX 1: RECORD OF PRACTITIONERS

A record must be kept of every practitioner as follows:

Name and address of establishment	
Telephone number of establishment	
Name of practitioner	
Address of practitioner	
Gender	
Home telephone number	
Mobile telephone number	
Exact duties	
Attach current passport photo	

APPENDIX 2: CLIENT CONSENT FORM

Name of business:

Address of business:

Local authority registration no:

	✓ ✗ or n/a	
I declare that: (initial) I am over 16 years old. I am aware that colonic irrigation may carry a health risk due to ineffective hygiene. I am aware that I should consult my GP as soon as possible if redness, swelling or infection occurs.		
Signature (Parent's or guardian's signature if under 16 years)		
Date		

APPENDIX 3: RECOGNISED TRAINING ESTABLISHMENTS

The Colonic International Association recognises the following training organisations:

College of Colonic Hydrotherapy
515 Hagley Road, Warley, Birmingham B66 4AX
Tel: 0121 429 9191

National College of Holistic Medicine
32a Wessex Road, Lower Parkstone, Poole, BH14 8BQ
Tel: 01202 717727

Scottish School of Colonic Hydrotherapy
Body Management, Coveyheugh House, Reston, Berwickshire, TD14 5LE
Tel: 01890 761202

APPENDIX 4: SUPPORTING INFORMATION
Relevant legislation

Business operators should familiarise themselves with the following legislation:

- *Control of substances hazardous to health regulations 1999:* chemicals and biohazard substances, for example, disinfectants, body fluids, contaminated equipment and wastes, etc, shall be assessed in accordance with the requirements of these regulations (SI 1999/437 at the time of writing, but subject to regular update). The outcome of the risk assessment must be used to implement safe working practices.

- *Controlled waste regulations 1992:* requires that all clinical waste (used needles, soiled dressings, used swabs) is collected and disposed of by a licensed contractor in an approved incinerator.

- *Disability discrimination act 1995:* access should be provided for disabled people at the premises.

- *Electricity at work regulations 1989:* requires all portable electrical appliances used within the premises are to be maintained regularly.

- *Health and safety at work etc act 1974:* requires employers and self-employed people to ensure the health, safety and welfare of persons attending their businesses.

- *Management of health and safety at work regulations 1999:* the business operator shall carry out, and implement the findings of, a workplace risk assessment of the business. The outcome of the risk assessment must be used to implement safe working practices.

- *Provision and use of work equipment regulations 1998:* requires prevention or control of the risks to human health and safety from equipment used at work. Basically, work equipment must be suitable for its intended use; safe for use, maintained in a safe condition and, where necessary, inspected; only used by adequately informed, instructed and trained people; accompanied by suitable safety measures. The Regulations cover all equipment used by employees at work, regardless of whether it is supplied by the employer or employee. Powered equipment for use at work must have the 'CE marking', to demonstrate it conforms with relevant European safety standards.

- *Reporting of injuries, diseases, and dangerous occurrences regulations 1995:* requires employers to report certain categories of workplace accidents and serious incidents and infections which result from a work activity. The incident should be reported to the HSE's Incident Contact Centre, via the telephone (0845 300 9923) or fax (0845 300 9924), by post to Incident Contact Centre, Caerphilly Business Park, Caerphilly CF83 3GG, or e-mail to 'riddor@natbrit.com'. Further information is available on the website 'www.riddor.gov.uk'

Nuisance/complaints

The operator must ensure that there is no noise or other type of nuisance arising from the operation of the business.

Maintenance

All systems, for example, fire-safety equipment, boilers, electrical equipment, etc, housed in the premises must be maintained regularly by competent persons, and maintenance records kept.

All equipment used in connection with special treatments shall be serviced/maintained in accordance with the manufacturers/suppliers recommendations, and records kept.

Electricity

The business operator shall ensure that all portable electrical appliances used within the premises are checked regularly and maintained in accordance with the 'Electricity at work regulations 1989'; see 'Relevant legislation'. Records of maintenance checks must be available on the premises.

The business operator must also ensure that the fixed electrical installation is inspected by a competent electrical engineer, and that a copy of the current certificate is available at the premises.

Fire precautions

All fire exits, staircases and other means of escape must be kept unobstructed, immediately available, and clearly signed, in accordance with the council's requirements, and any requirements of the fire authority.

All fire-resistant and smoke-stop doors must be maintained self closing, and must not be secured open.

All exit doors must be available for access and egress whilst the public are on the premises.

A notice, or notices, reading 'No Smoking' should be prominently displayed within the treatment area.

MASSAGE THERAPIES AND LIFESTYLE CONSULTATIONS

This 'best practice guidance' covers traditional Western massage therapies, and the increasing number of Eastern bio-energy therapies, such as *shiatsu* and *ayurveda (marma)*. It also deals with holistic consultations, including homeopathy and naturopathy. Generally, the aim of these therapies is to provide the client with comfort, relief, and a sense of well-being or enhanced performance as a result of the treatment.

Some of these treatments have few (if any) public health hazards, and the aim of this 'best practice guidance' is to provide basic sanitary standards for premises and for the conduct of the business in line with licensing, and health and safety legislation.

The main focus of concern for public-health protection is on the practitioners themselves, especially the hazards of malpractice leading to mis-diagnosis, failure to refer to orthodox medical practitioners, and failure to explain the risks, precautions and limitations of the proposed therapy to their clients.

CONDUCT OF THE BUSINESS

The business operator should comply fully with this 'best practice guidance', and must ensure:

- good order and moral conduct in the premises

- that all clients in any part of the premises are decently and properly attired, unless receiving treatment in accordance with this 'best practice guidance'

- that neither the operator nor the client is under the adverse influence of drugs, alcohol or any other substance.

The operator must have public liability insurance cover.

RESPONSIBILITIES

The business operator must:

- take all reasonable precautions for the safety of all persons using the premises

- carry out, and implement the findings of a risk assessment of the business as required by the 'Management of health and safety at work regulations 1999' (see 'Relevant legislation')

- ensure that all persons carrying out special treatments are suitably qualified or trained, and are competent (see 'Training/competency')

- notify the local authority in writing of any proposed change to his/her name or private address, of changes in the business address, of significant changes to the treatments provided, or changes to the nature of the business carried on at the premises.

RESPONSIBLE PERSON

The business operator must ensure that a 'responsible person' aged 18 years or more is in charge of the premises at all times during business hours. The responsible person must be nominated, in writing, by the business operator, and this notification should be continuously available for inspection at the premises.

The responsible person must be familiar with, and implement, the requirements of the relevant 'best practice guidance', and must:

- be in charge of the premises

- be on site at all times when the public have access to the premises

- be assisted as necessary by suitable persons, aged 18 years or more, to ensure adequate supervision

- not be engaged in any other duties which will prevent him/her from exercising general supervision.

CLEANLINESS

For the purposes of cleanliness, the following points should be observed:

- all instruments, towels, materials and equipment used on the premises must be appropriately cleaned, disinfected and/or sterilised

- tables, couches and seats should be wiped down with a suitable disinfectant between the treatment of each client, and thoroughly cleaned at the end of each working day

- where tables or couches are used, they should be covered with a disposable paper sheet, which shall be changed for each client

- a 'no smoking' notice(s) should be displayed in the treatment area(s).

PERSONAL HYGIENE

Any person carrying out any special treatment must ensure that:

- any open boil, sore, cut or other open wound is effectively covered by an impermeable dressing

- hands are kept clean and are washed immediately prior to carrying out any treatment

- they refrain from smoking, or consuming food and drink during the course of the treatment

DISINFECTANTS

Disinfectants do not sterilise, they only reduce the number of some microbes. Disinfection is required for table tops and general surfaces in the treatment area.

Disinfectant preparation

Agent: hypochlorite (bleach).

Preparation: make up daily, dilute to 70% bleach/30% water.

Use: corrodes metal; excellent for other materials and for disinfection of needles prior to disposal

Agent: 70% alcohol.

Preparation: do not dilute.

Use: suitable for intact skin, table tops, metals.

THERAPISTS

Treatment should only be given by therapists who meet the criteria for training and competency, see below.

TRAINING/COMPETENCY

All persons carrying out any of the treatments described should have successfully completed a relevant course or obtained a relevant qualification, preferably one recognised by a professional association or a single regulating body. The associations listed in Appendix 2 should be consulted for more information.

All therapists must be able to demonstrate competency to the satisfaction of the recognised association, and must provide evidence of safety in practice by being in possession of an annual certificate of registration or similar document.

Therapists should demonstrate continuing professional development by attending suitable workshops, seminars and training courses.

Full records must be kept on the premises of all qualifications gained and courses attended (including dates, titles of courses, and venues) for all therapists. These details must be available for inspection at all times.

Training of doctors of homeopathy is regulated by the Faculty of Homeopathy, a statutory authority.

EQUIPMENT

All gowns, wraps or other protective clothing, paper or other covering, towel, cloth or other such articles used in treatment, must be clean, and in good repair.

PREMISES

The following points shall be adhered to:

• all internal walls, doors, windows, partitions, floors, floor coverings, and ceilings, must be kept clean and in such good repair as to enable them to be effectively cleaned

• effective pest control measures, such as pest proofing, and appropriate treatments should be carried out, as necessary, and proper records kept

• the floor of the treatment area should have a smooth, impervious surface

• the treatment area must be solely used for giving treatments, and must be completely separated from all other rooms (for example, any room used for human habitation, catering establishment, hair salon, retail sales, or other) by full height walls or partitions

• there should be a minimum of 5m² of floor space for each operator in the establishment

• no animals of any kind should be permitted in a treatment area, except service animals used by persons with disabilities, for example, guide dogs for the blind

• suitable and sufficient means of heating to a reasonable room temperature, appropriate to the treatment offered, must be provided

• all furniture and fittings in the premises should be kept clean. Furniture in the treatment area (for example, tables, couches and seats) should be covered with a smooth, impervious surface, so that they can be effectively cleaned

• there should be an adequate, constant supply of clean hot and cold water at a hand basin, as well as sanitising soap or detergent and disposable towels. The wash basin should be easily accessible to the operator and be for his/her sole use. Taps should preferably be wrist- or foot-operated

• there should be suitable and sufficient sanitary accommodation for therapists and clients

• there must be adequate, clean, and suitable storage for all items, so as to avoid, as far as possible, the risk of contamination

• suitable screening to provide privacy must be provided

• the premises must be adequately ventilated.

TARIFF

A comprehensive tariff shall be prominently displayed in a location where it can be easily seen by all persons entering the premises.

REGISTRATION CERTIFICATE

A current registration certificate should be conspicuously displayed at all times to the satisfaction of the local authority. It must be clearly visible by all persons using the premises, and adequately protected against theft, vandalism or defacement.

RECORD KEEPING AND INFORMATION

A record must be kept of the establishment, including the name and address, hours of operation, and the operator's name and address.

A copy of this 'best practice guidance' should be available on the premises.

Anyone under 18 years of age shall be accompanied by a parent/guardian who must give written consent for treatment.

Every client should read and sign a consent form which gives details of their name, address, age, and medical history (see 'Appendix 1'). These consent forms must be kept for a period of at least three years after the cessation of treatment, and should be available for inspection at all times so that alleged cases of infection can be epidemiologically checked.

Confidential records, including name, address, date and type of treatment received, should also be kept for all treatments, again, for a period of at least three years after the treatment has finished. They must be made available to the authorised officer upon request, and with the client's written consent.

Any contra-indications, for example, heart conditions, diabetes, epilepsy, etc shall be discussed with the client prior to any treatment.

Where appropriate, clients are to be given written information to take away about after care contra-indications and risks of treatment. This shall be noted on their record card, which they shall sign and date.

A notice shall be prominently displayed, giving the name, address, and phone number of the local health authority and environmental health department, so that the public can report complaints or seek additional information.

FIRST AID

There must be a first-aid kit on site that complies with the 'Health and safety (first aid) regulations 1981'. There are no specific mandatory items which must be included in a first-aid box.

The Health and Safety Executive has issued a recommended list of contents. Where the risk assessment as revealed no special hazards, a minimum stock of first-aid items includes:

• a leaflet giving general guidance on first-aid (for example, the HSE leaflet 'Basic advice on first aid at work')

• 20 individually-wrapped sterile adhesive dressings, of assorted sizes, appropriate to the type of work

• two sterile eye pads

• four individually-wrapped triangular bandages

• six safety pins

• six medium-sized individually-wrapped sterile, unmedicated wound dressings (approximately 120x120mm)

• two large sterile individually-wrapped unmedicated wound dressings (approximately 180x180mm)

• one pair of disposable gloves.

First-aid kits for travelling practitioners (ie, staff who frequently carry out domiciliary visits) would typically contain:

- a leaflet giving general guidance on first-aid (eg, HSE leaflet 'Basic advice on first aid at work')

- six individually-wrapped sterile adhesive dressings

- one large sterile individually-wrapped unmedicated wound dressing (approximately 180x180mm)

- two triangular bandages

- two safety pins

- individually-wrapped moist cleansing wipes

- one pair of disposable gloves.

WASTE

Rubbish must be stored in covered receptacles and suitable arrangements should be made for its proper disposal.

INSURANCE

The business must have third party liability, to cover claims for damages or negligence, as well as employer's liability insurance.

LOCAL AUTHORITY AUTHORISED OFFICERS

Authorised officers carry written authorisations and proof of identity, which they will produce on request. They must be admitted on request during opening hours, and at any other reasonable time, to all parts of the premises. An officer may be accompanied by anyone else who is deemed necessary for the purposes of the inspection, for example, a medical or other specialist practitioner.

APPENDICES

APPENDIX 1: CONSENT FORM

Name of business:

Address of business:

Local authority registration no:

	✓ ✗ or n/a
I declare that I give (full name of therapist) my full consent to (describe treatment) The information given below is true to the best of my knowledge. I have had/currently suffer from the following:	
allergies, for example, plasters	
concurrent drug treatments, such as antihistamines, steroids	
diabetes	
epilepsy	
haemophilia	
heart condition/pacemaker	
hepatitis	
high blood pressure	
immuno-compromising condition	
implants, as a result of surgery/artificial joints	
pregnancy	
radiotherapy	
skin condition, for example, psoriasis	
surgical procedures	
taking blood thinning medication, for example, aspirin	
I will follow the verbal and written aftercare instructions which have been given to me.	

Full name	Address	Age	Date of birth	Signature of client	Date

APPENDIX 2: RELEVANT ASSOCIATIONS

Reputable associations and training organisations maintain standards of education, ethics, discipline and practice to ensure the health and safety of the public at all times. Their members should be covered by malpractice and public liability insurance, and offer a disciplinary or complaints procedure in case of grievance.

This is not an exhaustive list of associations or trade organisations, nor does it purport to offer endorsement of their status as professional or training organisations:

Alexander Teaching Network
PO Box 53, Kendal, Cumbria LA9 4UP

Aromatherapy Organisations Council
PO Box 19834, London SE25 6WF
Tel: 020-8251 7912. Fax: 020-8251 7942
Website: http://www.aromatherapy-uk.org/

Association for Systematic Kinesiology
39 Browns Road, Surbiton, Surrey KT5 8ST
Tel: 020-8399 3215

Association of Reflexologists
27 Old Gloucester Street, London WC10 2BB
Tel: 0870 5673320
E-mail: aor@reflexology.org

Ayurvedic Medical Association UK
The Hale Clinic, 7 Park Crescent, London W1N 3HE
Tel: 020-7631 0156. Fax: 020-7637 3377

British Complementary Medicine Association
Kensington House, 33 Imperial Square, Cheltenham GL50 1QZ
Tel: 01242 519911. Fax: 01242 227765
E-mail: info@bcma.co.uk
Website: www.bcma.co.uk

British Federation of Massage Practitioners
78 Meadow Street, Preston PR1 1PS
Tel: 01772 881063

British Homeopathic Association
15 Clerkenwell Close, London EC1R 0AA
Tel: 020-7566 7800. Fax: 020-7566 7815
E-mail: info@trusthomeopathy.org
Website: www.trusthomeopathy.org

British Reflexology Association
Monks Orchard, Whitbourne, Worcester WR6 4RB
Tel: 01886 821207. Fax: 01886 822017
E-mail: bra@britreflex.co.uk
Website: www.britreflex.co.uk

Chartered Society of Physiotherapy
14 Bedford Row, London WC1R 4ED
Tel: 020-7306 6666. Fax: 020-7306 6611

Chinese Medical Institute and Register (UK)
103-5 Camden High Street, London NW1 7JN
Tel: 020-7388 6704

College of Ayurveda
20 Annes Grove, Great Linford, Milton Keynes MK14 5DR
Tel: 01908 664518. Fax: 01908 698371

Guild of Naturopathic Iridologists (International)
94 Grosvenor Road, London SW1V 3LF
Tel: 020-7834 3579

Institute of Complementary Medicine
PO Box 194, London SE16 7QZ
Tel: 020-7237 5165. Fax: 020-7237 5175
E-mail: icm@icmedicine.co.uk

International Association of Clinical Iridologists
853 Finchley Road, London NW11 8LX
Tel: 020-8458 7781

International Federation of Aromatherapists
Stamford House, 2/4 Chiswick High Road, London W4 1TH
Tel: 020-8742 2605
E-mail: i.f.a@ic24.net

International Federation of Reflexologists
76-78 Edridge Road, Croydon, Surrey CR0 1EF
Tel: 020-8667 9458. Fax: 020-8649 9291
E-mail: ifr44@aol.com

International Register of Massage Therapists
PO Box 5537, Hatfield Peverel, Chelmsford CM3 2QN

International Society of Aromatherapists
ISPA House, 82 Ashby Road, Hinckley LE10 1SN
Tel: 01455 637987. Fax: 01455 890956

Kinesiology Federation
PO Box 7891, London SW19 1ZB
Tel: 020-8545 0255

London and Counties Society of Physiologists
330 Lytham Road, Blackpool FY4 1DW
Tel: 01253 408443

Massage Therapy Institute Of Great Britain
PO Box 2726, London NW2 3NR

National Institute of Medical Herbalists
56 Longbrook Street, Exeter EX4 6AH
Tel: 01392 426022. Fax: 01392 498963
E-mail: nimh@ukexeter.freeserve.co.uk

Northern Institute of Massage
100 Waterloo Road, Blackpool FY4 1AW

Register of Qualified Aromatherapists
PO Box 3431, Danbury, Chelmsford CM3 4UA
Tel: 01245 227957
E-mail: admin@R-Q-A.demon.co.uk

School of Herbal Medicine/Phytotherapy
Bucksteep Manor, Bodle Street Green, Hailsham BN27 4RJ
Tel: 01323 834 800

Scottish School of Herbal Medicine
6 Harmony Row, Glasgow G51 3BA
Tel: 0141-401 8889. Fax: 0141-401 8891
E-mail: sshm@herbalmedicine.org.uk

Shiatsu Society (UK)
Eastlands Court, St Peters Road, Rugby CV21 3QP
Tel: 01788 555051. Fax: 01788 555052
E-mail: admin@shiatsu.org
Website: www.shiatsu.org

Shiatsu International
Robwood House, 31 Fletton Avenue, Peterborough PE2 8AX
Tel: 01733 762092. Fax: 01733 762645

Society of Homeopaths
2 Artisan Road, Northampton NN1 4HU
Tel: 01604 21400. Fax: 01604 22622
Web: www.homoeopathy.org.uk

Society of Teachers of Alexander Technique
20 London House, 266 Fulham Road, London SW10 9EL
Tel: 020-7351 0828

UK Homeopathy Medical Association
6 Livingstone Road, Gravesend DA12 5DZ
Tel: 01474 560336
Web: http://www.homoeopathy.org/

APPENDIX 3: SUPPORTING INFORMATION
Relevant legislation

Business operators should familiarise themselves with the following legislation:

• *Control of substances hazardous to health regulations 1999:* chemicals and biohazard substances, for example, disinfectants, body fluids, contaminated equipment and wastes, etc, shall be assessed in accordance with the requirements of these regulations (SI 1999/437 at the time of writing, but subject to regular update). The outcome of the risk assessment must be used to implement safe working practices.

• *Controlled waste regulations 1992:* requires that all clinical waste (used needles, soiled dressings, used swabs) is collected and disposed of by a licensed contractor in an approved incinerator.

• *Disability discrimination act 1995:* access should be provided for disabled people at the premises.

• *Electricity at work regulations 1989:* requires all portable electrical appliances used within the premises are to be maintained regularly.

• *Health and safety at work etc act 1974:* requires employers and self-employed people to ensure the health, safety and welfare of persons attending their businesses.

• *Management of health and safety at work regulations 1999:* the business operator shall carry out, and implement the findings of, a workplace risk assessment of the business. The outcome of the risk assessment must be used to implement safe working practices.

• *Provision and use of work equipment regulations 1998:* requires prevention or control of the risks to human health and safety from equipment used at work. Basically, work equipment must be suitable for its intended use; safe for use, maintained in a safe condition and, where necessary, inspected; only used by adequately informed, instructed and trained people; accompanied by suitable safety measures. The Regulations cover all equipment used by employees at work, regardless of whether it is supplied by the employer or employee. Powered equipment for use at work must have the 'CE marking', to demonstrate it conforms with relevant European safety standards.

• *Reporting of injuries, diseases, and dangerous occurrences regulations 1995:* requires employers to report certain categories of workplace accidents and serious incidents and infections which result from a work activity. The incident should be reported to the HSE's Incident Contact Centre, via the telephone (0845 300 9923) or fax (0845 300 9924), by post to Incident Contact Centre, Caerphilly Business Park, Caerphilly CF83 3GG, or e-mail to 'riddor@natbrit.com'. Further information is available on the website 'www.riddor.gov.uk'

Nuisance/complaints

The operator must ensure that there is no noise or other type of nuisance arising from the operation of the business.

Maintenance

All systems, for example, fire-safety equipment, boilers, electrical equipment, etc, housed in the premises must be maintained regularly by competent persons, and maintenance records kept.

All equipment used in connection with special treatments shall be serviced/maintained in accordance with the manufacturers/ suppliers recommendations, and records kept.

Electricity

The business operator shall ensure that all portable electrical appliances used within the premises are checked regularly and maintained in accordance with the 'Electricity at work regulations 1989'; see 'Relevant legislation', page 00. Records of maintenance checks must be available on the premises.

The business operator must also ensure that the fixed electrical installation is inspected by a competent electrical engineer, and that a copy of the current certificate is available at the premises.

Fire precautions

All fire exits, staircases and other means of escape must be kept unobstructed, immediately available, and clearly signed, in accordance with the council's requirements, and any requirements of the fire authority.

All fire-resistant and smoke-stop doors must be maintained self closing, and must not be secured open.

All exit doors must be available for access and egress whilst the public are on the premises.

A notice, or notices, reading 'No Smoking' should be prominently displayed within the treatment area.

APPENDIX 4: DESCRIPTIONS OF TREATMENTS
Alexander technique

An individually-developed programme for improving posture.

The Alexander technique is not a fixed series of exercises, but a rationalisation which encourages a person to rediscover their natural posture.

The technique may involve therapists using their hands on the neck, back, shoulders etc to provide feedback on improved posture. Benefits come from loosening of body tension, enabling improved posture.

Aromatherapy

The word aromatherapy was coined in 1936 and means 'treatment using scents'. It refers to a particular branch of herbal medicine that uses concentrated plant oils ('essential oils'), to improve physical and emotional health, and to restore balance to the whole person.

Essential oils are diluted by carrier oils for reasons of economy and safety. They are not taken internally, but are inhaled or applied to the client's skin by massage. Each oil has its own natural fragrance and healing properties.

Aromatherapy benefits are said to include:

• prevention and treatment of stress and anxiety-related disorders

• muscular and rheumatic pains

• digestive and hormonal problems

• insomnia

• depression.

Aromatherapy does not offer a cure, but can assist in the healing process. It is helpful in alleviating sub-clinical symptoms, before they escalate into full-blown disease.

Aromatherapy techniques and aids include massage, baths, steam inhalers, vapourisers, creams, lotions, gels, shampoos, mouthwashes, and hot and cold compresses.

When practising aromatherapy, the following should be noted:

- keep all oils away from children

- do not apply oils undiluted to the skin, unless it is stated that it is safe to do so

- essential oils should not be taken internally

Hazards

Use of certain oils is unsuitable in the following cases:

- during pregnancy (thyme, basil, rosemary, clary sage, and juniper)

- if the client has sensitive skin or suffers from dermatitis

- if the client suffers from high blood pressure

- if the client is recovering from a recent operation

- if the client is taking certain drugs or homeopathic remedies

Recently, the HSE has drawn attention to the hazard of contact allergy caused by some essential oils – notably lavender, *neroli* and *ylang ylang*. This may affect the aromatherapist, or their clients.

Ayurveda

Ayurveda is practised in India and Sri Lanka. *Ayurveda* followers believe everyone is born with specific levels of three bio-energies (called *doshas*). As we go through life, diet, environment, stress, trauma and injury cause the '*doshas*' to become imbalanced (the '*vikruthi*' state).

Ayurvedic practitioners work to restore individuals to their optimum '*prakruthi*' state, through *panchakarma* (detoxification), meditation, *marma* therapy (applying pressure or massage to *marma* points), *marma* puncture (rather like acupuncture), yoga and breathing exercises.

Marma puncture is an element of *Ayurveda*, involving skin piercing (see the 'best practice guidance' on Acupuncture).

Hazards

- infection

- damage to blood vessels, nerves, and body tissues

- malpractice leading to misdiagnosis or failure to refer or explain precautions.

Herbalism

Herbalism is the use of plants for medicinal purposes, and has been in use throughout the evolution of man. Native or tribal cultures have a well-developed understanding of local plants, and most of humanity still relies on herbal expertise for primary healthcare.

The basic tenets of herbal medicines are:

- the whole plant is better than an isolated extract

- treat the whole person, not just the symptoms

- practise minimum effective treatment and minimum intervention

- strengthen the body so it can heal itself

Herbalism is practised professionally by medical herbalists who are trained in orthodox medical diagnosis. Such practitioners must undergo extensive training, as well as belong to an established body of practitioners.

Herbal remedies are not subject to the standard controls for licensed medicines.

Hazards

Toxic effects of herbs, for example, *mu tong* and *fangji* (mistakenly substituted by *Aristolochia*)

Malpractice leading to misdiagnosis or failure to refer or explain precautions.

Homeopathy

Homeopathy works on the principle of stimulating the body's defence mechanism by treating it with minute doses of a substance that produces symptoms similar to those of the illness. Its origins can be traced to classical times, but has been practised in something similar to its present form for the past 200 years.

Homeopathy works by treating a person as a whole and is effective for most reversible illnesses and acute infections.

Despite scepticism about the effectiveness of extreme dilutions, several trials have suggested that homeopathic dilutions have more objective effect than placebo. An independent study financed by the European Commission concluded '...among the tested homeopathic approaches some had an added effect over nothing or placebo'.

Many homeopaths are medically qualified, subsequently taking a qualification in homeopathy, and are accountable to their professional registering body. It should be noted that homeopathy is available in five NHS homeopathic hospitals.

Hazards

- initial aggravation of symptoms

- possibility of no effect over no treatment or placebo

- malpractice leading to misdiagnosis or failure to refer or explain precautions.

Traditional Chinese medicine

Traditional Chinese medicine (TCM) is a collection of ancient practices, usually with reference to the body meridians. It includes Chinese herbalism, acupuncture with pulse and tongue diagnosis, and lifestyle advice. This is a holistic means of treatment which promotes prevention, as well as treatment, of disease.

Case law (Shakoor (Administratrix of the estate of Shakoor, deceased) v Situ (t/a Eternal Health Co) indicates that anyone prescribing a chemical or herbal remedy that will be ingested must:

- be competent to practise under the system of law and practice by which he will be judged

- know, rather than believe, that a remedy is not harmful

- anyone suffering harm due to ingestion of a remedy and who consults an orthodox doctor is likely to have the case reported in an orthodox medical journal. Practitioners should take steps to ensure they are aware when remedies have been reported adversely.

Hazards

- toxic effects of some herbs

- infection, where acupuncture is involved (see 'best practice guidance' on 'Acupuncture')

- malpractice leading to misdiagnosis or failure to refer or explain precautions.

Iridology

Iridology is not a treatment but a way of diagnosing the causes of illness or imbalance by studying the iris of the eye.

By analysing the markings on the irises of the eyes, iridologists can suggest treatment and also offer warning signs of later problems.

Kinesiology

This therapy was developed from the tapping test of muscle reflexes. When the muscles are working well, so is the body as a whole. Having isolated imbalances, deficiencies or physical problems, the therapist aims to rectify these by gentle massage on pressure points on the body and scalp.

Hazards

Little/no improvement.

Massage therapies

A variety of massage styles available, for example, lymphatic massage, after ultra-sound for cellulite removal.

Benefits the area under treatment, for example, the lymphatic massage directs the toxins and broken-down calcified deposits towards the nearest lymph nodes for natural elimination.

Hazards

Little/no improvement.

Rolfing

A deep, manipulative form of massage, using great pressure by the 'rolfer', using elbows and knees.

The benefits of rolfing are said to include Increased comfort and suppleness in movements, as well as improving abnormal posture.

Hazards

Painful.

French

A deep intensive body massage for the purpose of stimulation and sexual arousal.

Hazards

Risk of indecency.

Indian head

Indian head massage, also known as *champissage*, has been practised in India for many thousands of years. It assists in the release of built-up tension in the neck and shoulders by removing blockages to the energy centres through firm, but gentle, rhythmic massage.

Swedish

A deep intensive body massage, which uses talcum powder, Swedish massage relieves stress and tension and promotes relaxation. It also speeds up the circulation, relieves tired muscles, eliminates toxins and promotes lymph circulation.

Hazards

Risk of indecency.

Reflexology

Massage of defined pressure points in the hands and feet which correspond to different parts of the body, resulting in relief of stress and anxiety.

Shiatsu

Literally meaning 'finger pressure', this involves both physical manipulation and growth of body, mind and spirit.

Shiatsu entails stretching, leverage and leaning the practitioner's weight into various parts of the recipient's body. The same system of energy 'meridians' are followed as in acupuncture.

GLOSSARY

Glossary of special treatments	Description	Stated benefits	Hazards
Skin piercing treatments: health effect			
Acupuncture	Acupuncture is a system of healing which has been practised in the East for thousands of years, and focuses on improving the overall well- being of the patient, rather than the isolated treatment of specific symptoms. The acupuncturist uses a variety of methods to stimulate acupuncture points, usually fine, solid, disposable needles. Electricity, magnetism or other forms of energy, such as gentle heat may also be used. Fine needles (usually disposable) are inserted into channels of energy (Qi) or in an area of treatment. See also *Moxibustion, trigger point acupuncture,* and *periosteal acupuncture.*	Stimulates the body's own healing response. Conditions treated include emotional and physical ailments.	Infection through dirty needles. Bleeding. Damage to blood vessels, nerves, and body tissues. Little/no improvement over no treatment or placebo. Requires accurate diagnosis. Concurrent drug treatment may interfere (eg, corticosteroids).
Auricular acupuncture	Developed during the 1950s, all the body parts are mapped onto the ear. Treatment is carried out by acupuncture techniques on the various parts of the helix. Sometimes an in-dwelling needle is left in-situ (looks like a stud earring), for self- therapy when required, as well as for pain relief. See also *Acupuncture.*	Do not have to believe in the treatment to experience healing. Stimulates the body's own healing response. Conditions treated include emotional and physical ailments. Is often used for treating addictions such as smoking, alcohol, obesity, etc,	Infection through dirty needles. Bleeding. Damage to blood vessels, nerves, and body tissues. Little/no improvement over no treatment or placebo. Requires accurate diagnosis of condition to be treated. Concurrent drug treatment may interfere (eg, corticosteroids).
Chiropody	Practical care of the feet using a variety of techniques, such as caustics, liquid nitrogen and electrotherapy. Local anaesthetics may be applied for minor surgery. Synonymous with podiatry.	Routine care of corns, calluses and nails, and treatments for verrucas. Minor surgery for resistant verrucas and in-grown toenails.	Infection through dirty equipment. Bleeding. Damage to blood vessels, nerves, and body tissues. Scarring. Painful.
Electro acupuncture	The electrical stimulation of the needles during acupuncture, also used in traditional Chinese medicine (TCM). See also *Acupuncture* and *TCM.*	Stimulates the body's own healing response. Conditions treated include emotional and physical ailments. Increases the intensity of the acupuncture. Has an anaesthetic effect to relieve pain.	Infection through dirty needles. Damage to blood vessels, nerves, and body tissues. Little/no improvement over no treatment or placebo. Requires accurate diagnosis of condition to be treated. Concurrent drug treatment may interfere (eg, corticosteroids). Over stimulation (pain and burning).

Glossary of special treatments	Description	Stated benefits	Hazards
Interferential treatment	A physiotherapy electrical treatment, which uses two interferential currents, from a large, fixed machine, to provide a therapeutic dose to the affected part.	Reduces swelling. Counters pain.	Burning. Infection. Scarring.
	Specialist interferential treatment using pulsed current: faradic and galvanic treatments work through the stimulation of the nerve motor points to elicit muscle contraction.	Induces muscle contraction.	Painful. Temporary effect. Contra-indications.
	See also *Galvanics, skin piercing,* and *cosmetic effect*.		
Laser	In physiotherapy, the use of a light source, to give a therapeutic effect.	Tissue healing (including where there is a metal implant).	Inaccurate location of point of treatment.
	For epilation, to inhibit hair growth by thermally disabling each hair follicle.	Hair removal.	Over use of laser. Contra-indications (eg, epilepsy). Damage to the eye. Temporary, rather than permanent hair removal.
Megapulse	A physiotherapy electrical treatment, which uses electromagnetic energy Usually administered in pulsed form to avoid heating the tissue.	Improves tissue healing. Reduces swelling. Reduces pain.	Burning. Infection. Painful. Temporary effect. Contra-indications (pacemakers and hearing aids).
Mesotherapy	A branch of homeopathy involving intradermal injection of homeopathic drugs and medicines.	Cosmetic treatment of cellulite. Reduces swelling. Reduces pain.	Allergic reaction. Little/no improvement over no treatment or placebo. Infection through dirty needles.
Moxibustion	Moxibustion is the process of applying heat during acupuncture. The practitioner ignites a ball of dried *Artemesia* on the top of the acupuncture needle to warm the needle.	Stimulates the body's own healing response. Conditions treated include emotional and physical ailments. The heat intensifies and speeds up the healing process.	Infection through dirty needles. Bleeding. Damage to blood vessels, nerves, and body tissues. Little/no improvement over no treatment or placebo. Requires accurate diagnosis of condition to be treated. Concurrent drug treatment may interfere (eg, corticosteroids). Danger of burning.
TNS	A physiotherapy electrical treatment, TNS (transcutaneous neuro stimulator) to provide a therapeutic dose from a portable machine. Different types of TNS machines available; eg, obstetric TNS.	Reduces swelling. Relieves pain. Induces muscle contraction.	Burning. Infection. Scarring. Painful. Temporary effect. Contra-indications.

Glossary of special treatments	*Description*	*Stated benefits*	*Hazards*
Trigger point acupuncture	Trigger point acupuncture is the application of needles to the trigger points (site of pain).	Stimulates the body's own healing response. Conditions treated include emotional and physical ailments. Do not have to believe in the treatment to experience healing.	Infection through dirty needles. Bleeding. Damage to blood vessels, nerves, and body tissues. Little/no improvement over no treatment or placebo. Requires accurate diagnosis of condition to be treated. Concurrent drug treatment may interfere (eg, corticosteroids).
Periosteal acupuncture	Periosteal Acupuncture is the deeper insertion of a needle, so that the tip contacts the covering of the bone (periosteum)	Stimulates the body's own healing response. Conditions treated include emotional and physical ailments. Do not have to believe in the treatment to experience healing.	Infection through dirty needles Bleeding Damage to blood vessels, nerves, and body tissues Little/no improvement over no treatment or placebo Requires accurate diagnosis of condition to be treated. Concurrent drug treatment may interfere (eg: corticosteroids)

Skin piercing treatments: cosmetic effect

Anti-ageing treatment	The use of a micro-current for line and wrinkle elimination.	Cosmetic improvement with reduction in lines and wrinkles.	Burning. Infection. Scarring. Painful. Temporary effect.
Beading	The insertion of small beads under the incised skin of the phallus, or other body parts	Aims to increase the thickness of the phallus, and/or to increase the stimulation of the partner.	Infection through dirty needles, or contaminated beads. Bleeding. Damage to blood vessels, nerves, and body tissues. Scarring. Painful.
Body art	'Body art' is a term usually applied to tattooing, scarification, and the wearing of jewellery in unconventional sites. Sites pierced include the tongue, face, belly button, nipples and genitalia.	Cosmetic. Fashion. Sign of rebellion. Sexual stimulation.	Allergy through metal sensitivity. Excess bleeding. Fainting/seizure. Follicular cysts. Healing problems. Hypergranulation (a raw looking bump at the point of piercing). Infection. Inflammation. Nerve damage. Scarring. Septicaemia. Societal disapproval. Uncontrolled use of anaesthetic.

Glossary of special treatments	Description	Stated benefits	Hazards
Body piercing	Perforation to the skin and underlying tissue in order to create a small tunnel in the flesh in which jewellery of one kind or another is placed.	A means of body adornment, with jewellery, beads, etc being attached to the body. Parts pierced include ears, nose, tongue, nipples, genitalia.	Allergy through metal sensitivity. Excess bleeding. Fainting/seizure. Follicular cysts. Healing problems. Hypergranulation (a raw looking bump at the point of piercing). Inflammation. Infection. Nerve damage. Scarring. Septicaemia. Societal disapproval.
Branding	A form of scarification usually achieved by burning the skin with heated metal.	A means of adornment, often in conjunction with tattooing.	Allergy through metal sensitivity. Excess bleeding. Fainting/seizure. Follicular cysts. Healing problems. Hypergranulation (a raw looking bump at the point of branding). Infection. Nerve damage. Scarring. Societal disapproval. Uncontrolled use of anaesthetic.
Depilation	Temporary hair removal by mechanical (tweezing or wax) or chemical means.	Cosmetic removal of hair.	Irritation of the skin (both mechanical and chemical). Allergic reaction. Painful. Bleeding. Burning, from hot wax.
Diathermy	In beauty therapy, a form of electrolysis relying on the thermal effects of high frequency alternating electric currents. Thermolysis is an alternative (archaic) name for diathermy.	The purpose might be (for example) to cauterise a blood vessel.	Burning. Infection. Scarring. Painful. Temporary effect.
Galvanics	Applied in a variety of treatments; eg, use of a direct current applied via a probe to achieve epilation. Applied as a deep cleansing treatment eg: 'cathiodermie back treatment'. When galvanics and diathermy are combined, electrolysists call the treatment 'the blend'. See also *Epilation*.	Skin cleanser, reduces shadows, puffiness and lines around the eyes. Improves the complexion. Clears acne and spots.	Burning. Infection. Scarring. Painful. Temporary effect.

Glossary of special treatments	Description	Stated benefits	Hazards
Electrolysis	Use of a small probe to deliver an electrical current to individual hair follicles. Systems are available which do not use a probe or needle, just a special gel and a high frequency current. See also *Epilation*, and *diathermy*.	In terms of beauty therapy, electrolysis is used for a variety of treatments of the skin; eg, for mole removal, and the removal of 'skin tags' (Verruca filiformis). It is also a means of permanent hair removal.	Burning. Infection. Scarring. Painful. Temporary effect.
Epilation	The permanent removal of hair at the root, usually by electrolysis, using a disposable needle as the electrode to deliver current. Laser epilation is also available. See also *Electrolysis, laser*.	Cosmetic hair removal.	Burning. Infection. Scarring. Painful. Temporary effect.
Exfoliation	Massage of the area to be cosmetically treated, either mechanical or with chemicals; eg, alpha and beta hydroxy acids and retinoic acid.	Removes dead cells, smoothes fine wrinkles and rough skin. Prevents the formation of pimples.	Excess rubbing or strength of chemicals on a delicate area, such as under the eyes may develop blood vessels. Allergy to cosmetics Some skin conditions may be spread further, such as severe acne.
Face lift	The use of a microcurrent to tone and lift the muscles of the face. Alternatively, use of plastic surgery to rejuvenate the appearance.	Claims a real difference can be felt after one treatment.	Burning. Infection. Scarring. Painful. Temporary effect.
Make up, semi-permanent	Small amounts of natural pigment are tattooed into the skin.	Applied as a beauty treatment to the eyebrows, as an eyeliner, to enhance the lip line and to produce beauty spots.	Pain. Tissue damage. Infection. Healing problems. Excess bleeding. Hypergranulation (a raw looking bump at the point of tattooing). Inflammation. Scarring. Follicular cysts. Fainting/seizure. Nerve damage.
Scarification	This is the incising or slashing of the skin. May be repeated many times to achieve deep and clearly visible marks/ scars. See also *Body art*.	Body adornment and decoration.	Healing problems. Excess bleeding. Hypergranulation (a raw looking bump at the point of cutting). Infection. Scarring. Follicular cysts. Fainting/seizure. Nerve damage. Societal disapproval.

Glossary of special treatments	Description	Stated benefits	Hazards
Tattooing	The placement of pigment underneath the epidermis of the skin, to remain indelibly in the dermis. See also *Body art*.	Markings such as signs, symbols and letters are applied in a decorative fashion.	Healing problems. Excess bleeding. Hypergranulation (a raw looking bump at the point of skin piercing). Infection. Inflammation. Scarring. Follicular cysts. Fainting/seizure. Nerve damage. Societal disapproval.
Telangectasia (thread vein treatment)	A condition caused by dilated capillary veins, which is treated by electrolysis; also known as thread veins.	Removal of thread veins from the face and body.	Infection. Scarring. Follicular cysts. Fainting/seizure. Nerve damage.
Temptooing	Controversial type of tattoo, said to use ink which will rise to the top of the skin and vanish after three to five years because the needles do not breach the epidermis. Allegedly sold as a temporary tattoo, but evidence suggests they are permanent.	Markings such as signs, symbols and letters are applied in a decorative fashion. Alleged to be temporary.	Healing problems. Excess bleeding. Inflammation. Hypergranulation (a raw looking bump at the point of piercing). Infection. Scarring. Follicular cysts. Fainting/seizure. Nerve damage. Societal disapproval.

Body treatments: health effect

Acupressure	The application of pressure to the acupressure/trigger points (site of pain/discomfort) to produce stretch and ischaemia resulting in greater blood circulation and healing. Often used in conjunction with shiatsu.	Improves circulation in the acupressure/trigger point, and thus healing.	Little/no improvement over no treatment or placebo. Misdiagnosis.
Aromatherapy massage	Aromatherapy massage is the systematic use of essential oils in massage. Essential oils are fragrant, volatile liquids that occur naturally, and are extracted from flowers, fruits, leaves, roots etc. Each essential oil possesses distinct therapeutic properties that help to promote health and prevent disease. They can also be applied in baths and inhalations.	The combination of essential oils and therapeutic massage enhances the circulation of blood and lymph, relaxes and tones tense, tired muscles, improves nervous conductivity and promotes an overall sense of well-being.	Little/no improvement over no treatment or placebo. Misdiagnosis. Skin irritation/dermatitis/allergy.

Glossary of special treatments	Description	Stated benefits	Hazards
Beauty massage	A variety of massage styles available; eg, lymphatic massage, after ultra sound for cellulite removal. See also *Rolfing*.	Benefits the area under treatment, eg: the lymphatic massage directs the toxins and broken down calcified deposits towards the nearest lymph nodes for natural elimination.	Little/no improvement. Misdiagnosis.
Colon hydrotherapy	The introduction of warm, purified water via the rectum into the colon whilst the therapist uses special massage treatments to stimulate the release of stored matter. Also known as colonic irrigation.	Detoxification of the body by the removal of stored faecal matter, gas, mucus, and toxic substances from the colon.	Damage to blood vessels and nerves. Infection. Indecency. Malpractice could lead to trauma.
Heat treatment	In physiotherapy, the application of heat, through, for example, wheat bags which are heated in a microwave oven.	Pain relief. Reduction of swelling.	Over heating. Burning/scalding.
Ice therapy	In physiotherapy, the application of ice, usually to reduce swelling and decrease pain. Also called cryotherapy.	Pain relief. Reduction of swelling.	Over cooling. Ice burn.
Infra-red therapy	In physiotherapy, the superficial treatment by heat. Now replaced by pulsed electro-therapy, due to the dangers of burning.	Pain relief. Reduction of swelling.	Overheating. Electrocution. Burning. Infection. Scarring. Painful. Temporary effect.
Osteopathy	Osteopathy is a system of diagnosis and treatment, which is concerned with the inter-relationship between the structure of the body and the way in which it functions. Osteopaths work with their hands using a variety of treatment techniques, such as manipulation, soft tissue massage, rhythmic stretching techniques, articulation, traction and exercises. Osteopathic manipulation is also known as a 'high velocity thrust', a small precise movement applied to a spinal or peripheral joint.	Provides physical treatment for specific injuries, including sports injuries and rehabilitation. Requires no medication.	Indecency. Damage to tissues. Little/no improvement over no treatment or placebo.
Podiatry	Podiatry deals with the biomechanics of the foot and the provision of functional foot orthoses for postural and gait imbalances. This involves the detailed examination of the lower limbs and making of plaster casts, from which foot orthotics (foot insoles), are prescribed. See also *Chiropody*.	Orthotics may alleviate foot/knee/back/hip pain, callosities, shin splints, and prevent bunions. Particularly useful with the treatment of sports injuries of the lower limb.	Little/no improvement over no treatment or placebo. Damage to tissue/bone.
Rolfing	A deep, manipulative form of massage, using great pressure by the 'rolfer', using elbows and knees.	Counteracts abnormal posture. Increased comfort and suppleness in movements.	'No pain no gain'. 'If it hurts you'll need more sessions to get properly loosened up'. Clients are encouraged to cry.

Glossary of special treatments	Description	Stated benefits	Hazards
Trichology	Science of the structure, function and diseases of the hair, and corresponding treatment of disease. Treatments include ultraviolet, infra-red and massage, with the application of medications.	Diagnosis and treatment of hair and scalp conditions; eg, psoriasis, eczema, hair loss.	Misdiagnosis and wrong treatment. Infection. Electrocution. Burning. Pain.
Ultraviolet therapy	Used in physiotherapy, the application of ultraviolet light for therapeutic effect, 'Puva' is a concentrated form of ultraviolet treatment, where patients receive a stronger dose for a shorter period.	The treatment of skin conditions, such as psoriasis, acne and eczema.	Burning. Infection. Over-exposure to UV. Overheating. Painful. Scarring. Temporary effect.

Body treatments: cosmetic effect (non invasive)

Glossary of special treatments	Description	Stated benefits	Hazards
Bleaching	The application of a cosmetic bleaching product to lighten facial or body hair.	Cosmetic improvement.	Skin irritation. Allergic reaction. Chemical burn.
Body bronzing	The area to be treated (may be complete body or face, neck and shoulders) is prepared by polishing and moisturising, then sprayed with a fine mist (lighter to darker shades)	Cosmetic improvement	Skin irritation. Allergic reaction. Chemical burn.
Body polish	An invigorating exfoliation of the arms, legs, stomach and back.	Removal of dry, flaky skin, often followed by a deep moisture treatment	Skin irritation
Cellulite treatment	Deep massage followed by an electro and manual body mask. Mechanical massage also used for cellulite treatment.	Tightening of the skin and assists in the breakdown of cellulite.	Inflammation. Infection. Damage to tissues.
Depilation	The removal of hair from the skin surface, using wax, cream, tweezers, sugaring etc. See also *Epilation*.	Cosmetic improvement through the removal of facial hair.	Burning. Infection. Scarring. Painful. Temporary effect. Inflammation. Infection. Damage to tissues.
Eyelash and eyebrow treatment	The colouring of eyelashes and shaping/colouring of eyebrows.	Tinting is done to enhance fair eyelashes by darkening them with beauty products. Shaping of the eyebrows with tweezers is done to achieve a well-groomed appearance.	Skin irritation Allergic reaction Infection

Glossary of special treatments	Description	Stated benefits	Hazards
Facials	Covers a number of different treatments; eg, face mask, electrolysis.	Improves and cleanses the skin.	Burning. Infection. Scarring. Painful. Temporary effect. Inflammation. Damage to tissues. Allergic reaction. Skin irritation.
Flotation tanks	Treatment is provided through depriving the body and mind of all external stimuli. The person floats in a flotation tank containing an Epsom salts solution.	Inspires a deep sense of well-being and relaxation.	Drowning. Skin irritation. Allergic reaction.
Heat treatment	Intense thermal treatment to the back, neck and shoulders to produce a heat effect.	Alleviates tension, fatigue and stress.	Over heating. Burning.
Manicure	Treatment of the hands and fingernails; may include a hand scrub and massage, and cut, file, soak, cuticle removal and varnish of the fingernails. Uses a variety of conventional beauty products and nail care equipment (nail file, scissors, etc).	Cosmetic effect. Strengthen nails.	Damage from scissors and other equipment.
Nail extensions	The application of nails extensions made from gel, glassfibre, acrylic, which are then buffed into shape.	Cosmetic effect. Strengthen nails.	Damage from scissors and abrasive equipment. Respiratory hazard.
Pedicure	Treatment of feet and toenails; may include a foot scrub, massage, and some dry skin removal, and cut, file soak, cuticle removal and varnish of the toenails. Uses a variety of conventional beauty products and nail care equipment (nails file, scissors, etc).	Cosmetic effect. Strengthen nails. Prevent in-growing toe nails.	Damage from scissors and other equipment.
Sauna, Jacuzzi, steam treatment	Treatment through high temperatures/ high humidity/ warm water baths and immersion in steam.	Relaxation, stress relief. Relieve muscle tension.	Over heating. Burning. Scalding. Skin irritation.
Sugaring	Sugaring is a method of temporary hair removal, which is popular in North Africa and the Middle East. Warm sugar is spread on the hair to be treated and covered with cotton strips. The strips are then pulled off against the direction of hair growth.	Hair removal. Less painful than wax. Lasts longer than wax. Cotton strips can be reused.	Painful. Makes a mess. Ineffective. Infection (through cotton strips).
Tanning, sunbed, solaria	Exposure of the skin to ultraviolet tanning equipment, eg: sunbeds, tanning booths and sunlamps.	Cosmetic effect. Provides a suntan under controlled conditions. Prepares the skin for further exposure to the sun.	Dehydration. Over heating of the body. Over exposure to UV. Skin cancer.

Glossary of special treatments	Description	Stated benefits	Hazards
Ultra sound	Ultra sound is used to break up cellulite deposits, sometimes in conjunction with a high tech thermal imaging process to detect and monitor the stage of cellulite. See also *Beauty massage*.	The cosmetic removal of cellulite, without surgery. Claims a visible difference can be seen and felt after the first treatment.	Burning. Infection. Scarring. Painful. Temporary effect. Inflammation. Infection. Damage to tissues.
Waxing	Temporary hair removal using wax, may provide aftercare with essential oils, or an aloe gel.	Hair removal for cosmetic purposes	Painful Short lived effect Burning Bleeding
Wrapping, enveloping	The application of a body wrap consists of covering the part to be treated with sea clay, or other suitable mud/gels, which is then bandaged.	Detoxifying the body, and improving shape. Removes stretch marks.	Infection. Skin irritation. Skin allergy. Ineffective.

Bioenergy therapies: health effect

Glossary of special treatments	Description	Stated benefits	Hazards
Ayurveda	Ayurveda is practised in India and Sri Lanka. Ayurveda followers believe that you are born with specific levels of 3 bio-energies (called doshas). As we go through life, diet, environment, stress, trauma and injury cause the 'doshas' to become imbalanced (the 'vikruthi' state). Ayurdedic practitioners work to restore individuals to their optimum ('prakruthi') state, through meditation, marma therapy (applying pressure or massage to marma points), marma puncture (rather like acupuncture), and breathing exercises.	Benefits are holistic: improved health, physically, emotionally and spiritually.	Depends on the treatment. For massage, see *Beauty massage*. For marma puncture, see *Acupuncture*.
Crystals	Use of the Chakra system, an ancient Indian system of seven energy centres in the body. Each Chakra has a particular focus of action, but all are inter-related. When one Chakra becomes disturbed it can upset the functioning of others. Over time, this may contribute to physical illness and emotional upset. Placing specific crystals close to an energy imbalance may encourage the healing process to be more effective.	A holistic approach to healing, physical, emotional and spiritual healing.	Little/no improvement over no treatment or placebo.
Homeopathy	Works on the principle of stimulating the body's defence mechanism by treating it with minute doses of a substance that produces symptoms similar to those of the illness. Origins go back to Hippocrates, in the fifth century BC, with the present form beginning around 200 years ago.	Homeopathy works by treating a person as a whole; mental, physical, emotional and spiritual health. Effective for most reversible illnesses and acute infections.	Allergic reaction. Little/no improvement over no treatment or placebo.

Glossary of special treatments	Description	Stated benefits	Hazards
Indian head massage	Indian head massage, also known as champissage, has been practised in India for many thousands of years.	Assists in the release of built-up tension in the neck and shoulders, by removing blockages to the energy centres, through firm but gentle rhythmic massage.	
Kinesiology	An ancient practice centred on the body's own bio-energy and electromagnetic energy, which can include 'hands on' body healing. The therapist aims to rectify imbalance by gentle massage on pressure points on the body and scalp.	A holistic treatment for the body, including physical, emotional and spiritual health.	Physical, emotional and spiritual damage.
Meditation	Total concentration of the mind on an image, or series of images, to bring about an improvement physically, mentally and spiritually. There are many different styles, eg: Yogic, Buddhist and Transcendental.	A holistic treatment for the body, including physical, emotional and spiritual health.	Physical, emotional and spiritual damage.
Psychic healing	Consultations include palm readings, tarot cards, crystal balls, tea leaf, photo, pyramid readings.	Claim to help conditions such as skin problems, depression, weight loss, as well as dealing with nightmares and relationship problems.	Emotional and spiritual damage.
Reflexology	Reflexology is an ancient therapy, which is based on the principle that there are reflex points in the feet that relate to, or mirror, every part of the body. The therapist works on these reflex points, using gentle pressure and massage.	Helps to restore harmony and balance to the natural energy pathways of the body. It helps in conditions such as arthritis, hay fever, digestive disorders and insomnia.	
Reiki	Reiki means 'universal life energy', the energy within and around us, from which all things are made. This is seen as being a creative, intelligent and unlimited supply. Reiki is the process of directing energy through the hands into various parts of the body.	Used on a range of conditions, such as pain, disease, injury, allergy and cancer. It also helps with mental conditions, such as phobias.	Physical, emotional and spiritual damage.
Shiatsu	Shiatsu, Japanese 'finger pressure' therapy is a natural healing process, using pressure and stretching to stimulate the body's vital energy flow, along 'meridians'(energy lines). The practitioner uses thumbs and fingers, elbows and feet in the process.	Benefits a range of emotional and physical symptoms; eg, stress, back problems, headaches, migraine, insomnia, a healthy pregnancy and others.	Physical damage.
Traditional Chinese medicine (TCM)	TCM is a collection of ancient practices, usually with reference to the body meridians. It includes Chinese herbalism, acupuncture, with pulse and tongue diagnosis, and lifestyle advice. See also *Acupuncture*	Health promotion, as well as the treatment of disease. A holistic means of treatment	Physical and emotional damage . Infection. Toxic effects of herbs (malpractice).

Glossary of special treatments	Description	Stated benefits	Hazards
Lifestyle/other			
Alexander technique	An individually developed programme of improved postures. The Alexander technique is not a fixed series of exercises, but an explanation, which encourages a person to rediscover natural posture. 'Hands on' teaching to improve posture.	The benefits come from loosening body tension, so it becomes available for expression.	Physical damage.
Feng shui massage	Massage	Eliminates all the negative, stagnant energy from the body and allows the free flow of positive energy.	
Hypnotherapy	Hypnotherapy is founded on the idea that anything that happens in the mind also happened in the body, and vice versa. Using mental processes to produce change in the mind gives rise to change in the body. Through imagery, individuals give exclusive attention to a chosen topic, so that all other aspects of the present are ignored.	Practitioners aim to assist the healing process of acute/chronic pain, disease, and change habits, such as smoking.	Emotional and spiritual damage.
Naturopathy	Naturopathy is a philosophy, which provides a holistic healthcare approach through nutrition/diet, posture and movement and 'natural' treatments, wherever possible. Diagnostic techniques include 'natural' analysis using specific body parts, such as the iris, face, skull, ear foot and abdomen. Practitioners use massage and manipulation, and give advice on nutrition and diet. Techniques such as yoga and the Alexander technique often accompany naturopathy. See also *Reflexology*.	Holistic treatments, covering physical, emotional and spiritual health.	Physical, emotional and spiritual damage.
French massage	A deep intensive body massage for the purpose of sexual arousal and stimulation.	Sexual arousal and stimulation.	Indecency.
Swedish massage	A deep intensive body massage, which uses talcum powder.	Relieves stress and tension, promotes relaxation. Speeds up the circulation, relieves tired muscles, eliminates toxins and promotes lymph circulation.	Indecency.

REFERENCES

Tattooing

A hygienic guide to tattooing. British Tattoo Artists Federation

An outbreak of Hepatitis B from tattooing. Limentani, A, et al. The Lancet; 1979, 2; pages 86-88

Be sure code. British Tattoo Artists Federation

Hepatitis B from tattooing. Harrison, M A, and N D Noah. The Lancet; 1980, Sep 20; 02 (8195, Part 1); page 644

Hepatitis C virus transmitted by tattooing needle. Abildgaard N, and N A Peterslund. The Lancet; 1991, Aug 17; 338 (8764); page 460

Infection control guidelines for use in tattooing/skin piercing practice. Gunn, J K. North Staffordshire Health

Infectious complications of tattoos. Long G E, and L S Rickman. Clinical Infectious Diseases. 1994, Apr; 18 (4); pages 610-9

Return of the tribal: a celebration of body adornment: piercing, tattooing, scarification, body painting. Camphausen, Rufus C. Park Street Press. ISBN 0892816104

Risk factors for Hepatitis C virus infection: a case-control study of blood donors in the Trent region (UK). Epidemiology Infection; 1994, Jun; 112(3); pages 595-601

Risks associated with tattooing and body piercing. Braithwaite, RL, et al. Public Health Policy; 1999; 20(4); pages 459-70

Skin penetration guidelines. NSW Health. ISBN 0 7313 40612

Standards of practice for tattooing and body piercing. Department of Human Services, Victorian State Government, Australia

Tattooing of minors act 1969. The Stationery Office

Tattoos and tattooing: Part I, history and methodology; Part 2, gross pathology, histopathology, medical complications, and applications. Sperry, K. American Journal of Forensic Medicine and Pathology; 1991, Dec; 12(4); pages 313-9, and 1992, Mar; 13(1); pages 7-17

Infection control

BS 2646-3:1993 Autoclaves for sterilization in laboratories: guide to safe use and operation

BS 3970-4:1990 Sterilizing and disinfecting equipment for medical products: specification for transportable steam sterilizers for unwrapped instruments and utensils

BS 7152:1991 Guide to choice of chemical disinfectants

BS EN 867:2001:Part 4 Non-biological systems for use in sterilizers; specification for indicators as an alternative to Bowie and Dick test for detection of steam penetration

BS EN 374-1:1994 Protective gloves against chemicals and micro-organisms: terminology and performance requirements

Body and skin piercing: guidance for local authorities. SCIEH (Clifton Place, Glasgow; tel, 0141-300 1100)

Chemical disinfection in hospitals. Aycliffe, Coates, Hoffman. PHLS, 1983

Chemical germicides in health care. Polyscience Publications Inc. ISBN 0 921317 48 4

Choice of skin care products for the workplace. HSG207. HSE Books

Clean steam for sterilisation. Health technical memorandum 2031. NHS Estates

Effective cleaning and disinfection. Hygiene in focus 17. Society of Food Hygiene Technology Glutaraldehyde and you. IAC 64L. HSE Books

Guidance for clinical health care workers: protection against infection with HIV and hepatitis viruses Department of Health. The Stationery Office

Guidance on the purchase, operation and maintenance of vacuum benchtop steam sterilizers. DB 2000(05). Medical Devices Agency

Guide to hygienic skin piercing. Noah, Norman. (1983) PHLS Communicable Disease Surveillance Centre

Guideline for handwashing and hospital environmental control. Garner, J S, et al. Centers for Disease Control

Guideline for prevention of surgical site infection. Infection Control and Hospital Epidemiology; 1999, Vol 20, 4

Guidelines on AIDS and first aid in the workplace. WHO. ISBN 92 4 121007 9

Guidelines on sterilization and disinfection methods effective against HIV. WHO. ISBN 92 4 121202 0

Handwashing. Association for Professionals in Infection Control and Epidemiology. Website: www.apic.org/html/cat/jjbroch1.html

Handwashing-related research findings. Dairy, Food and Environmental Sanitation; Sep 98

Infection control guidelines for use in tattooing/skin piercing practice. Gunn, J K. North Staffordshire Health; Management of occupational exposure to hepatitis C. PHLS Communicable disease and public health. Vol 3 No 4

Needlestick injuries and hepatitis B virus vaccination In health care workers. Communicable Disease and Public Health; vol 3, 3; September 2000

Needlestick injuries. Local government and Entertainment Services; NIG Sheet 1. HSE Books

Purchase, operation and maintenance of benchtop sterilisers. DB 9605 second edition. Medical Devices Agency

Recommendations for the control of Hepatitis C virus (HCV) infection and HCV-related disease. Morbidity and Mortality Weekly Report; Vol 47, RR-19

Risk factors for Hepatitis C virus infection: a case-control study of blood donors in the Trent region (UK) Epidemiology and Infection; 1994, Jun; 112(3); pages 595-601

Safety at autoclaves. PM 73. HSE Books

Scottish infection manual - guidance on core standards for the control of infection in hospitals, health care premises and at the community interface. Public Health Policy Unit, Room 401, St Andrew's House, Regent Road, Edinburgh EH1 3DG; tel, 0131-244 2501

Selection and use of disinfectants. HSE Books

Sterilization. Health Technical Memorandum 2010 Parts 1-5. NHS Estates

Validation and periodic testing of benchtop vacuum steam sterilisers. DB 9804. Medical Devices Agency

Law affecting piercing and special treatments

Application of regulations to cosmetic lasers in private practice. Crawley, M T and H J Weatherburn. Radiological Protection; 20, 2000; pages 315-319

Body art: a comprehensive guidebook and model code. National Environmental Health Association

J Burden MP; House of Commons Hansard Written Answers; 9 Feb 1999; part 12, page 1. TSO website, http://www.parliament.the-stationery-office.co.uk

D Clark MP; House of Commons Hansard Written Answers; 20 Apr 1999; part 4, page 1. TSO website, http://www.parliament.the-stationery-office.co.uk

Gillick v West Norfolk and Wisbech AHA, and another. 1986; 1FLR 224

Girl of 12 came home with gold ring through her navel. Stokes, P. Mail on Saturday; 8 Jun 1996

Greater London Council (general powers) act 1981. The Stationery Office

Health and safety (enforcing authority) regulations 1998, SI 1998/494. The Stationery Office

Health and safety at work etc act 1974. The Stationery Office

Infectious complications of body piercing (letter). Fisman, D N. Clinical Infectious Diseases; 1999, 28; page 1340

T Jowell MP; House of Commons Hansard Debates; 12 May 1999; part 5; page 1. TSO website, http://www.parliament.the-stationery-office.co.uk

Legislative and preventive measures related to contact dermatitis. Liden, C. American Journal of Contact Dermatitis; 2001, Feb; 44(2); pages 65-9

Local authorities act 1972. The Stationery Office

Local government (miscellaneous provisions) act 1982. The Stationery Office

London local authorities act 1991. The Stationery Office

London local authorities act 2000. The Stationery Office

Modernising regulation: the new Health Professions Council. NHS Executive. Noah, N. The Guardian; 24 Oct 1999

Nursing homes and mental nursing homes regulations 1984, SI 1984/1578. The Stationery Office

Professions supplementary to medicine act 1960. The Stationery Office

Prohibition of female circumcision act 1985. The Stationery Office

Regina v Brown and others 1994 1 AC 212

Registration and inspection of premises using lasers for medical and surgical purposes. DHSS Circular HC (84) 15. The Stationery Office

Regulation of skin piercing businesses. Mithani, A. (letter from Department of Health, 30 Jun 1998)

Regulation of skin piercing: consultation paper; 3 Oct 1996. Department of Health and Welsh Office

Reporting of injuries, diseases and dangerous occurrences 1995: guidance for employers in the healthcare sector. HSE Books, Health Services Sheet 1

Shakoor (administratrix of the estate of Shakoor, deceased) v Situ (t/a Eternal Health Co). [2001] 1 WLR

Tattooing of minors act 1969. The Stationery Office

Waste disposal

BS 7320:1990 Specification for sharps containers.

Clinical waste: guidance to local authority client officers on disposal of clinical waste. Institute of Waste Management

Clinical waste disposal. GMB

Disposal of healthcare waste in the community. Royal College of Nursing

Healthcare waste management and minimisation. Institute of Waste Management

Safe disposal of clinical waste. HSE Books. ISBN 0 7176 2492 7

Sharps in the community. Guidance note 10/99. Scottish Centre for Infection and Environmental Health

Special waste explanatory notes. SWEN001. Environment Agency

Waste management - duty of care. 95EP159. DETR

Risk assessment

Assessing and managing risks at work from skin exposure to chemical agents. HSG205. HSE Books

Control of substances hazardous to health (general ACoP); Control of biological agents (biological agents ACoP). L5. HSE Books. ISBN 0 7176 1670 3

COSHH essentials - easy steps to control chemicals. HSG193. HSE Books

COSHH: A brief guide for employers. INDG 136(L). HSE Books

Essentials of health and safety at work. HSE Books

Essentials of occupational skin management: a practical guide to the creation and maintenance of an effective skin management system. Packham, C L. Limited Edition Press. ISBN 1 85988 045 2

Five steps to risk assessment - case studies. HSG183. HSE Books

Five steps to risk assessment. INDG 163. HSE Books

Guidance on risk assessment at work. European Commission. ISBN 92 827 4278 4

Management of health and safety at work regulations 1999: approved code of practice and guidance. L21. HSE Books

Successful health and safety management. HSG65. HSE Books

Body art

A piercing issue: body piercing in Bury and Rochdale. Benons, L, et al. Environmental Health Journal, Oct 1999

Body and skin piercing. Scottish Centre for Infection and Environmental Health

Body art: model code and guidelines. National Environmental Health Association

Body piercing. Ferguson, Henry. British Medical Journal; 1999, 319; pages 1627-1629

BS EN 1810:1998 Body piercing post assemblies: reference method for determination of nickel content by flame atomic absorption spectrometry

Cheap and nasty. New Scientist; 30 Jan 1999; page 22

Dangerous substances and preparations (nickel) (safety) regulations 2000, SI 2000/1668. The Stationery Office

Eye of the needle. Clarke, P. ISBN 0 9521175 0 9

Female genital mutilation. Information Factsheet N153. WHO

Guide to hygienic skin piercing. Noah, N. Communicable Disease Surveillance Centre

Oral piercings. Association of Professional Piercers

Pathogen causing infection related to body piercing should be determined (letter). Khanna and Kumar.
British Medical Journal; 2000, 320; page 1211

Procedural manual. Association of Professional Piercers

Prohibition of female circumcision act 1985.
The Stationery Office

Return of the tribal: a celebration of body adornment: piercing, tattooing, scarification, body painting. Camphausen, Rufus C. Park Street Press. ISBN 0892816104

Risks associated with tattooing and body piercing. Braithwaite, RL, et al. Public Health Policy. 1999; 20(4); pages 459-70

Skin penetration guidelines. NSW Health. ISBN 0 7313 40612

Standards of practice for tattooing and body piercing. Department of Human services, Victorian State Government, Australia

Tattoos and tattooing: Part I, history and methodology; Part 2, gross pathology, histopathology, medical complications, and applications. Sperry, K. American Journal of Forensic Medicine and Pathology; 1991, Dec; 12(4); pages 313-9, and 1992, Mar; 13(1); pages 7-17

Traditions around the world body decoration . Powell, J. Wayland (Publishers) Ltd

Ear piercing

BS EN 1810:1998 Body piercing post assemblies: reference method for determination of nickel content by flame atomic absorption spectrometry

Comparison between cartilage and soft tissue ear piercing complications. Simplot, T C, and H T Hoffman.
American Journal of Otolaryngol; 1998, Sep-Oct; 19(5); pages 305-10

Guide to hygienic skin piercing. Noah, Norman. 1983; PHLS Communicable Disease Surveillance Centre

Acupuncture

Acupuncture: efficacy, safety and practice. British Medical Association 2000 ISBN 90 5823 164 X

Code of Ethics. British Acupuncture Council

Code of Practice. British Acupuncture Council

Outbreak of hepatitis B in an acupuncture clinic. Walsh B, H Maguire, and D Carrington. Communicable Disease and Public Health; Vol 2, 2; June 1999

Electrolysis and beauty treatments

Assessment for membership manual. British Association of Electrolysists

Beauty treatments and risk of parenterally transmitted hepatitis: results from the Hepatitis Surveillance System in Italy. Mele, A, et al. Scandanavian Journal of Infectious Diseases; 1995; 27; pages 441-44

Contact allergen avoidance program: a topical skin care product database. Yiannias J A, and R A el-Azhary. American Journal of Contact Dermatitis; 2000, Dec; 11(4); pages 243-7

Cosmetic use of alpha-hydroxy acids. Vidt, DG, and W F Bergfeld. Cleveland Clinical Journal of Medicine; 1997, Jun; 64(6); pages 327-9

Electrolysis (leaflet). British Association of Electrolysists

Essentials of occupational skin management: a practical guide to the creation and maintenance of an effective skin management system. Packham, C L. Limited Edition Press. ISBN 1 85988 045 2

Legislative and preventive measures related to contact dermatitis. Liden, C. American Journal of Contact Dermatitis; 2001, Feb; 44(2); pages 65-9

Occupational allergic contact dermatitis from colophony in depilatory wax. de Argila, D, J Ortiz-Frutos, and L Iglesias. American Journal of Contact Dermatitis; 1996, May; 34(5); page 369

Occupational allergic contact dermatitis in beauticians. Matsunaga, K, et al. American Journal of Contact Dermatitis; 1988, Feb; 18(2); pages 94-6

Occupational contact dermatitis in the UK: a surveillance report from EPIDERM and OPRA. Meyer, J D, et al. Journal of Occupational Medicine, (London); 2000, May; 50(4); pages 265-73

Occupational dermatitis from cosmetic creams. Rudzki E, P Rebandel, and Z Grzywa. American Journal of Contact Dermatitis; 1993, Oct; 29(4); page 210

Safety of alpha-hydroxy acids. SCCNFP/0370/00 final. Website, http://europa.eu.int/comm/food/fs/sc/sccp/out121_en.pdf

Sensitizers commonly causing allergic contact dermatitis from cosmetics. Penchalaiah, K, et al. American Journal of Contact Dermatitis; 2000, Nov; 43(5); pages 311-3

Unwanted hair and its removal: a review. Liew, S H. Dermatology Surgeon; 1999, Jun; 26(6); pages 431-9

Electrotherapies

Animal and human responses to UVA and UVB. R297. National Radiological Protection Board

BS EN 60335-2-27:1997, IEC 60335-2-27:1995 Particular requirements for appliances for skin exposure to ultra-violet and infra-red radiation

BS EN 61228:1995, IEC 61228:1993 Method of measuring and specifying the UV radiation of ultraviolet lamps used for sun-tanning

BS IEC 60825:Part 8 Guidelines for safe use of medical laser equipment.

Controlling health risks from the use of UV tanning equipment. INDG209. HSE

Guidance on safe use of lasers in medical practice. Department of Health

ISRM operator's guide to suntanning services. Institute of Sport and Recreation Management

Sunbeds and skin damage. Imperial Cancer Research Fund

Sunbeds exposed. 182: 09/99. Institute of Sport and Recreation

Sunbeds in current use in Scotland: a survey of their output and patterns of use. McGinley J, C J Martin and R M MacKie. British Journal of Dermatology; 1998, Sep; 139(3); pages 428-38

Survey of the variation in ultraviolet outputs from ultraviolet A sunbeds in Bradford. Wright A L, et al. Photodermatol Photoimmunol Photomed; 1996, Feb; 12(1); pages 12-6

Ultrasound. Environmental Health Criteria 22. WHO

Use of lasers in the workplace: practical guide. OSH Series 68. International Labor Organization

Massage therapies and lifestyle consultations

General

Code of conduct. British Complementary Medicine Association

Complementary and alternative medicine; sixth report, session 1999-00. The Stationery Office. ISBN 0104831006

Complementary medicine: information pack for primary care groups. Department of Health

Guidance notes on law and ethics. British Complementary Medicine Association

Aromatherapy

General Information Booklet.
Aromatherapy Organisations Council

HSE Toxic Substances Bulletin. 2000, Sep; issue 43; page 3

Occupational allergic contact dermatitis caused by ylang-ylang oil. Kenerva, L, et al American Journal of Contact Dermatitis; 1995, Sep; 33(3); pages 198-9

Homeopathy

Code of conduct and guidance to practitioners. British Complementary Medicine Association

Code of ethics. British Register of Complementary Medicine

Homeopathic Medicine Research Group: report to the European Commission DG XII, science, research and development; vol 1

Randomised controlled trial of homeopathy versus placebo in perennial allergic rhinitis with overview of four trial series. Taylor, M, et al. British Medical Journal; Vol 321, number 7259; pages 471-476

Massage

Code of practice for Teachers. The Shiatsu Society

Code of professional conduct and ethics. The Shiatsu Society

Register of practitioners, 2001. The Shiatsu Society

Shiatsu: a patients' guide. Shiatsu International

Shiatsu: an introductory guide. The Shiatsu Society

Phytotherapy

Code of ethics. National Institute of Medical Herbalists

Code of practice. National Institute of Medical Herbalists

Legal requirements for practitioners and clinics.
National Institute of Medical Herbalists

Traditional Chinese medicine

Shakoor (administratrix of the estate of Shakoor, deceased) v Situ (t/a Eternal Health Co). The Independent, 25 May 2000

Colonic irrigation

Guide to good practice. Colonic International Association

Minimum UK standards for training of colonic hydrotherapists. Colonic International Association

Saunas, spas etc

BS EN 60335-2-53:1997, IEC 60335-2-53:1997 Specification for safety of household and similar electrical appliances; particular requirements; sauna heating appliances

BS EN 60335-2-60:1998 Specification for safety of household and similar electrical appliances; particular requirements; whirlpool baths

Guidelines for safe recreational water environments: swimming pools, spas and similar recreational water environments (draft for consultation). WHO publication SDE/WSH/DRAFT/00.8. WHO

Hygiene for spa pools. Public Health Laboratory Service

Legionnaires' disease: the control of legionella bacteria in water systems: approved code of practice and guidance. L8. HSE Books. ISBN 0 7176 1772 6

Minimising risk of legionnaires' disease. Technical Memorandum 13.
Chartered Institute of Building Services Engineers

prEN 12764 Sanitary appliances: specification for whirlpool baths. 97/101962 DC

Pseudomonas dermatitis/folliculitis associated with pools and hot tubs - Colorado and Maine, 1999-2000. Morbidity and Mortality Weekly Report; Vol 49, 48

Sauna and steam baths.
Swimming Pool and Allied Trades Association

Suggested health and safety guidelines for public spas and hot tubs. DHHS publication CDC)99960. Centers for Disease Control; US Department of Health and Human Services, Public Health Service. 1985

Swimming pool guide: ultimate guide to buying swimming pools and spas. Swimming Pool and Allied Trades Association

Treatment and quality of swimming pool water. DETR